THE
ART
WORLD
DREAM

Alternative Strategies
for Working Artists

Eric Rudd

PUBLISHER

North Adams, Massachusetts

CIRE CORPORATION - PUBLISHER
An imprint of Cire Corporation
Historic Beaver Mill
189 Beaver Street
North Adams, MA 01247-2873 USA
Orders and information: order@cirepub.com, www.cirepub.com
or (800) 689-0978

Cover: Design by Keith Bona; background photograph: The Solomon R. Guggenheim Museum, New York. Photograph by David Heald © The Solomon R. Guggenheim Foundation; front photograph: © Eric Rudd Studio

Printed by Proforma Universal Marketing, North Adams, MA

All photographs © Eric Rudd Studio unless otherwise noted.

Publisher's Cataloging-in-Publication Data
(Provided by Quality Books, Inc.)

Rudd, Eric.
 The art world dream : alternative strategies for working artists/Eric Rudd. –1st ed.
 p. cm.
 Includes index.
 LCCN: 2001089007
 ISBN: 0-9709959-0-3

 1. Art—Vocational guidance. I. Title.

N8350.R83 2001 700'.23
 QB101-200632

Table of Contents

Walter Hopps
No Time to Lose – Look Fast
Saying "No" First
There are Better Salespeople than You
Thick Skin: Early Start
In the Nude
How to be Honest/Cruel
What Are Your Roots?
The Older You Get
Give a Little Too
How Many Can See Your Art?
Floating Fried Eggs
Exhibiting: Make it Look like a Million Dollars
Making it Popular
Simple Agreements
Another Way in Japan

Romantic Studio
Keeping Abreast
Become the Boss
The Work is in the Details
Slides
Resumes
Time to Protect
Storage
Cold Storage
Free Grant Applications
Where Ignorance is Bliss
Eat, Sleep but Make Art
Bad Teeth?
The Business of Passion
New Economics – Irritable Regulatory Stuff
Junkets
Aggressively Legal
Buying Futures

Better than a Gallery Show
Don't Put Off until Tomorrow
A Light Puzzle
Make the Museum Cry "Uncle"
Politics 101 or "Why Not Have an Artist Running the Show?"
Local Art
Museum Babies
Guggenheim on the Move
A Walk on the Dark Side
Eating with Art
Corporate Partners
Use Some Public Taste

Contemporary Artists Center
An Out-Of-The-World Experience

About The Author

Eric Rudd is a well-known sculptor/mixed media artist. He has exhibited extensively for thirty-five years and is represented in many museums and private collections. His exhibition, the Dark Ride Project (www.darkrideproject.org), is a futuristic 15,000 square-foot art installation that includes an actual ride on the robotic "Sensory Integrator" through "creative space." He is currently working on robotic sculpture installations and his first "Top Secret" project, with a sneak preview in this book.

Eric founded and for ten years directed the Contemporary Artists Center (www.thecac.org), a not-for-profit artists' studio residency and exhibition facility. He has been instrumental in helping several new and alternative galleries and museums, has founded several studio buildings and currently has one of the largest individual artist studios in the country; he has worked with many new industrial materials and processes, has been the recipient of an NEA fellowship grant and a fellowship from the Japan Foundation, has created art during corporate and foreign residencies, and has taught, lectured and been politically active and idealistic as an artist.

While busy with many art projects, Eric was prompted to write this book because so many artists have come to him for advice. Equally compelling is Eric's desire for artists to have more control over their careers. We hope you can put his secrets and experiences to good use.

Eric Rudd is author of <u>The Art Studio/Loft Manual–For Ambitious Artists and Creators</u>.

Preface – Note to the Reader:

Being an ambitious, hard working, dedicated and talented artist is not easy business. In a crowded world, where millions of crafts people and amateurs compete for the same market as you, potentially great artists can get left at the opening gate or lost in the shuffle. This book is an attempt to help artists get control over their lives. It's great to believe that you will be discovered or that a gallery will sell enough work so that you'll never have money troubles again, but that is not the reality. At the same time, not achieving commercial recognition should not prevent you from making great art. This book hopefully will give you new ideas and strategies to produce the work that in your heart you know you are capable of making.

Disclaimer:

This book is an attempt to outline many of the issues involved with being a professional fine artist. It can not foretell every possibility or necessarily fit every individual case or predict every possible contingency. The author, while experienced, is not a lawyer, accountant, licensed expert or psychologist.

The purpose of this book is to introduce ideas and issues. You are responsible to seek expert advice about all individual cases. The author and the publisher shall have neither liability nor responsibility to any person or entity with respect to any loss or damage caused, or alleged to have been caused, directly or indirectly, by the information contained in this book.

If you do not wish to be bound by the above, you may return this book to the publisher for a full refund.

Acknowledgements:

In one book, I can not acknowledge all the people who have given me advice throughout my career.

Foremost thanks go to my wife, Barbara, who has shared in the struggle and rewards. She has been an active partner in all of this.

I want to thank my sons Thaddeus and Nikolai, now grown, but who grew up with various art experiences. I want to thank my parents who encouraged me early to be an artist. It's been a rewarding experience and hopefully there's a lot more to look forward to.

I've had teachers and mentors who especially stand out: Carol Cameron, Luciano Penay, Emilio Vedova and Walter Hopps. I've been in contact with hundreds if not thousands of respected artists/colleagues as well as gallery and museum directors, curators, critics and scholars and all have contributed to my knowledge. I've been lucky to move to a receptive arts and technology community. Individuals such as John DeRosa and Joe Dolan helped get me established here.

Finally I want to acknowledge the people who helped to put this book into final form- Keith Bona for design, Mary Misch, Barbara Rudd and Ulrica Rudd for editing, North Adams Transcript, MASS MoCA, D.C. Public Library, Caroline Bonnivier, Contemporary Artists Center, Guggenheim Museum and the Smithsonian American Art Museum for photos, and Joe Manning for making an important early suggestion.

Dedicated To:
Barbara
Ulrica and Irving
Thaddeus and Nikolai
Walter

In Memory of Nina

INTRODUCTION TO THE ART WORLD DREAM

Every artist wants his or her work to hang in the Museum of Modern Art, if not soon, then sometime in the not too distant future. This would signify recognition, financial success and the artist's place in art history. Rock stars can get famous by the age of twenty, so why not visual artists? Sure, the art has to be good, but mostly it has to be discovered and recognized, right? There must be a secret way for that to happen, and if you find the answer, then admission to greatness will be assured!

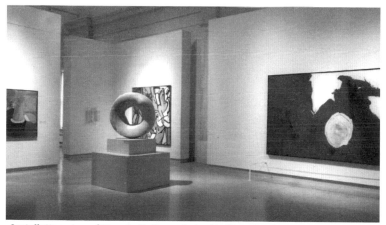

Installation view of Lincoln Gallery; photo: Smithsonian American Art Museum

How can you join the ranks of a Michelangelo, Goya, Van Gogh, Picasso, Johns, Rauschenberg or...Schnabel and Holzer? Julian Schnabel and Jenny Holzer are included not because they are necessarily in the league of the others mentioned - they are fine artists, but it's too soon to tell - but because their climbs were so fast and so inspiring to a new crop of young artists. You have

to realize that to be in the ranks where your work hangs in major museums, and hundreds of art scholars write about you, and your work is always in demand, and you are - within the art world, because fewer artists get into the popular culture - a household name, that's like being a basketball player with a ten- million-dollar contract out of the hundreds of thousands of high school, college, and city court players in the country. It's like winning the Boston Marathon - thousands of runners compete, but they are just a small percentage of the hundreds of thousands of serious recreational runners in the country. There are many more than a hundred thousand artists just in the New York City area alone, and hundreds of thousands more artists in the rest of the country and the world.

So how do you get your work out in front? Without a doubt, you need to do good work. I will propose to you that you need to do better than that - you need to make great art. Does making great art mean that you will also achieve recognition as soon as you make the art? History is full of artists who only achieved fame very late in life or after death. Obviously, there are other factors. This book will discuss these other factors, because all artists have to deal with the commercial art world to some degree. The premise of this book, however, is that even if an artist has the ambition and talent to make great art, the potential art may never come about if the conditions around the artist and the artist's own lifestyle do not support the production of this work. At the same time, decisions and actions can be taken to help achieve recognition, but this should not be the priority for the artist. In the process of achieving recognition, however, the artist must have opportunities to exhibit and to realize significant projects. This may require substantial resources. This book will demonstrate new concepts, resources, and processes for artists to utilize.

THE RUN OF YOUR LIFE

How do you know if you are good enough to begin with? To continue the 'running the marathon' comparison, rather than moving to a new environment, rather than spending thousands of dollars for new shoes and clothing and a coach and training equipment, you can just put on a regular pair of running shoes and go run around the block. You will soon know in what condition you are. If you are disciplined and ambitious, you will run ten blocks, then twenty blocks, then five miles, then ten miles and so forth. It does not take great genius to know if you are even ready to consider whether to compete with others in a real marathon race. At one point, after running the full 26 miles dozens of times and having recorded your stamina and time, you might be in the league where professional coaching could become crucial. In your art, you might be at a level where the judging (unlike an athletic race with an absolute winner) is subjective. This is where many good artists get left behind unfairly. But if you are just running around the block for the first time, you have a long training routine to go through before you get even close to being competitive.

If it seems rather elementary that one can tell instantly whether someone is in the 'running' for a professional or Olympic athletic event, for those of us who have been in the art business for a number of years, including the many gallery directors, museum curators and critics out there who will be judging you, it is pretty obvious who isn't in the running. So this book is to help you become an artist who can be in the running for museum recognition (to use that as just one measure). In some ways, it is as easy as telling you to start running, but in the art world there are many more factors to consider. These are not necessarily very difficult, but a hint or suggestion in some areas can save you, in many cases, months of wasted effort, time and money.

Make no mistake: this book can give you invaluable

help in achieving your goals. No, it can't hold the paintbrush and stroke the canvas for you. It also is not an elementary 'how to paint' or 'how to be an artist' manual. There are plenty of advice books already written for that. That's like giving you advice on how to go hiking in the woods.

In fact, you are not reading this because you want to go for a recreational run, or even a hike. You want to climb Mount Everest! For such an undertaking, there definitely are steps to consider and ways someone can help you. No book can tell you if you will have the strength, but a book can tell you how much strength you will need and how to measure your strength. No book will guarantee that you will be able to raise the funds to finance such an expedition, but a book can tell you what you will probably need and whether there are ways to attain it more easily.

This book will tell you about other peaks, just as challenging, and present new concepts for you to consider. This book will miss the mark if you are, like a recreational hiker, a novice in art. This is a 'how to' book to help you undertake an artistic mission of the most serious nature, needing the utmost determination from you.

Many books tell artists how to approach galleries, present their work through slides and resumes, and so forth. These techniques will do little good if your work is not worthy of consideration. This book has some alternative advice, but in truth there are not any secrets that will guarantee that your work, whether it's good or not, will be pulled out in front by the powers that be. However, it will help you get your work to the point where it deserves to be out in front, and it will suggest how you can be less dependent on the powers that be by becoming your own independent power! There's a big difference.

GREATNESS IS NOT FOR THE TIMID

This book is not for the timid. Although I've included many practical suggestions, it will not give you

the ABCs about signing your first lease, writing your first resume, getting a discount from your friendly art store or dealing with a gallery contract. There are plenty of 'how to' books to help you with those easy things, if that's what you're worried about. I am writing this assuming that you are as tough and as ambitious as you need to be to get to where you want to be. If your goal is just to decorate your home or show at your neighborhood art gallery or outdoor art fair, read no further. If your goal is to set up the conditions where you can create art that will compete in quality with every big name you have ever studied in art history, then read on.

There is every reason why a young or developing artist should compare himself or herself to da Vinci, Rembrandt, Manet, Picasso or Pollock, just to arbitrarily name a few. We sometimes immortalize these historical figures, but they were humans just like you and I. They learned, they struggled, and they worked hard to accomplish their places in the major museums. Some of them accomplished their greatest work while still young. We need to analyze how they went about their work in real terms and how that would translate into today's world. I can quite easily imagine Leonardo da Vinci sitting in front of his computer and using the latest graphic software to realize all kinds of innovative projects. I can imagine Michelangelo constructing monumental public sculptures using honeycomb synthetics and other plastics. I can imagine Manet or Rembrandt testing the boundaries of pornography. I can imagine Duchamp using the Internet for chess and art.

WHO'S GIVING THE ADVICE?

Certainly, this book would have a different slant to it, and you would have a slightly different attitude when reading this, if I were a famous artist with whom you could identify, and had happened to write a book on how I succeeded and 'how you can also succeed.' It does little

good to tell you I had several chances at the 'big time' (like being offered the leading role in a movie, only to either decline it or get sick, and for the movie to become the hit of the year) and could just as easily be a 'name' artist today as not. It might help to show you my resume of exhibitions, a list of museums that have my work, and a list of other accomplishments.

Most artists struggle to create art from a small studio and to exhibit their art after being given the nod from a gallery dealer. It may impress you even more than knowing my exhibition history to know that I own a mill turned into an arts center about seven football fields in size - a few blocks from a major museum undertaking involving the Guggenheim Museum; that my personal studio is about three football fields in size; and that I opened my own multi-media/robotic/futuristic prototype exhibition that compares in size to most major art museums. It may impress you to know that I have stocked in my studio for my personal use, thousands of sheets of paper, hundreds of gallons of paint and tons of canvas, and I have been given access to a million-dollar machine and thousands of pounds of materials to produce art using a new industrial process. It may impress you to know that, as I write this, my current work is a "Top Secret" project, so unique that it might amaze you.

Admittedly, there is a big gap between being known professionally and being famous.

Perhaps I am somewhere in the middle; perhaps my near misses point out what I should have done more graphically than if superstardom had just happened. It should inspire you more to learn what I have been able to accomplish without being an art superstar. Certainly, when you read the end of this book, you may realize that I'm not out of the running yet for greater recognition - but that is really a very minor concern. My main concern is to create art that pushes me into the visual unknown.

14

Nevertheless, just as I founded a not-for-profit artists' studio center to help younger, developing artists and to create a stimulating environment for all artists who participate at the center (including me), I wrote this book as a partial payback - a way of using my experiences, knowledge, successes, and especially including my mistakes, to help whoever happens to be reading this book and wants to make art of the quality that will be worthy of recognition.

Hopefully, as you read, you will have an open mind about what practical changes you can carry out in order to pursue your career. There are people who can barely deal with renting an apartment or a small studio; I will talk to you about buying the entire apartment/loft building. There are people who get rattled every time they need to purchase a few more supplies from an art store; I will talk to you about bypassing the art store and about receiving tons of supplies. If you think you will never be able to deal with loading docks, pallet shipments, or bulk goods, you had better think twice about your career.

Go to your contemporary art museum and take a hard look at the best art you see there. Then forget the aesthetics and study the physical craft and assemblage. *Think about the fabrication plant and the life management necessary to carry out the work.* If you want to compete, you need the frame of mind, the concentration, the factory, the resources, and the right attitude, to even begin to be competitive with the artists already in the museums. I say competitive because, for better or worse, there are others who will decide which few artists to include.

I cannot tell you if you have enough talent eventually to elevate your art to the ranks of greatness - nor do I want this book even to try. I cannot tell you if you have the ambition; and, as in everything else, for public recognition there is always an element of being in the right place at the right time with the right work. But you should at least be cognizant of the playing fields, the approaches taken by successful artists, the alternatives and some

ways to recognize the effects on your art. You need to know why you are creating art - whether to satisfy your need to realize your own ideas, or to try to join a bandwagon for purposes of recognition.

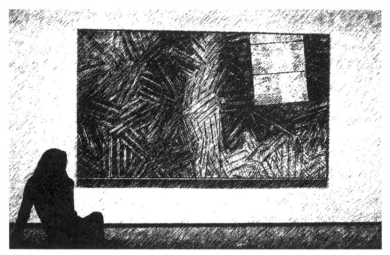

A museum viewer gazes at a modern masterpiece.

Most great artists, at the beginnings of their careers, have been stimulated and taught things by their mentors - other artists whom they respect. The only thing this book cannot do is to give you any advice about your actual art. It will give you advice on how to go about making the art, and even how to go about getting professional feedback on your art, and this can actually be more important. A true artist really doesn't need to be told what to create. There are books that will talk about creative blocks. I've never known a great artist to be so stumped that he or she can't produce. I've only known artists who get blocked because they run out of space and materials and time to carry out their more ambitious ideas. If your studio/factory is organized for a lot of creativity, there will just be too many things going on to ever experience a blockage.

I want to pause and tackle one potential weakness up front. I've had several people read the preliminary

manuscript to this book. Although I had many positive comments, one reader criticized (as an artist I have a thick skin) that while I had managed to accomplish the goals set forth in this book, how could I expect others to do so? This person suggested that I should go out and find other artists who had achieved similar goals and get their testimonials. This critic felt that the 'average' reader - probably a younger, developing artist - would not be able to duplicate or even associate mentally with my accomplishments. He felt that I was talking about rockets when I should be talking about skates.

Well, perhaps there is some truth to this, especially because everyone's circumstances are unique. On the other hand, if I were to drop the goals and expectations outlined in this book to a level that would find a more common denominator so that all readers would feel comfortable, I would also be dropping the very reason that younger artists dream of creating works that will achieve immortality. I would be joining a vast array of art 'manuals' geared as much for the amateur as for the ambitious professional, and that is clearly not my purpose.

I hope that all readers will be inspired - even if it's only by one or two new ideas offered in this book. That in itself would be reward enough. But for an overall perspective, I have written this book not as a manual, but rather as an example. As a young artist, I was idealistic - and I believe that I have maintained that mindset ever since. (Hopefully I've stayed young also!) By not waiting for, or depending upon, superstardom, you too can actively realize all the accomplishments which you are going to read about. Always remember that as an artist, even while dealing with the realities of this industry, you can remain idealistic. I hope that by gathering all your ambition, talent, and the resources available to you in your circumstances, you can achieve similar levels, if not similar specifics.

I am promising you a lot, however. The world is a hectic place; society is much too busy to allow a naive

artist to thrive. An artist needs to be smart - not just intellectually but practically - to carry out his or her dreams. I hope this book will tell you how you can accomplish your dreams without being beholden to anyone and without needing the luck of winning a lottery.

Making It

First, let's take a little time off and talk about what I've discovered is more on the minds of young artists today- 'making it' - rather than thinking about what is great art. It's a sad state but true. Chasing fame is what seems to go on too much. It happens in subtle ways - picking up an art magazine, seeing what your studio neighbor is doing, looking at the latest show in a New York gallery and then trying to do one better, or simply trying to find the latest fashion instead of pursuing the long haul of making great art. It is the same criticism we hold for American corporations that seem to worry more about their quarterly profit and loss statements than about their long-term investments. There is not one artist who can deny thinking or acting in ways to get ahead in the art market. So, rather than hide this fact, let's talk about it.

In fact, an artist shouldn't be stupid about the art market. Commercial success for an artist can lead to many artistic opportunities. The problem is, success will only come to a very few. Even that is justified, because most artists don't deserve success. The problem endures because the market is not a fair or just place for the remaining artists who do deserve success. Nor is it supportive of artists early on, before anyone can tell if the artist has 'what it takes.' Out of frustration, too many artists make decisions in order to pursue recognition that really undermine them from creating better art.

This book will deal with ways to get around this system and allow as many if not more opportunities for artists as the recognized elite are given. Hundreds of decisions have to be made by individual artists regarding the work environment and how it impacts their chances to do better in the commercial art market. Knowledge about the forces in the art market is important for making those decisions. There is no use in overspending for a studio in SoHo to be near the dealers if galleries still won't look at your work. There is no use in creating only saleable work

19

if your 'great art' demands large, temporary installations that are harder to sell. There is no use spending time taking slides to show galleries if you don't have the work that will 'knock them dead.'

Even with adequate knowledge of how the art market operates, there is still only a slim chance of winning - regardless of the quality of work. Artists need a mental defense, so that losing in the art market is not translated into losing in one's career. Artists need to maintain the attitude that they are good - and they need to be correct with that assessment. Finally, artists need to produce the great art they are capable of producing, regardless of how the world treats them. In this regard, artists will constantly need to balance how much time to spend on achieving recognition with when to say the hell with it and just concentrate on their studio art. Artists need to know when their working and living strategies are justified and they should stay the course. If their actions are not justified, they might improve their chances to achieve recognition and put their time to better use by setting up an alternative course. For better or worse, the consequences of your actions need to be considered. 'Making it' is great. Not 'making it' should not be fatal if you are prepared. Even better, there are ways to insure that you will 'make it,' if you are open to alternative strategies.

CAN YOU FACE REALITY?

In the back of every artist's mind there is always the question, "What do I do if I realize I am not going to be a great artist?" Can you be satisfied with permanent secondary status? (And even this ranking is a small elite group.) Can you find satisfaction from just doing what you enjoy? Can you find satisfaction from teaching, showing in community halls or restaurants, and - it's the naked truth to thousands of artists who won't admit this – making art as a hobby? Most artists do something else in order to

20

fund their studio activities, whether it is teaching, commercial art of some form, or a job not related to art. In truth, the vast majority never gets much further than a few unimportant group shows a year. If you ask them what they do, they will all state that they are artists, when in reality this is like a lawyer who plays golf three times a week saying he/she is a golfer. If this is cruel, so be it, but not to know reality is to encourage a lifetime delusion. But the point of this book is that there are concrete ways to give yourself a better shot. It also depends on your real ambition. In the case of the lawyer, to take golf beyond recreational play would mean playing more, pushing his/her score, and eventually competing. He/she also might have to quit the legal practice. It is the same in the art world.

I know good artists in their seventies who still hope to be discovered as if they were twenty-five years old. I hope this book will prevent that from happening to you. When you are young, you think you will live forever. It's difficult to tell teenagers to stop smoking because they might get cancer one day. 'One day' is too abstract and too far away to be of any concern. It's the same for young artists - they think they will be discovered in the near future, and life will be great after that. *What really happens to 99.9% of talented artists is that they get a little local success, thinking it will bring broader recognition, but the years fly by quicker than their success expands.* They will find themselves in their thirties and then forties, still holding on to the dream that it's 'not too late.'

The other thing that happens to most artists is that they never really make the art that they could have made in order to become recognized. I believe that some of them could have, if the conditions had been different and the support mechanisms had been in place. Sometimes developing artists need that extra bit of encouragement, not from their best friends but from a respected scholar, in order to give them a surge of creativity. Sometimes they need to conquer some of life's difficulties in order to free up

the time to allow concentration on their art. Sometimes they need that exhibition offer to get them to complete some ambitious work. Sometimes they need to have access to a process whereby work can be crafted. Making art is hard work, and trying to get to a finished product in a couple of hours of free time, without proper tools and materials, in a cramped studio, will not usually be the formula for success.

WHAT NOT TO DO

Artists waste a lot of time. They worry, fret, and act petty. I can tell you a few very good things to do in this book. I can also tell you many things not to do. Having taught, having founded loft buildings with dozens of artists' studios (hundreds over the years), having dealt with galleries and alternative spaces both as an artist and behind the scenes – here are just a few random samplings of the many, common but sad observations I have made.

I've seen artists worrying about their neighbors and whether their techniques will be stolen - *but they have no new techniques of consequence.* I've seen artists fighting for years to get a show at some middle-of-the-road gallery; then, when a review comes out, usually about two paragraphs, they read and reread the article, hoping that if they read it enough they will get some positive feedback - *they don't know that it's just the opinion of one reporter who usually has a limited art background, if any, and readers just glance at the reviews anyway, and throw them in the trash by the next day. It's like savoring a high-school football game for the rest of your life - it's a lot more important to you than to anyone else.* I've seen slides fussed with and a lot of expense put into them - *I've also seen those slides come into galleries and get handled along with the other two thousand slides. Artists think that their slides will somehow jump up and do a dance in front of the people judging.* I've seen art on the wall of a gallery for several thousand dollars, and the dealer trying to do a

sales job on a potential client - *I've also seen the gallery finally go under and a lot of this precious art being left behind, to collect dust, to get damaged, and finally, because the artist couldn't be reached or didn't care enough to fetch the pieces, how it soon is no different from broken lamps and wobbly chairs; all of it just getting tossed into the dumpster.* I've seen scam 'artists' set up a membership gallery to which artists send slides and works (and a monthly fee) with promises of being put on a national or world tour - don't laugh, I've personally seen hundreds of artists send in thousands of slides and artworks - *only for the organizers to eventually blow town, break down, or somehow leave all these hopeful artists with lost artwork.* I've seen how large sales and commissions for artists have made the news and have made other artists jealous, *only for the art to be discarded a few years later when the office complex, shopping center or apartment lobby got a million-dollar facelift.* I've seen good art sold during a show, *only to go to the million-dollar home where it will be displayed and find it a decorator's nightmare. (How about a pink and lavender, polka-dot and zebra- stripe combo?)* I've seen artists scrambling for the right party invitations to impress their friends or to get in with the collectors, *who are usually nice business people with a bit of cash - but that's all; they're certainly not curators of museums.* Most of all, I've observed artists staying in one place and acting the same way - *as if their little circle means anything more than it did twenty years earlier or it will ten years hence.*

My son was a successful teenage actor in Washington, D.C., and he would go up to New York almost weekly for auditions. In the same waiting rooms were many adults, there to try out for other parts, waiting up to an hour or two (per audition, with hopefully several auditions per week) for a one-minute audition, with the same slim chance as my son; this may be okay for a year or two, but not for a career. This is the feeling shared by artists who have struggled their entire professional lives for a crumb or two.

Understand two things. First, this is more common to most artists than you or anyone would want to admit or believe. Second, there are much better ways of being an artist.

I BITE MY TONGUE

I've been asked by countless artists to look at their work - the equivalent of a one-minute audition - and one look may tell me the person is wasting time being an artist. What can I say? I really want to say, "Make art as a hobby and don't expect professional recognition." I silently hope they have solid backup and security from jobs, family or teaching, for example. I hope in advance that I am looking at someone very young, because then there is a chance of improvement. Unfortunately, often it's the work of people in their mid-thirties, working for over ten years. Yet even if I give them my honest assessment, it won't make a difference in their determination to continue art. And they would be correct in their view. Being good does not mean you will get success; being bad does not mean you will be denied some degree of success. Just survey art magazines from ten years ago. Go look at fifty art galleries in New York. You will see a lot of so-so art in the magazines, and you will see a lot of bad art exhibited. But showing in a New York gallery is already a big step in seeking recognition. So how come so much bad art gets even that far? It is often baffling, but the art market allows for it to happen. In a few years, you will not hear from most of these artists again - just as you won't know most of the younger artists mentioned in art magazines from ten years ago. In another ten years you will forget 95% of the younger artists showing in the New York galleries today.

HOW TO GET HOT?

The late Gene Davis was a big name even when he was makng his art, from the 1960s to the 1980s. Today,

he is still widely recognized as an important Washington, D.C., color field painter and is collected by museums all over the country. The color school was recognized during the 1960s and championed by the critic Clement Greenberg. His favorite was Helen Frankenthaler, whom he considered the inspiration for Morris Louis, who returned to Washington from a New York visit to Frankenthaler's studio and perfected his stained paintings (so the story is told). By recognition ranking, Ken Noland was second, followed by Gene Davis and Tom Downey, Howard Mehring, Paul Reed and others.

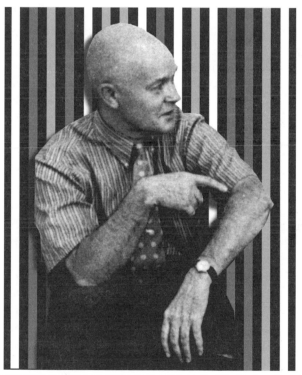

The late artist Gene Davis; photograph detail from the Washington Evening Star Achieves; © Washington Post; Preprinted by permission of the D.C. Public Library.

Gene used to give the following advice to young artists who were more concerned with making it and less than idealistic. (Mind you, this is a very commercial

approach to art, but one that needs at least to be heard.) He would say that you should get yourself a 'style,' do it and show it around for about six months, even if it's only to your friends. If you hit upon something that is hot, you will know it. If you don't get these vibes, change styles and try again. 'Vibes' does not mean a few compliments; it means a state that is undeniably clear - you'll know because other artists will be envious, galleries will ask you to show, and collectors will want to get in early to purchase your work. *Never ask yourself if you have a hot style; if it's hot, it will be more obvious to you than anything else that has ever happened to you professionally.* Gene said that if you keep trying new styles, you'll eventually hit upon something that catches on. Then, he advised, stay with the style.

Gene was a very smart artist in promoting his work. He was a reporter in his early days, then had a full-time, well-paying day job in the public relations department of AAA. He would retire each evening around 7:30 and rise around 3, go to his downtown, second-story studio only a few blocks from his office, and paint until he had to be at work at 9. He kept this up for years, even when he started to become known. In fact, he got a National Endowment for the Arts grant in 1965 which he would never had gotten (I was told firsthand) if they had known he was independently secure. Eventually, he quit his job when his success was assured.

I think Gene did great paintings. I also think Gene was a second-rate artist. A contradiction? Not really. Gene would never be in the category of a Picasso, and he probably sensed it, or at least never thought about it. But he found himself a hot style - painting vertical stripes - and he stuck with it. From the 1960s and for more than twenty- five years, he painted stripes. Occasionally he did a few other experiments for fun. He did micro-paintings and got into the Associated Press national news - which didn't happen accidentally - because he had his entire show in his pocket; he also painted stripes on the road in

front of the Philadelphia Museum, made videos of young nude girls walking in and out of a picture frame, and painted black silhouettes of his bald head - which was also a public relations stunt; but the heart of his art was painting stripes. He went from four-inch stripes to 1/8-inch stripes two decades later. When you thought of Gene Davis, you thought of vertical stripes. When you saw vertical stripes in a painting, you thought of Gene Davis. (When you thought of bald men in the art world, you also thought of Gene Davis.) He was part of a movement, and his paintings, by concentrating on one thing, were beautiful. Museums that collected a Frankenthaler and a Louis eventually needed a Noland and then a Davis. He could not have accomplished the quality of work, had he not zeroed in on just stripes. Along the way, he was good at promotion (that is what he did for the AAA) and it showed.

SOUND-BITE STYLE

Is this a good example for younger artists? Personally, my advice for younger artists is to concentrate on doing what they sincerely feel like creating, *and not to make artistic decisions based on getting known*. Obviously, there can be contradictions in each of these options. Getting known can increase your opportunities to make art; sticking to your convictions can decrease those opportunities. Practically, few artists can stylistically bounce around the way Picasso did, for example, and expect to be recognized. Of course, once you are famous, you have a lot more latitude. But the art world is also a much more crowded profession these days, and everyone wants sound bites.

When you think of most artists, you usually think of one style for each. It's likely that many successful artists stay with one style because of the commercial pressures and rewards, rather than because they have the artistic inclination to do so. Do you think Roy Lichtenstein

would have continued to paint comic-book-style paintings, after he started painting that way thirty years ago, if no one showed his work, bought it or considered it important? If your current paintings were selling for $200,000, would you be inclined to change styles? There are exceptions, but most of the exceptions were known artists or well on the way to becoming known before they starting shifting styles. Frank Stella and Gerhard Richter come to mind. Stella could still be successful doing hardedge wall constructions, yet he has enjoyed an entire second life doing expressionistic work. Richter's retrospective demonstrates an inquisitive and quality artist exploring a host of directions and interests. Yet it holds together as a body of work because it is very clear that his directions are of his own interest, and not because he is 'fishing around' for a hot style.

Hopefully, while we talk about recognition, you, the artist, will think more about making great art. If you can get into the mode to make great art, surely it will at least help you in creating any art, even if you don't have the talent or ambition to make it all the way. Art needs to improve - constantly.

WHAT'S GREAT IN THIS CROWD?

The question is now obvious. What is great art, or even good art? Who says so? Is it just what the art magazine writers say it is, or is it the work of artists picked by museum curators to show and to produce catalogs and essays about their work? Is it art chosen by the galleries who select, from thousands, a dozen or two dozen artists to be exhibited and push their work? Is it the art selected by collectors to hang in their Fifth Avenue penthouses? Is it the art that you determine is great, but if so, are you correct or is it just wishful thinking? Is it art you deem the best among the art you see exhibited, or compared to the art that is being made currently throughout the world - in which case, do you need to review more of it?

How many artists make up your competition? There are hundreds of thousands of visual fine artists. (A study once indicated that four out of ten Americans consider themselves active participants in the arts; this can include those who play in a band, do weekly square dancing, are Sunday painters, and so forth. Just extrapolating the visual artists, perhaps even millions more people would then be counted as artists.) Even editing out the amateur artists, probably one could still dismiss 90% of the so-called professional artists rather easily. In fact, during a jurying process for an art show where 900 artists submitted over 3,000 slides, and we were viewing at the rate of one slide every second or two (which still added up to several hours), fully 95% could be dismissed easily during that short one- or two-second glance. Before you get all excited over the fact that you might only be competing with the remaining 5%, this still leaves thousands upon thousands of good artists nationally.

If you want to spend the time with a calculator, add up all the colleges and universities with adequate art departments, multiply by the number of students in a period of years which would represent your generation, and you can see that to go to New York - where everyone wants to make it - and expect to be singled out is quite an act of faith on your part. Do we feel sorry for the artists who only got the one or two seconds in front of some prominent jurors? Some of the rejected applicants could even have had good work, but perhaps not well presented in a slide, and so were tossed out unfairly. Certainly, subtle works don't fare as well by slide during a quick glance as big sculptures do. Do we feel sorry? It's much too busy a world - and life goes on - to worry about who got left behind. The art world is not going to stop and make up for trampling all over you as an artist. Many New York galleries get over a hundred artists' submissions every week. If you owned an art gallery and you had to waste time dealing with all that mail rather than spending time to sell more art to make a

living, how would you look at the slides?

If art schools and art departments of universities didn't need the students so badly, they would spend some time drumming into prospective students the realities of the art world, and be more selective in admitting students. On the other hand, hypocritical artists (and many will admit this privately) who need teaching jobs to support their studio work would be out of jobs, so they perpetuate the idea that everyone can make good art. (And who really knows who is good?) In any case, even if we were to change the system, an underground movement would develop nonetheless (just as every community in the country has lots of teenage bands who hope to be discovered and make it big) and we would still end up with too many artists. The success of a few artists stimulates multitudes of hopefuls who probably would not become artists if there were for certain only poverty and obscurity in their future.

There is no real way to eliminate the competition when we are dealing with a large, educated population that can see art from around the world just by picking up a magazine. During the heyday of the Renaissance, the entire city of Florence had just 70,000 residents. Today, that would be a small town. Even with so small a number of artists in those days, many good artists became only the minor footnotes in the history books. Florence's entire population of 70,000 during the Renaissance was smaller than the number of artists you now have to compete with, which is probably in excess of 700,000 and growing - and that's counting only the serious, good artists.

THE LONELY PATH

Great art has a relationship to history and trends. It also has a lot to do with individual pursuits. A lot of great art is recognized after the artist has completed many years of solitary work; it is rarely recognized at the time the first painting or work is created. This is the romantic

image of most of art history - where the great struggling artists like Rembrandt, Van Gogh, or Pollock did not achieve success until late in their professional careers or until after their deaths. (However, in most cases, they were indeed known and admired within their circles, but did not have the financial rewards common today.)

This means that if you believe in what you are doing, and you continue to pursue and develop your work with professional zeal, you may eventually be recognized. First, however, you may have to complete years of work. My friend whom I respect more than anyone else in the art world, Walter Hopps, used to smile and say, "Eric, you will have your retrospective at the Guggenheim...when you are 80." He was serious about my work; he was serious in that not many will have a retrospective at any age. Of course, he allowed that it could happen much earlier, but I could, in his opinion, and his opinion means a lot, at least look forward to recognition by old age. I just wish he could guarantee that I would be around for it. Wouldn't it be fun if museums like the Guggenheim, Whitney or the Modern could offer gift certificates to artists, good for one retrospective fifty years from now, on the condition that you work like crazy till then? Of course, you wouldn't get the fun - the emotional satisfaction - at 80 that you would get as a young person. If success comes in old age, it is too late to cash in on the success in order to secure even bigger projects. The time clock never stops. But it is this hint of success down the line that keeps many artists going.

MAKE YOUR MOTHER PROUD

I used to ask young artists, in the hypothetical example of being on a deserted island and somehow knowing that their art would never be seen by anyone else, would they still make art, and would they make it with as much seriousness as now? The human factor is a very large ingredient in the mix of art elements. There's no

doubt about it - having a studio, going to art parties and openings (preferably your own), not having to wear a uniform or tie or formal dress, and being considered a genuine 'artist' is a lot neater and more sexy than being a junior manager in a nondescript little company.

Human factors can be fun and enjoyed for no other purpose, but they can also be helpful in creating better art. Aggression, rejection, and need for acceptance, for example, have often been key in getting people motivated creatively. A bad childhood, an 'I'll show you' feeling, rivalry, 'to make your mother proud' and so many other primal emotions can move a person into a level of creation that someday will be recognized as great.

Sometimes a very directed fascination with a very specific subject matter will do the trick. At the same time, it must be pointed out that there is a fine line between a novelty, a weird fascination or even a disgusting perversion, and something that is perceived as universally felt, or something so individually interesting that it should be put on a pedestal for everyone to gaze at. Robert Mapplethorpe and Diane Arbus are prime examples of photographic artists, recognized yet controversial in that some people consider what they exposed photographically to be somehow perverted and void of taste.

The situation is aggravated by the thousands of followers who did not do it sincerely when there was no one caring about the work, but only try to get onto the public bandwagon when they see that it's getting attention. This makes it a trend. I've never understood why artists, once they are past the student stage of practicing by imitation, do outright copies of principal styles and think that someone will then pick them up and recognize them as an equal to the primary initiator. Of course, I also can't understand how some people can go through years of architecture school, get a license, and then design boring buildings devoid of any aesthetic value. (I don't mind spectacular failures, though.) Perhaps many 'artists' feel that professional success is measured in dollars, and to

knock out commercially viable art products that sell is satisfactory. Without a doubt, there are thousands of artworks, some which may also have a craft element, done quite well, in thousands of retail stores and galleries all across the country. They can vary from systematic landscapes (I once learned to paint a watercolor featuring a flower stand in Paris under the rain in twenty seconds) to big-eyed children. I am gearing my words for those of you who want to be measured in other terms.

Making your own path, without sinking to gimmicks, and feeling honest about what you are doing at the same time will, in the long run, make you more satisfied with yourself as well as give you the best chance of being recognized for doing something distinctive and, even in this age of masses, courageous.

If you believe in nothing else, believe in the idea that rejection can be very satisfying if you think it's because you are too far ahead of your time or because you are off on your own path or because you aren't playing the 'game' - mild acceptance is a mediocre condition and, in the long term, forgettable. Plus, mild acceptance usually comes from people for whom you have little respect. If you believe that rejection is due to the caliber of your work, then the answer is to concentrate and improve your art. Just do it. Don't even think about what others think, until you feel good about your work.

INFLUENCING HISTORY

While you think about the solitary route for success, it should be soberly pointed out, a la Gene Davis, that had Jackson Pollock worked in an isolated barn and purposely stayed out of sight, not only would he not be recognized today, but even if his paintings had been discovered ten years later, he still would not have been recognized as more than a footnote. Great art influences younger artists; without the influence, great art will still be

ignored historically. Hence the dilemma: how much time do you spend in promoting your art to the world, versus the time spent doing it?

An added element is the speed at which life moves in today's world. A few decades ago, you might have had a few years to do a work of art, be discovered and still influence history. A century ago, an even longer period could have been allowed. Today, works get made, exhibited and promoted all over the world in a matter of weeks. With the Internet, this time gap may get even shorter. A work not seen for a few months just might miss its golden opportunity to be discovered and promoted.

There are many curators and gallery dealers who will say that, no matter where you live, you cannot really remain a hermit. If your art is good, the art world won't let you hide it. All artists are in contact with even a few other artists, dealers, curators, or collectors. Art that is truly good will be discovered. At the same time, I cannot think of many great artists throughout history who did not spend considerable time talking to the media or seeking commissions, exhibitions, or other public opportunities.

It has already been stated, but the work must be good; one must walk into an artist's studio and know that the art is of the highest quality. I cannot think of many artists recognized historically as great who did not have the work to support their reputations. Can you imagine going to da Vinci's studio and not being floored by the work? In many ways, this is true for contemporary artists as well. Tong Cragg and Martin Puryear are two very recognized sculptors of recent years. Can you imagine not recognizing their strengths after walking into either one of their studios? Well, yes and no. If you see a few prime examples, I think their quality is obvious. In 1981, I remember seeing two of Puryear's 'circle' works (they looked like wooden snakes) in Harry Lunn's gallery. Harry was already predicting Puryear's climb, but from the two small works I saw, I thought nice, but not much more. In Puryear's case, the chance to show substantial work was

Even with museums all over the country, the number of artists far outnumber the capacity of museums to include more than a tiny fraction of the work produced. What qualifies one artist's work over another?

necessary. Had I seen some of the larger works, I think I would have had more respect for his work. The point is, when you see a major Puryear or Cragg in a museum, you can instantly see it belongs. The quality is there, and that includes the craft as well as the integrity of the art. Somehow, even if the artist lives in the boondocks, some major work has to be seen. Seeing a Picasso sketch all by itself and not knowing the body of work might not be enough to identify the enormous talent involved. But given a chance to view ten Picassos, or ten de Koonings, or ten Rembrandts, I think anyone would be able to see the quality in the work. That is why I will constantly go back to the notion that the quality of the artwork has to be the utmost priority for every artist.

Compare this to the goal of many artists who want to push their work into a national or international showcase when even their major work simply does not have the strength. How can you tell? It is easy to tell when it's there, believe me. It is as easy to tell as to see a runner who has just finished a 26-mile marathon in a time competitive with the winners' times published in the papers. Usually. There are exceptions. Jean-Michel Basquiat comes to mind. In all honesty, there are more amateur painters than sculptors, because the process can be easier. Thus the artistic development and rapid, by some standards, rise of Basquiat's reputation was a combination of good art and good luck. His art could just as easily have stayed obscure to the world. And had it, he would not even have produced the pieces which are admired today, because public recognition gave him many more opportunities to produce. He would not so easily have obtained the materials to do the large-scale works, and certainly he would not have been able to work with Warhol on collaborative paintings.

Would Robert Rauschenberg and Andy Warhol and Roy Lichtenstein have continuously created the works they did, and had the major, expensive commissions, if their careers and therefore the demand for their work hadn't

skyrocketed early on? It would be logical to expect them to continue to work, but their work would never have reached the level or magnitude it did without the momentum from popular support and sharp promotion by Castelli.

It is critical to understand that steps can be taken to insure that the bulk of your 'potential' great work does get realized - regardless of your recognition.

Craft is the ingredient so often left out of a lot of contemporary art. Typically, I remember one visit to an artist's studio to look at fairly ambitious painted constructions. The works were up to ten feet in height and width. Although the intentions were interesting and had promise, where someone with Frank Stella's resources would have used strong honeycomb metal or heavy wood sheet materials with welded metal connectors and brackets, this artist used thin plywood, already warping, and had screwed in light 'L' brackets purchased from the neighborhood hardware store. Construction-wise, it was only a few steps above a student group project. Ironically, I knew that money was not an issue in this case. The concept was valid and the potential was there, so why couldn't she see the same thing I did?

The lesson to be learned is, even if you have not achieved recognition, don't let that hamper your production. You should create as if the entire world does care, as if each new piece was going to go straight to the Gagosian Gallery to be sold for a quarter of a million dollars, and as if it could very quickly be hanging in the Museum of Modern Art. With this attitude, I doubt that many artists would be putting out the - to be polite - inferior artwork which is so obvious and common in today's studios.

15 MINUTES OF FAME?

Even if you have achieved recognition, the battle is not over. Not all recognized art will be so well known fifty years hence. There is a continual sifting process that

continues, with input from scores of art writers and curators. Some of the fast risers in the art world have crashes - even during their prime. Look at an old art magazine and you'll see faces of artists you know, but haven't heard about recently.

This tendency is the same as with a singer who has one big hit song. I once attended a concert of popular music from twenty-five years earlier where each of the singers, whose names everyone knew, sang two or three songs. One would be a song that everyone knew and could sing to, and this was probably the singer's only career hit; the other songs were totally unknown. I have a cousin who is part of a singing folk trio that did get famous. Now they struggle. They almost had it all, but needed to stay together another two years, in order to build up enough of an audience base to carry them for the rest of their lives. They had bookings of two million dollars for the next year (this was back in the mid-1960s), but they decided to break up; one wanted to go solo and the other wanted to join a commune. Two million in those days is like twenty million today. My cousin has a very businesslike attitude about the music industry. He says the way you know how good you are is to sell tickets to a concert. You are as good as the number of tickets people buy. There are many street singers who he says are easily better than he is, but they are singing on the streets for volunteer handouts and he is on a stage where people will spend twenty dollars for a ticket. The audience has more respect for his singing before he sings his first note.

Being famous can be a fragile status, and the gallery where an artist shows, just like the performer's stage, can make a tremendous difference in the way the art is perceived.

Five years is about the lifetime for "fame" in the music business. There are only a handful of singers who are known for more than five years. You keep reading

about the Madonnas and the Dylans over and over again, and you never hear about the yearly succession of singers, numbering in the tens of thousands, who drop off to the background after they find the road blocked. Even many who make it don't last more than a year or two. In some cases, the rest of their lives might be spent singing their single big hits. There were many visual artists, working at the right time in a style that was acclaimed and supported, only to be forgotten a few years later. Of course, once you have any kind of national recognition, you can always milk it for something.

But the big names keep on rolling. The artists who were famous thirty years ago are still making most of the news. Artists Stella, Rauschenberg, Johns, Kelly, Lichtenstein- they are the Madonnas and Dylans of the art world. Only death is beginning to decrease their number.

The real answer to making it? Being damn good and being in the right place at the right time with the right work. Good luck.

There is a funny aspect about this idea of becoming famous and rich. As a young art student, I simply knew that I would struggle my whole life. All artists did: even the ones who were recognized within the art world weren't really famous at all to the general public, and certainly they were not rich. Then it all started to change in the 60s. By the 80s, several artists went from rags to riches in just months. This made it difficult for everyone else, not because we were poor, just because a few got rich. It was no longer emotionally acceptable to be left behind. You wanted to join the elite.

Nowadays, younger artists simply expect to become famous. It's like investing in a bull stock market if you've never lived through a crash. You simply don't know what it's like to lose money; and similarly, you don't know what it's like to live your life with only little recognition, lots of struggle and no big payoffs. When you find out, the hard

way, it's more than troubling for most artists I know.

Much of success comes from people and organizations and events that are outside your control. You can play the game with intelligence, but there is no sure way of winning. However, this is true if you are only trying to play on the existing playing fields; this book will demonstrate other playing fields using other strategies that are more within your power and your inclinations. There are other ways to be a successful artist - even a great artist. This book is not your road map to success if your work isn't there. This book is not an 'how to get popular' manual. Rather, it addresses the steps and the mindset needed to make great art. Whether it is then recognized as great or ignored is at that point, really, immaterial - at least if you are idealistic. That is not to ignore the commercial aspects of contemporary art. It is, instead, to give it its correct priority.

Great art, which you will know when you do it, is the true goal.

Read the ideas and concepts in this book and then use your intelligence, ambition and talent to make it happen.

STUDIO SPACE

THE SOUL OF YOUR LIFE - AND PLENTY OF IT!

Bigger is better. Pretend you are a dealer and you have time to see just one artist out of two who are trying to get your attention. You've heard that each of them is young and good; one paints in his/her garage/spare bedroom/basement, and the other has a 10,000-square-foot studio in an industrial warehouse. Which artist are you going to go visit? Which artist do you think might have more potential? This may be a flimsy hypothesis, but in the real world, the artist with 10,000 square feet will most likely have the environment where more serious work can be carried out. To me, space is a most important element in making great art and, at the same time, being artistically true to yourself. If you have a big studio, even if you paint miniatures, you are painting small because you choose to, not because you just don't have the space to carry out large works.

MAKING YOU JEALOUS

If, after this discussion, you think that I must be thinking all the time about real estate instead of art, I want to assure you that if you could see how much art I've created you would change your mind. I put space as a priority, but only in order to carry out my artistic goals.

It has taken me some years to build up to it, but finally I can smile at it all. I have one of the largest studios in the world. (Including our loft, I'm using about 60,000 square feet and I can expand easily.) I live in a place where people vacation year-round. (Five months depend on your attraction to cold weather and skiing, but the seven other months are, without any question, beautiful.) I have a loft

41

space that in New York City would cost several million dollars. (For the first few years, local residents would ask with puzzled expressions, "You live in a factory?") Some of the most interesting people in the art world not only come to the Berkshires but now to the mill itself. I have all the technical help nearby I could ever need or even get in a large metropolitan area. I work with industrial equipment and processes (blow-molders, polyurethane spray foam, resins, silicones, airless paint spray, robotics, computers, multi-media, etc.) I am very close to more cultural stimulation than I ever was able to access easily when I lived in Washington, D.C. (Everything is easy to get to, much is free, and without crowds.) Best of all, I am just up the road from one of the most visible contemporary art museum projects in recent years, with the Guggenheim Museum as one of its participants. If I had ten million dollars in the bank I don't think I could live, as an artist, in a better spot on the globe. If I am making your mouth water, I do it on purpose.

HINT: It is important to point out that the accumulation of space, in my case a lot of space, is not directly linked to how good my art is. On the other hand, with this kind of space, I can organize my studio to better carry out various processes, store my works, and carry out my own large-scale experiments without needing the permission of the art world gurus.

WHAT SPACE DO YOU NEED?

What are an artist's normal needs? Let's take a painter, for example, and for purposes of this example, let us assume he/she is not doing a Cornell type of work (although Joseph Cornell's studio was fascinating and far more extensive than his small works would at first indicate). Our painter will need space to work on one or two paintings at a time, and larger space if the paintings are over ten feet. Combined with space for paints and

viewing area, this area is already quite large. Then there is need for table space to do drawings or small works on paper, as well as for storage of new paper, storage of old drawings, storage of small and large paintings in such a way that paintings can come out and be looked at as needed. Also needed is clean space to frame, assemble stretchers and stretch canvas, or to put protective plastic over the finished paintings. Space for storing the wood for stretchers and frames, and possibly a woodshop area, space for additional supplies, an office/computer area, sink, bathroom, wall to photograph against, and if the artist is into making other types of art, such as printmaking, then space for that is needed as well. For mixed-media artists and sculptors, the need for space is multiplied. (Sculptures needing interior installations do not sell nor store as easily as sculptures that can go outdoors; all sculptures are harder to store than flat canvases.) The idea that I am trying to convey is that all this activity is not going to be professionally carried out in a spare bedroom.

It is also a mindset. You go to your studio, which is very serious and which is obviously set up for the making of great art. You know you are not working in an environment like that of every art hobbyist in the country. This fact alone defines who you are, what you want, and how serious you are. As I will repeat throughout this book, there are many exceptions; but to me, the studio is also your work of art. It reflects your explorations, your dreams, your struggles and your diversions.

A note for curators: I've always wanted to exhibit the studio - intact - because a work of art out of the studio is isolated; the entire environment with the major artworks in dialog with the models, sketches, experiments, tools, raw materials and mementos collected by the artist can collectively be a more meaningful 'work.' One day I hope someone will do a museum show replicating several artists' studios.

Finally, there is a realization that this great studio space is needed in order to develop great art - not only to do work now, but to do work for a long period of time. This means working for the rest of this year, next year, for five years, for ten years, forever. To pay for this space - if you are not famous - will entail time and money away from your art. Are there systems and strategies to make this happen in a beneficial way without necessitating your becoming one of the few chosen artists receiving stardom?

THE GLOBAL VIEW

After World War II, Europe was the place where artists could go, be inspired by centuries of art, and live and work cheaply. Americans tourists soon became the arrogant symbols of power. As defeated countries rebuilt their economies, products and materials were cheap by American standards. During this process, where American productivity dominated each industry, American art also dominated the international art market.

Today, the economics have changed. Although there are still plenty of places where cheap labor can be found, most are rather remote and changing rapidly. The biggest splash of cold water is the realization that America is no longer the dominating leader in the world; in fact, we are sometimes given the third-world nation treatment we used to give others. Go to Asia and Europe, and you will find few bargains. Even in Southeast Asia, where labor and processes are cheap, finding large studio space is not easy.

Today, the richest vein for artists to mine is in our own backyards. America has abandoned buildings all over the country, trash containers full of discarded materials from industries, space to allow for big experimental projects, and it is still the largest art market in the world. If we are living the consumers' disposable lifestyle for the most part, artists as scavengers can take advantage of this and be more productive than their counterparts in other

nations. Imagine working in the tiny spaces of Japan, or selling to collectors who have closet-sized homes. There is still an active Japanese art scene, with corporate lobbies fulfilling an exhibition demand, but the scene there is very tight by American standards. Real estate in Europe is also high-priced. True, the successful do well, as the elite foreign artists sell here also, but the developing artists struggle more with the raw necessities of making art than their American counterparts.

All in all, artists living in the United States can count their blessings and take advantage of many opportunities available. While support from grants and sales has eroded significantly in the last two decades, when it comes to the practical needs of making art - space and materials - artists can easily find treasure.

WHERE TO SETTLE?

You can't imagine David Smith's Bolton Landing farm full of steel and stainless steel sculptures being produced in a SoHo loft studio. You wouldn't expect Andy Warhol's commercially inspired and produced work to have originated in a rural studio barn. Ed Kienholz's tableau sculptures seem logically to have their origins in the consumer flea markets of Southern California. The surrounding environs as well as the studio structure itself can have tremendous impact on the creative output.

Proximity to other cultural stimuli and technical processes will affect the creative production as well. If you had millions of dollars, it would be possible to assemble the best elements to give positive support to your work. If you needed land but wanted to be near New York's art culture, this would be possible with adequate funds. But reality being what it is, with physical and monetary limitations, artists usually need to choose and therefore to forgo some elements that they would normally want to include. However, before artists lock into their studio environments, consideration first has to be given to needs

45

of space, materials, income sources, cultural stimulation or connections, and family concerns as well as alternative strategies and choices.

In basic terms, the closer you are to the art commerce, the more expensive the real estate will generally be, and therefore the smaller the space one is able to afford. There are ways, however, to get much larger spaces than would at first appear, as well as a greater possibility of getting superb space not too far away from the 'action.' Additionally, the closer an artist is to a major educational and commercial business market, the more resources might be directly available. However, with the telephone, fax, computer, Internet, Federal Express and United Parcel Service or other delivery companies, and wider distribution of industrial services and manufacturers, the ability to be in one particular space matters less.

Once settled, artists will find it difficult to pack up and move. Studios involving thousands of square feet of storage, equipment, and new projects just do not move about without great disruption to the creative process. So the first decision probably will center on in which part of the country (or world) to settle and its proximity to various types of resources.

AVAILABLE LOFT SPACE

Each city and region in the United States has affordable spaces. Even with limited financial resources, the possibilities can be endless. In Washington, D.C., where there are few industrial buildings, artists traditionally had second- and third-floor walk-up studios in row houses, above small commercial stores. The long, narrow space influenced the art being made. In New York, SoHo's industrial lofts inspired a different kind of 'large' art, with similar enclaves in other major cities. Southern California has newer buildings of more than one story, and the South has a mixture. In Houston, which doesn't have

the zoning laws found everywhere else, artists are in all kinds of spaces, from group industrial buildings to residential properties. New England has vacant mills, although few are broken into small spaces at economical rents. Urban areas invite group loft buildings; rural areas encourage conversion of barns and garages and open-air use.

The concept of a 'loft' space is that it be a shell, with minimum interior partitions. Artists need only the basic necessities - a sink, toilet, heat, light (hopefully some natural light, but certainly not the valued 'north light,' and daylight is not an absolute necessity for today's contemporary processes), electricity, and otherwise raw space. The bigger and cheaper the better. Loft space as just described, obviously, can get very fancy, depending on the desires of the artist or, in other cases, non-artists who like this kind of space aesthetic for living. The influx of 'yuppies' to former art enclaves has generally resulted in the artists having to move out.

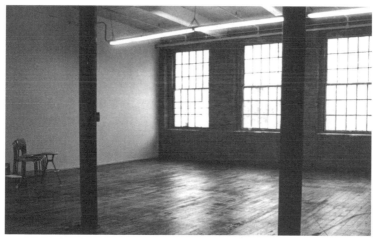

Ample open space at an affordable price is every artist's necessity to carry out work. Photo by Caroline Bonnivier.

Artists seek low-rent and not-in-demand areas. It once was easy to be in SoHo; today you couldn't afford a closet there. Artists often pioneer areas, and by making

them arty, soon appreciate the values of the area only to be later driven out by higher rents. Certainly they are the lambs; the wolves recognize what is going on from the beginning and get a piece of the action. Real-estate investment may not be for everyone, but to me it is the same as learning to stretch canvas or making a sculpture armature. When considering the long term, which idealistically means the ability to continue to do creative work, _early_ ownership has a lot to offer over constant rent payments and rent increases.

Artists are like vultures. We take what others don't want, because it is therefore affordable. Look in your area at what is not doing well; as will be described elsewhere in this book, when companies close down or move up, they often discard materials and equipment and buildings. A vacant building is an eyesore to anyone; it may be a gold mine to you. Vacant buildings are also bargains compared to new construction.

To build a loft space, which is defined in construction as having windows, minimum interior partitions and the basic necessities as just described, the cost for new construction starts around $60 per square foot for a reasonable size, and would be more per square foot for small buildings. A smallish 1,000-square-foot studio would cost at least $60,000 (and $90,000 would be more likely) plus land. A more workable studio having 5,000 square foot at the $60 per square foot rate would cost at least $300,000 plus land, and 10,000 square feet would top $600,000. To make it livable with a kitchen and full bath, add another $30,000 or more. Compare this with existing buildings and you will quickly realize that existing buildings are more affordable.

Artists often take over a large building as a group. Usually a building is discovered by one artist, but within a short time others move in. Some have developed more formally, like the Brickbottom in Brookline, outside of Boston, and some downtown buildings in San Francisco, Oakland, Los Angeles, Houston, and Washington are also

hosts to a concentration of artists. The problem with some of these artist-dominated buildings is that even though they seem attractive, you still end up with only about one to two thousand square feet at a reasonable rent - but certainly not cheap. My advice is to think at least ten times that scale, and if you do, then these shared or jointly developed buildings don't work - *unless you get to the building first and set up the deal.*

Some cities have even adopted loft laws, allowing artists to live legally in industrially zoned buildings. I've found that many towns have antiquated zoning laws still on the books which permit living in industrial buildings; they were in place a century ago to allow a watchman or proprietor to live on premises, and probably were last used decades ago.

Even if zoning laws do not favor economic studio/loft space, it is often because no one has 'enlightened' the bureaucrats about artists' needs. Artists can organize and change the laws to their benefit, or simply apply for a zoning variance.

Then there are places where no one cares what you do. Don Judd had airport hangars in rural Texas as well as a SoHo loft. Peter Voulkos had two large buildings in Oakland and was a landlord for lots of artists in that community. David Smith had a farm in Bolton Landing in upstate New York for his many steel sculptures. Anselm Keifer had more than 5,000 square feet in Germany and was once looking for 80,000 square feet in the United States. It can vary, but serious artists need space.

Even choosing where to locate is important. Most people live in places where they attain a job, go to school, have a family, grow up, or have a good connection. Few say where they would like to live. Unless, of course, they want recognition; artists go where the action is. If you want to become a great actor, you go to New York or to Hollywood. You can have a fine and satisfying career in

hundreds of smaller communities, but the major roles, big money and important productions will not happen, most likely, unless you live in one of those two places. The art world is similar, if you want recognition. But unlike performers who need an audience, you can, of course, create art anyplace. 'Anyplace' just may not be where you can achieve recognition easily. Once you have achieved recognition, you can also live anyplace without it negatively affecting your career.

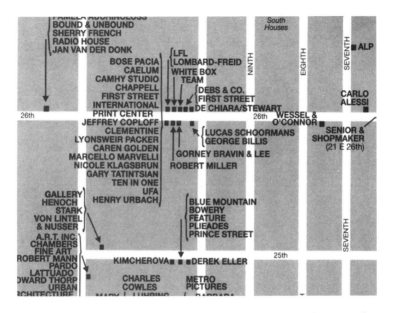

Just some of the commercial art galleries concentrated in the Chelsea area of New York City. Detail of Map: Gallery Guide/ Art Now, Inc.

Today's most common message is: *Either be in New York, at least close enough to be accessible, or lose out on most of the action.* There will be mention of this later, but for quite a while there has been talk that New York is becoming less and less the main market, because other markets are growing. It's nice to think this, but the truth is, as you are reading this, New York will remain - *for the existing gallery system* - the major market in our professional lifetime. What may happen years from now is

too far in the future to help us now. That is not to say that other kinds of venues don't exist outside New York; but you won't find the Pace, Castelli, Paula Cooper, O. K. Harris and Mary Boone galleries leaving New York and moving to another city anytime soon. *This is a realistic fact, not a recommendation. I believe in alternatives.*

By the very nature of cities, artists tend to settle where there is an active art scene - near other artists, galleries, collectors, museums, and jobs. Many artists settle in the secondary markets, where there is still a lot of action and where success there might propel them into the New York, i.e., the international market. Possibilities include Chicago and Los Angeles; followed by San Francisco, Houston, Dallas, Washington, Miami; followed by Philadelphia, Boston, and scores of other cities. Many artists make the case that you can more easily make a name in a smaller market, and then be brought to New York with proper introductions. It depends on whether there are some up-and-coming savvy regional curators who are tuned in to the New York scene and who will opt to recognize and promote you. Even in smaller markets, the competition can be fierce.

It's a sad state of affairs when you can't even become the leading name in a smaller community, because smaller communities have different standards. They may recognize a good regional artist, who will have no interest to the international art world, and ignore the beginnings of a raw but better talent. Local curators should (but seldom do) try to recognize the local talent who are ripe for national attention and then go to New York to promote them. Theoretically, what helps local artists will help the city or region from where that artist comes. Unfortunately, too many curators try to bring in 'big talent' instead.

Because of this, the action will not come to an isolated studio-barn on an Iowa farm; you have to make the trip and make your presence known in whatever place you want to attach to. This may seem logical, but you would be surprised how many artists live in the boondocks

and expect to be discovered. Even in a major city like Washington, I knew artists who would have had national reputations if they had not stayed there. I had invitations to move to and show in New York during the 60s, which was the beginning of some real excitement, but stayed idealistic and remained in Washington. There is no question that, while I did the work I wanted to do for the most part, showing in a Washington gallery instead of a New York gallery, which would automatically get national coverage, resulted in a dramatically reduced commercial success. It should be mentioned, however, that at that time, my work consisted of large painting constructions, which could just as easily have been realized in a large (then economical) SoHo loft.

I also mention the so-called 'mistake' of not moving when I got invitations from the likes of Henry Geldzahler (he coined the word 'Pop' as in 'Pop Art'), just as I will mention how I mistakenly didn't follow up on an offer to show at the most prestigious New York gallery of them all back in 1970 - because I want you to realize that, if I mention alternative strategies, I have faced the magnetic pull and attraction of New York success and fame, and I know how difficult it is to balance between seeking recognition and doing what it takes to produce the art.

Diane Brown, who for many years had the Diane Brown Gallery in New York City, used to lament that in order to give an artist a proper studio visit, even if the studio was located in close-by Brooklyn, for example, she would have to leave the gallery, get a taxi which – door to door - might take 45 minutes to get there in traffic, spend up to a couple of hours if she was really looking at the work and learning where the artist was coming from, as well as giving the artist a fair chance (imagine how you would feel if she was visiting your studio and she came and left after only a few minutes), and then get back to the gallery. By the time she was back at work, she'd spent/wasted half her day. Studio visits, therefore, had to be selective. With dozens of artists each week appealing to

her to visit, you can see the difficulties and why gallery owners are hesitant to look at work or make studio visits. Besides, they have plenty of other work to do; they need to get more paying clients for the art they are already showing, in order to pay their bills.

And that is what happens when you live a short drive away from the galleries. Imagine the difficulties if you live a few hours away. Slides do not suffice. I knew many artists who used to load up a truck with paintings, drive to New York, and either invite the dealer inside the truck, or spread the work out on the sidewalk, or pull a few paintings from the truck and take them inside the gallery, or even set up a five-hour mini-show in a hotel room and invite the one or two dealers who had indicated an inclination to come, after proper introductions and connections were made in advance. After expending energy and money doing this kind of thing, your idealistic feelings about creating great art begin to evaporate. *They just never mentioned in art school that you would have to go 'hawk' your goods like a vacuum cleaner salesperson.*

These comments add up to a powerful rationale for moving to New York City. However, the New York of two decades ago is not the New York of today. The commerce is not the same, the accessibility is not the same, the cluster of artists is not the same, the affordability is not the same, the competition is not the same, the quality of life is not the same, and the likely return of investment is not the same. Although I made a mistake, there is little doubt that in my early days, the reasons for moving to New York were overwhelming. To have stayed in Washington was, in a commercial sense and in hindsight, a major career mistake. Today, the opposite might be true.

NOT IN NEW YORK

Having outlined reasons to be in New York, I must now tell you that there are other kinds of locations in which to be. If your primary goal is to make great art,

there are other important considerations that enter the equation. If one chooses to support the process of making the art rather than the process of what happens to the art once it is made, many more artists would be taking a cold, hard look at whether living in New York is advantageous. No matter where an artist locates, however, it is essential that there exists some degree of art commerce. To live far removed from this activity may do more harm than just the obvious financial considerations. Non-tangential considerations of stimulation and artistic opportunities must remain high on the list. On the other hand, without the physical art-making plant, the artist can't even get off the ground.

In order of priority, most important to consider is the ability to get ample studio space. Next is to have materials, be able to use processes, and deal with the necessities of living (for yourself and for your family). The third main ingredient is to have proper discourse and contact with other artists, dealers, curators, and scholars.

New York does not make this easy, especially now. In the 60s you would end up in a SoHo loft; now you are commuting from a dangerous section of Brooklyn or across the river in New Jersey. Even if you land right smack in the middle of SoHo, just the competition from multitudes of artists limits your access. Try even to talk with a museum director in New York and you will see how difficult it is to feel involved. If you go down the list of needs and examine each material you will use and find out how much it will cost and how you will get it physically into your studio; if you examine processes that have to be done, such as framing, printing, cutting, metal finishing, equipment repairing, etc., and again find out who can do these things and how much notice they need and how much it will cost; and if you then examine how much you will need for your living expenses and how safe and convenient your living area will be, considering your children and their schools, the doctor, hospital, recreational activities, and so forth, and don't forget

working and commuting - then New York or the New York area may not be the most conducive place to be or worth what you get in return. Let me tell you about vastly different alternatives.

FORGOTTEN SPACE

In Washington, D.C., I had what many considered - the dream studio. My previous studio was equally great - 6,000 square feet of ground-floor space in an apartment building on Connecticut Avenue, across from the Washington Hilton Hotel, just blocks away from the main galleries and eateries, to give you an idea of location. I paid only $150 per month including utilities, which in reality cost the owners at least the rent I paid. The space once was occupied by a restaurant, had had a fire, and when I first saw it, it was being used just for junk storage. Since it was not being constructively used, one of the owners agreed to allow me to fix it up and use it for a studio. The rent generally paid his expenses, I got rid of a potential firetrap (there was paper trash accumulating) and we did a large Rudd painting trade as a bonus or additional rent. I had to put in quite a lot of sweat (and needed surgery after lifting bag after bag of concrete to fill in long trenches where pipes were uncovered) but I had about eight glorious years with that studio, which was a five-minute walk from our townhouse. Because my kids were young, I could enjoy a full day at the studio, be home for the family, and walk back to the studio for some additional evening work. All good things - especially rentals - come to an end.

I found that studio because I studied what was available. Also, in Washington, there were fewer artists looking for large spaces than there would have been in New York. All regions have special types of real estate. Washington is not an industrial city, and so it had limited large spaces. In those days, with lots of big apartment buildings in Washington, many had enormous basements

with portions not really used. Many basements had windows and easy access for deliveries. I found lots of other possibilities then. Eventually, these buildings started being converted to condominiums, and every square inch of space, including basements, became valuable. That was when I had to move.

In the late 70s, during an economic recession, there was a window of opportunity in that the few industrial buildings that did exist in Washington had little value for the larger companies wanting to relocate to new, one-story buildings in the suburbs. At the same time, the existing industrial buildings were impractical for small companies, especially if they needed repair. There was also less speculation in real estate, and some properties stood empty. If you took a chance on dealing with lots of space, there were some real buys.

BEGINNING OF THE BIG TIME

Admittedly in a not-too-good neighborhood, but still only ten minutes from my townhouse and even less to the downtown galleries and museums, I purchased a 34,000- square-foot building in 1978 (it had been vacant for eight years) for only $66,000 - and it came with 90% owner financing. This amount was not even a lot in those days. Down the street from the building were small, renovated row houses selling for more - not that I would have purchased a home in this neighborhood.

Anyway, I purchased the building (I borrowed the remaining 10% I needed) in February, moved in all my art and equipment via a trash truck run by a neighborhood hauler, turned on the heat and found out when the tank ran dry after a few days and I had spent a few hundred dollars on oil - that I needed to share the expenses. With a small bank loan, I first divided up the basement floor into six smallish studios and rented them out. I then kept going and divided the rest of the building into large lofts. This was the first time that anyone had done this in

Washington, largely because there were few industrial buildings there (or so it seemed) and because there were few artists in Washington ambitious enough to want large space.

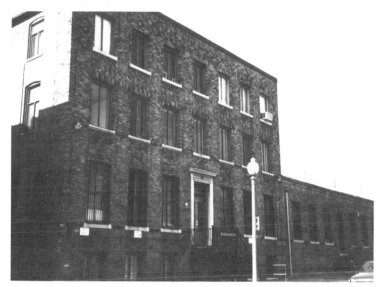

The 34,000 square-foot Washington D.C. warehouse converted into 25 artists studios. Studios range from 300 to 5,000 square feet.

I spent considerable time trying to explain to ('educate') bankers why artists would want to rent studio space. I was less than successful, but on the basis of renting space in the building for the minimum reasonable use (storage), they gave me enough of a loan to do most of the partitioning and improvements.

Eventually I was able to do the entire building. I rented out studios, some about 1,500 square feet in size, to various artists, and I talked my dealer into opening up a SoHo-type secondary gallery space to store artworks and to use as a private space for special clients to view the art. (She used it too much as a gallery, and the additional labor eventually became a drain, but what a wonderful run she had, complete with memorable openings!) I kept about 14,000 square feet in total for my own space. I had a full

three-bay garage, a first-floor studio of over 6,500 square feet with a loading dock, and a second- floor studio with another 4,500 square feet.

I learned that even large space is more usable if it can be divided up for various operations. A big shoebox space encourages a lot of mess, but shelving, storage areas, and 'dust' versus 'no-dust' areas all help the production of art. By the time everything was said and done, and by serving as developer, general contractor, superintendent, painter, janitor, etc., I had my entire studio free of charge. During some years, I even made a few dollars in addition, but 'free' meant that all utilities and debt service were paid. In fact, by refinancing (which was a shame, but I had to keep on making my art) I was able to manage many years of work and at the same time help support my family. Had I not had a family to worry about, I could have lived in this space and minimized my living costs greatly.

The first floor was used to create, set up and store large-scale works. The second floor contained the office area, smaller storage rooms, a kitchen, a bathroom and a gathering/conference area. With leftover large shelving units (which came with the building) used as partitions, I had separate studio areas for woodworking, drawing, framing, model making and additional storage.

Unfortunately, a decade later, even this studio filled up to the point where I could barely do additional work. I was not prepared to throw away half of my life's work to free up more space. It was a dilemma. I thought about expanding the studio and living there as well to save expenses, even though the neighborhood was not desirable for children. Thus began the process of searcing for other options.

A TIME TO MOVE ON

By the late 1980s, the other great factor was that Washington was no longer a meaningful place to be as an

artist. During the 1960s, with the recognition of the Washington Color School, and with the establishment of the National Endowment for the Arts, the Hirshhorn Museum and the National Collection of Fine Arts (now the Smithsonian American Art Museum), with important galleries (my first dealer was the nationally known Jefferson Place Gallery that had shown or was showing Ken Noland, Gene Davis, Sam Gilliam, and others), with the Washington Gallery of Modern Art and the alternative Washington Project for the Arts (WPA) and many other galleries exhibiting - Washington was a busy and good place to be.

In two decades, Washington had grown from a sleepy southern town to a culturally rich, international hub. I remember going to memorable after-opening parties with some of the biggest names in the business attending. Henry Geldzahler was interested in my work; I twice met and talked at long length with Barnett Newman (this is something that one doesn't forget when you think about his place in American art); I got to know most of the color school artists; I knew most of the players making the new museums happen and met most of the national artists who had their retrospectives in the museums (people like de Kooning, Rauschenberg, and Warhol came down); in short, for a 'kid' making art, I really got a whiff of the action.

Important New York art people were constantly coming down to do business. Others moved to Washington to take active roles with agencies and museums. But when the economy took its toll on the art world nationally, and politics, as always, but then seemingly more than ever, dominated the scene, Washington lost its attraction. A photo with Kissinger (or the current favorite) on the wall of a Georgetown townhouse was always a better status symbol than a de Kooning painting on the wall. I liked California and thought Los Angeles would be a lot more receptive to my type of work. But in order to have there what I had in Washington, including ample studio space as well as being in an adequate neighborhood for my family, I

needed several millions of dollars. As you might guess, some options were totally out of the question.

THE START OF A DREAM

What you are about to read may seem as if I just fell into it. It may seem like a one-in-a-million chance, but I've since discovered how available these opportunities are. Also, remember, I always had goals for more space. In fact, I posted these goals up on my studio wall to keep reminding me that eventually I wanted to have my own space where everything, from creating to showing to storage, could be under my control. (I can't tell you how many grueling hours I've wasted moving sculptures from one temporary storage space to another.) Ten years later I had accomplished everything I dreamed of and more.

I took an active role in exploring and finding alternative space options. At first we looked in the country outside of Washington for a small farm. I envisioned a complex of simple barn buildings or 'pre-built' buildings to use as my base and thus drastically decrease our presence in the city. Nevertheless, this seemed more like a luxury expansion of our city life than a real change. Whenever my wife, Barbara, and I would spot a vacant building during our travels, whether it was in this country or in Europe, we would always wonder whether it would be dirt cheap (as in Greece) and whether we would like to be there each summer. In the back of my mind I had the idea of finding, as a way to get out of the problem of running out of space in my Washington studio, a summer studio property that would be cheap and where I could carry out some large, complex and absolutely wild art projects that I somehow couldn't seem to make happen in my existing studio or in traditional exhibition galleries and museums. It certainly made our travels more interesting as we investigated various leads.

As you may guess, my motivation as to having space and resources to carry out my projects, without

regard to commercial and intellectual connections, was idealistic - I was prepared to drop out but carry on like never before.

One day, I saw a classified ad in the Wall Street Journal (HINT: Read the WSJ's and all other classifieds) advertising a mill of 180,000 square feet for about $175,000 in a small town somewhere in eastern Pennsylvania. First of all, you need to comprehend a space of 180,000 square feet. A room 100 feet by 100 feet is only 10,000 square feet. A room almost twice the length - 180 feet by 100 feet - is 18,000 square feet. That is almost the square footage of a football field. My Washington building was almost twice this size (my studio at 14,000 square feet was slightly less). Now we are talking about nine to ten football fields.

I didn't have that kind of money, although one can get creative in thinking about selling the house and combining living and working somehow. (HINT: Buy real estate as early as you can, even a cheap house. As you pay off the mortgage, you gain equity to help you in later years.) I also had ideas resulting from what I had accomplished in my Washington building by renting out half of the space in order for the other half to be free for my use. And I had this romantic image of a beautiful mill set upon a hill or in a pasture with trees and streams all around. I needed to see it.

One weekend we drove to inspect this mill. Rather than the beautiful image I had in my mind, we found it in a gully, dark, rundown and looking more like a prison. Most mills are built in industrial settings, or industrial settings develop around a mill, and they are not so pretty. It's one thing to have an industrial building in a city, and another thing to have the same setting out in the country.

A close-up inspection also brought out a lot of headaches. Just dealing with the roof could have bankrupted us. Large spaces requiring new roofs, heating systems, modern electrical and plumbing service, and other expensive maintenance can be out of reach for

anyone except a company large enough to use it and successful enough to be making the revenues to handle the utilities and upkeep. Most of these mills used to have several hundred people working in them. To convert them for use for a dozen people or so has to be done carefully.

Nevertheless, we soon got used to looking at space of this scale. After all, if I could deal with 34,000 square feet (and in fact I had looked at buildings in Washington far larger), 180,000 square feet was only six times the size. Having learned the lesson of heating space, I at first assumed that any property we would consider would be for summer use, except possibly for a small section heated year-round. In any case, large buildings with central heating systems are not workable. If you can't shut down the water and heat to most of the complex during the winter, it is not affordable.

(I appreciated utility costs when an old-timer described to me the operation of a large mill. This particular company would turn off the heat for the weekend. Early each Monday morning during the winter, plumbers would arrive and repair broken pipes. If there was less than $6,000 in repairs, the company would be ahead of the game.)

The mill I inspected was located in a charming Pennsylvania town called Jim Thorpe, less than two hours from New York City. Suddenly the long-term future seemed interesting - with a summer studio that could also be used on long weekends and eventually be a base studio/residence when our kids were grown and we could be away from Washington more often. This would also locate us a reasonable distance from New York, which was becoming more attractive since I had tired of the stagnation in Washington's art community. (I tried to be active in getting some major projects off the ground, such as a big loft/alternative space project and an Institute for Contemporary Art, but the political and artistic conservatism of Washington proved too much.)

A SIDE STORY -
THERE ONCE WAS A STRUGGLING TOWN OR TWO

There were once two towns in Pennsylvania across a river from each other - Mauch Chunk and East Mauch Chunk. The towns had their ups and downs, but for many years during the 1950s the towns remained in a deep recession. As it had in many towns in the region, the textile industry in these two towns had gone south, leaving the people without work. The businessmen and civic leaders of these two towns were looking for ways to stimulate their economy.

The famous Native American athlete, Jim Thorpe, had died after much drinking and several wives, the last of whom had a couple of young children. He was from Oklahoma, and its state legislature decided to pass a bill to build a memorial and to bury him on a Native American reservation that was his childhood home. Unrelated to anything in the bill, which was attached to other legislative items, was a large political scandal of some sort; the bottom line was that all the legislation, including the bill to build a memorial and to bring Jim Thorpe's body back to a final resting place, failed to pass. Mrs. Thorpe got stuck with his body and had no meaningful place to bury him.

One day she was in a hotel room in Philadelphia and heard on television about the plight of these two towns. She contacted her attorney, who contacted the leaders of the two towns and made the following proposal: If the two towns would merge and change their names to Jim Thorpe, she would allow them to bury her husband there. There were also vague promises about a cancer hospital and a football hall of fame.

The towns had a big vote, and sure enough, voted in favor of her proposal. The towns merged, changed their names to Jim Thorpe, buried the body under a modest memorial - and nothing else ever developed. Fast-forward about thirty years. The towns were still depressed. Jim Thorpe's children, now grown, wanted to bury him in a

reservation burial ground. This, according to Native American beliefs, was the only way he could get lasting peace. Half the town's residents believed that the body should go since it hadn't brought in any business, and the other half believed a deal was a deal and the body should stay. There is a Mauch Chunk National Bank and there is a Jim Thorpe National Bank.

The point of this story is the importance of understanding towns. Sometimes they have needs that you, or a small group which you could easily form, could propose to fulfill. Keep this in mind when I tell you about MASS MoCA.

MORE ABOUT INDUSTRIAL MILLS

Although we did not like the first mill we looked at, we ventured more and more into that region and discovered other possibilities. For example, in the next town over, we found a 30,000-square-foot mill building clean enough to eat off its floors (with everything in working order) for less than $50,000 (we were informed that a $30,000 offer would be accepted). You have to realize that although this town too, was depressed, even the small houses down the street were worth $30,000. *No one had any real value for a white elephant, nor did anyone have the aesthetic and artistic background to think living 'loft style' was attractive.*

This and other buildings we inspected were getting more affordable, but now we were getting fussier. For example, this building almost mirrored my Washington building - right in the middle of the industrial 'village' with just a little concrete yard. But if we were considering a part-time or future full-time move to a rural area, we really wanted something with a more country feel to it - at least, with some land. Our investigations provided many an interesting weekend as we came close to a few properties, but nothing was really available on our terms.

ONCE UPON A TIME - A TRUE FAIRY TALE

One year, I got myself invited to GE Plastics to make blow-molded Lexan sculptures. (See Corporations are your Friends.) GE Plastics' R&D Center was located in a place I had never heard of, Pittsfield, Massachusetts, in the Berkshires, which I had heard of, but at the time could not have located on a map. During my second residency working there, I had time to kill after some equipment breakdowns had caused delays. I took a little drive around the region and picked up a free weekly newspaper in which an article described a mill that seemed close to being torn down because no one had a use for it. I drove over to the mill, walked through an empty window and looked around the 80,000-square-foot shell. Although in poor shape with no working systems, the structure looked raw but solid and clean enough for basic studio space. Having just exhausted a series of proposals to get developers to convert a large loft complex with other industrial spaces behind my Washington studio building (they couldn't get the owner to sell despite giving him a 100% profit - is he sorry now), I was well acquainted with the economics of loft development. When I returned to Washington, I decided to write a letter to the mill's owners, telling them how it could be used for artists' studios and how, with federal and state funding, it could be brought to life again.

HINT: Get good at typing; using a computer, it doesn't take more than ten minutes to get a letter typed, printed and in the mail. Written contact with manufacturers, curators and other people you meet could be the most important way to conduct business and the surest way to grow.

It was almost a fun letter; I really didn't think anything would come of it. But I did not understand the workings of small towns. The letter made headlines - "DC Developer Interested in Adams Mill!" shouted the local

newspapers, and telephone inquiries from the local press began coming. The area was in a depression, and any interest from an outsider generated attention. I was in a bit over my head, since I was just an individual artist. What I didn't know was that the owners didn't want any interest in this particular mill. They wanted to be able to say that, since no one was interested, they should be allowed to tear down the historic mill and get the land ready for an industrial park. So the owners (a volunteer civic organization) called me and said that if I were really interested in a mill, they had another mill in much better shape in North Adams, five miles to the north. I had barely paid attention to the brief mention in an art magazine, but North Adams was also the blue-collar former mill town where a museum complex called "MASS MoCA" was proposed.

The next month, on a cold December day in 1988, Barbara and I made the seven-hour drive up to the Berkshires to look at the mill. Again, I was not sure what to expect (a beautiful mill set upon a hill?) but all I can say is, despite the poor shape the mill seemed to be in on the surface, the minute I walked in I knew where my studio would be, where our loft space would be, and where we would sleep. (It would be a year and a half of negotiations and then renovating before I would actually sleep and work there.)

Over 45 large dumpster loads of debris needed to be hauled out of the building, but beneath the trash was a renovated mill with new and – importantly - separate heating systems covering 80% of the total mill, a new roof over 95% of the building, new electrical and emergency systems, handicapped-accessible bathrooms, and a few tenants who would more than carry the building for the first few years. The total interior space contained 130,000 square feet. We are talking football fields! The mill sat on over 27 acres of land and, miraculously, because most mills and large old buildings are located in unattractive areas of industrial 'yuck,' this mill backed up to a state

park and had a river running around the front and side. It was the best of two worlds - large industrial space on beautiful country land.

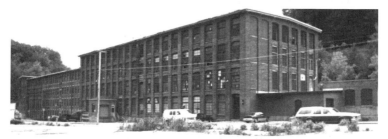

The 130,000 square-foot Beaver Mill in North Adams, Massachusetts; the Massachusetts Museum of Contemporary Art (MASS MoCA) is nearby. The mill houses fifteen large art studios, the galleries and studio residency areas of the Contemporary Artists Center, and the author's studio, loft and Dark Ride Project.

The owners, members of a non-profit civic organization which had been struggling to maintain the mill with a few tenants, never really expected to be able to sell it, but they were anxious for someone to take the burden off their hands. After all, they were volunteering their time and it was not working out. Being a landlord and developing space takes a lot of attention and a full-time, hands-on person. Furthermore, the 70% of the space not rented had broken windows and trash, piled in some areas, higher than your head. The initial asking price was less than a tiny house in Washington D.C. at the time. *Although I had no money, I offered to buy it on the spot.* Keep in mind that the building had several paying tenants (occupying only a portion of the total space) and with owner financing, I thought I could get away with very little actual cash. What they really wanted from me was manpower. It took one and one half years to negotiate. During that time they wanted, I guess, to know that I was serious, that I would try to continue some sort of economic development, i.e., try to rent out or use the additional vacant space. Which of course I would! The mill had some problems; a clear title could not be transferred to me for a long time, and so along the way I started to lower my price.

When a lease with an opton to purchase was finally settled upon, the price had been lowered, *but I had to take some risks.*

Although this all started with looking for a space for summer use to carry out large, ambitious and somewhat wild art projects that my main studio just could not accommodate, my plans soon changed. Why? Because I analyzed my present environment and could predict where I would be ten years in the future. It looked comfortable, but as an artist I needed to know that I was not compromising my art for convenience. Just as in painting, I needed to take a risk, give up something that was pretty good to discover something better - something great. *People who hold dearly to what they have will not attain the greater rewards that taking risks can bring.*

With this notion and despite a declining housing market, things started to fall into place and I was able to sell our Washington townhouse to finance this dramatic move. Leasing out most of my Washington studio brought additional income for the move. The mill purchase through the form of a lease/option really worked out to be a long-term installment sale. Don't get me wrong. This was not an easy deal, nor was it easy to renovate 130,000 square feet of space. (I didn't take advantage of the owners, and they knew they would be getting a good deal out of me. In fact, there were times during the renovation, as small problems expanded into large ones, when I thought I was being taken advantage of.)

But as an artist, I could seize a special situation and make it work for both sides. It was mutually beneficial. When I say to you that something is a steal, it's because as artists we have special needs and are not as concerned with elements that are critical to normal businesses. This is our ace in the hole, and we need to use it as much as we can.

What does it mean, after filling truck after truck after truck and moving every artwork I had ever made, to have so much space at my disposal? Time will tell; I

certainly solved storage problems and I have space for new work. But time is the other needed ingredient. Not that I'm complaining.

I worked my tail off. At the same time, as Barbara and I were discussing what to do with the remaining space after I took a lot for my studio (better than 30,000 square feet initially), 8,000 square feet for our loft, and kept the rented-out portion as it was, we still had about 45,000 square feet remaining. Barbara suggested that perhaps I could establish some sort of school/art center that would stimulate me, as I had been so stimulated when I studied many years ago at an international artists' facility in Salzburg. The idea of the Contemporary Artists Center was born.

ANOTHER TOWN: THE REAL HISTORY

I didn't lock into the move and purchasing the mill without giving careful consideration to the area that I was moving to. The region turned out to be one of the best environments in the country. Whether it was luck that I happened into the area, luck that real estate was available, or simply that I had my eyes and ears open to find these opportunities and then the willingness to make them happen, it is worthy to note that there were - and are still - other opportunities around. It was not a question of finding the only gem in the country.

Here's a story about another town - my new town - and you can see that, just like Jim Thorpe, towns can have an impact - this time for the arts. Towns, like museums and art centers, have their own characteristics, and artists can easily understand these traits. By being resourceful, artists can have active roles and make a dramatic impact with large art projects.

Once upon a time, the director of the newly expanded Williams College Museum of Art in Williamstown, Massachusetts, decided he would like to have a large, raw space to do some experimental

69

exhibitions which the polished wood and carpeted floors of the new college museum couldn't accommodate. There were other prototypes he had in mind, like the Temporary Museum of Contemporary Art in Los Angeles and the complex in Schaffhausen, Switzerland. He thought, since there were several mills close by in the next town of North Adams, perhaps he could lease one floor of one of the vacant mills to use for this kind of experiment.

Sprague Electric had been a world leader in capacitors. (Capacitors are in all motors and come in all sizes; their purpose is to store electricity until the motor needs it.) Sprague had, since moving as a small company to North Adams in 1930 (into the Beaver Mill to be exact), grown to employ almost four thousand people at its peak (out of a town of fewer than 20,000 residents, including children and seniors). Sprague dominated the town and at the same time kept other companies out. But due to any or all of the following (according to whom you want to believe), foreign competition, bad management as the business was handed down to the heirs, union problems and/or just not keeping up with a faster moving world - the company started to shrink, then moved most of its operations out of the area as it was bought up by a succession of conglomerates. By the late 1970s, there was only a crumb of the former company still in North Adams.

Large mill buildings, converted from textile use for Sprague's operations, were once again vacant. There was no market whatsoever for a million square feet of antiquated mill space, especially in the high-tax, high-utility and high-labor area of rural New England. (Remember the term Taxachusetts?) Sprague had purchased the Beaver Mill, then another mill of about the same size down the road, and then a complex of 28 mill buildings on 13 acres of land, right smack in the middle of downtown. It was all completely empty. When I first saw North Adams in 1987, the town was in the same state as you might imagine small towns during the height of the Great Depression. Some civic leaders pondered what to do

with so much empty space. Everyone knew that industry on the former scale would never return. One prominent active lawyer thought that perhaps some of it could become a museum to show off what the area's industry used to be.

THE MoCA STORY

I am stripping the sequence of events to the bone, but nevertheless, here is what happened behind the scenes. When a few of the city's leading businessmen learned that the Williams College Museum of Art director wanted one floor of a single mill up the road from the larger complex, they invited him to see the huge empty site. The director said of course not, he had just a side project in mind, and undertaking to use all this space would be far too costly and too huge a project. They basically answered, "Don't say it costs too much; just tell us how much you need." Well, after an initial college 'study,' the director presented his calculations and estimated that $10 million would be needed, thinking that would be the last of it. Lo and behold, the city leaders, spearheaded by attorney John DeRosa, who happened to be close to then Governor Dukakis, came back and said they could get the state's backing. As the project took hold over the months, more detailed studies and expanded plans were completed. To make a long story shorter, the museum project ended up being a $70 million project (with over $35 million coming from the state) proposed to initially renovate half of the vacant complex, or 335,000 square feet, to become the Massachusetts Museum of Contemporary Art, the largest contemporary art museum in the world!

While Dukakis ran for the presidency, the legislature considered this project along with other statewide projects, including a huge convention center in Boston. The bill was defeated but, during the peak of the presidential campaign, supporters were able to separate the MoCA project and get the state legislature to pass it by

itself. Timing had everything to do with its success; no one wanted to go against a governor who might in a short time be President of the United States and locally, the region had leaders who kept the project together. Also, along the way, the museum director, Tom Krens, was appointed director of the Guggenheim. (Publicity from this project helped him considerably. Years earlier, he had also been astute enough to go back to a graduate program for a business degree; he realized that museum directors in today's world could not deal only with art, but needed to deal with the realities of the new economics.) MASS MoCA then became a Guggenheim project as well.

The idea was to be able to show works of art from 1960 to today, mostly consisting of the big minimalist sculptures. It was sold as an economic revitalization project that would create jobs and attract visitors to the area. By the time it passed through the state's various agencies, piles of studies and economic projections had been written.

Begun in the late 1800s, the textile mills were added, one by one, when additional space was required. When the complex was later taken over by Sprague Electric, wonderful suspended walkways were added to connect various buildings. The entire setting gives the feeling of a cross between a medieval walled city and a post-modern architectural project. Various raw materials- unpainted brick, steel beams, metal siding, large grids of glass and concrete slabs - add to the rich, textural quality. Upon walking inside, the enormity of the interior space becomes apparent. Fortunately, the architects involved with the museum transformation elected to keep these textures intact and refined, rather than covered up, the large spaces turned into galleries. In one gallery, green and pink bathroom wall paint on brick is still visible behind the sculptures.

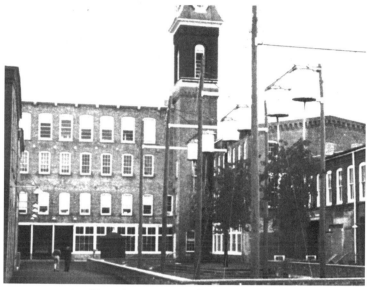

The entrance courtyard to MASS MoCA.

Museums are in some ways about real estate. A five-thousand-square-foot gallery might, for example, exhibit 40 impressionistic works or 20 contemporary paintings or only two minimal sculptures. So with 700,000 square feet of raw space, much of it not needed to be humidity controlled first-class museum space (large Serra steel sculptures cannot be stolen and are not fragile), there could be ample space to set up large-scale sculptures, which are expensive and difficult to transport and install, and leave them in place for long periods of time. Most museums can hold shows only for a couple of months. The concept for MASS MoCA was not to be a homogenized museum where there would be one or two works from any particular artist. Fifty works by one artist could be shown, and for long periods of time. The works could be gotten at reasonable prices or by gifts and long-term loans, because this place could take what other museums couldn't handle. In fact, at the core of the MoCA project was a deal made for Italian Count Giuseppe Panza

di Biumo's mostly American, minimalist collection, wherein he agreed to 'park' his collection free for a period of at least fifteen years. As different as this museum would be, it also had its traditional trappings; the artists involved were the same fifty artists that every other museum had, so it was not about discovering new talent. To offset this, Krens made hints about someday trying to introduce to the United States big international shows in the spirit of Germany's "Documenta."

The subject of 'destination museums' makes an interesting discussion. In Europe, thousands of people will travel to see "Documenta" or the "Venice Biennale." In the United States, all museums rely on local residents or tourists who are in the metropolitan center for other reasons. Few people travel more than a reasonable driving distance to see an American art museum. However, in the theme-park industry. there is a tradition for destination. People travel great distances and stay for several days to visit Disney World, for example. As will be mentioned later, combining some of the best from art museums and theme-park operations may stimulate new types of cultural attractions in the years to come.

When the new Republican governor, William Weld, came into office, he put a freeze on the Democratic Dukakis project. However, a year later, after visiting North Adams and dealing with the details, he approved of the project but wanted to put his own stamp on it and downscale it. So now MASS MoCA was on again, but at the same time, Tom Krens had run into his own difficulties in expanding the Guggenheim and just couldn't take on an additional project. Even with the governor's support, the project looked dead. I was doing whatever I could behind the scenes to help, and it was at this time that I asked then director of Houston's Menil Collection, Walter Hopps (more about him in the Gallery Scene chapter), to step in (I think the MoCA folks would have jumped to have Walter's

involvement), but he was busy and didn't want to take over the project. He did say he would help, so Walter formed the North Adams Collection, which was comprised of Robert Rauschenberg, Louise Bouregeois, Ellsworth Kelly, Agnes Martin and Richard Tuttle. It was mostly on paper, but it bought some time while the project searched for a restructuring.

Planning the new museum: (left to right) Joseph Thompson, Michael Govan, Thomas Krens. 1988. Photo: North Adams Transcript

For a long time, MoCA had been considered a Guggenheim project. Finally, when it became known on the street that the Guggenheim was out of it, others started taking a new look at it. Sam Miller from nearby Jacob's Pillow, a summer dance facility, formed a consortium of partners that included the Walker Art Center of Minneapolis, the Brooklyn Academy of Music, the Japanese American Community and Cultural Center in Los Angeles, and others. A new spin was put on the project - it would become a working complex of museums for the fine and performing arts. The players would not replicate their existing facilities but explore ways that new works, in collaboration, could be developed, rehearsed, performed, and put into other media for distribution through new technologically feasible venues (such as

digitization). In some ways, it was to have the feeling of a Hollywood studio, where the public could take tours and see the art while being made as well as when completed. Eighteen months later, the Guggenheim reappeared as a partner to replace the North Adams Collection.

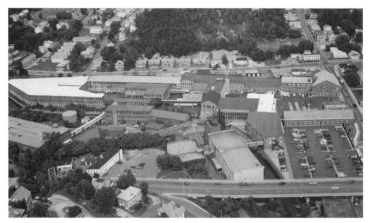

Aerial view of the Massachusetts Museum of Contemporary Art.
Photo courtesy of MASS MoCA, © N. Whitman

Finally, almost 14 years after Kren's first idea, MASS MoCA opened to the public. Phase one included renovating, out of more than 600,000 square feet, about 200,000 square feet, with 60,000 square feet dedicated to the museum portion. A state-of-the-art black box theater was added to the original plans, as well as renovation of space to rent out to commercial tenants - the rental income to make up for the absence of an operations endowment.

Although no longer claiming to be the largest contemporary art museum in the world, MoCA nevertheless has first-class museum space and enjoys a strong partnership with the Guggenheim Museum. As a 'young' museum, it enjoys the luxury of being able to offer more experimental shows that have an edge to them - including those dealing with new technology. In this regard, MASS MoCA has become more interesting than the original design indicated. That plan, while big and

impressive, was still to install the largest works, in quantities, from the same fifty big-name artists you would find in any museum. Now MoCA can be a laboratory that will better connect with artists who are working today.

Even though the town committed itself to trying to do the MASS MoCA project and received worldwide publicity, it did so purely for economic revitalization. A very grim mayor declared to the international press that he was in favor of the project but he wouldn't walk across the street to see the art inside. (This wasn't a very inspiring statement but in fairness, he was trying to sell the museum project to politicians more interested in baseball than in art.) The project had more than nine lives over the course of fourteen years, and many wanted to kill it during several periods when the project looked as though it would not survive another political chopping. Fortunately, others kept it alive and it successfully weathered the storms.

When I moved to North Adams full-time by 1990, it was as depressed as our generation will ever see a town. You would think that the main street would have been full of stores in anticipation of the project, but the town had little idea how to capitalize on the project through marketing. Then, after I established myself full-time in North Adams, the MoCA project took a turn for the worse and seemed absolutely dead because of the new governor. Nevertheless (as I participated with others in a score of committees and groups), slowly the appreciation of what art could bring to the area increased. If you ask anyone today, you will hear that art and technology make up the economic engine driving the future of the town. For the city's leaders to get to that point, a lot of patient education had to happen.

Another very fortunate thing happened about the same time the museum project was getting close to a 'done deal.' A couple of students at nearby Williams College started a web site; one student left, the other brought in their supervising professor, and the site grew. Within two or three years, it was the fifth largest web site in the world. A couple of short years later, the site was sold to Lycos for

$58 million. The two founders than spearheaded several other dot.com companies, and MASS MoCA became the natural high-tech, hip setting for their offices. Serendipitously, the principals in a Hollywood special-effects studio had moved to the Berkshires and made their base at MASS MoCA. North Adams soon became known in articles in major publications as 'Silicon Village.' It has become the perfect mix - contemporary art and cutting-edge business, fueled by a relatively youthful employee base.

ALWAYS A FEW NEGATIVE PEOPLE

I don't understand fully why some people are so hostile to art, but some are. You can experience this whenever you are involved in a public art project. I do know that most people don't understand contemporary art (I like to tell people to go see the Impressionists at the nearby Clark Art Institute - they were all contemporary artists when they were alive), and most think that artists and contemporary art curators are putting a big joke over on them. If you have little background in art to begin with, and if museums are so stuffy that you are not made to feel welcome unless you have a college degree, then you can sympathize with the residents of North Adams and similar communities.

Hint: In a small town with a strong mayor, be careful. When, in exasperation, I threatened to run for mayor but didn't (although two years later I did - see "Meaningful Projects - Political Warfare") I got plenty in retaliation. (In addition to wanting to do my share idealistically, I thought running would be a wonderful conceptual project for an artist. Can you imagine an artist, as mayor, being in charge of a project involving the Guggenheim?) Mayors can retaliate, but there were principles to live by which were more important than to buckle under threat. The mayor and I get along just fine now - and North Adams is expanding beyond any single person's control.

This is just one political role demanded of artists. Some precious time has to be spent constantly to educate, lobby, and prevent these negative waves from destroying culture. The political pressures are immense, as will be discussed later, but one way to offset this pressure is to do projects that are beyond the control of outside influences.

ARTISTS ARE SLOW THROUGH THE DOOR

While you, the reader, might have an automatic appreciation, others need to understand what this 'crazy art stuff' is all about. Again, the ups and downs as well as the art appreciation level of a town can be important to how an individual artist is treated and to determining how many opportunities are open. Even the national or international pulse can cost you an art sale or help you make the sale. The downfall of Communism in Russia stopped the Guggenheim from building a 'gateway' museum to the East, and possibly made re-entry into the MoCA project more possible; the recession in France cost me an exhibition opportunity; assassination attempts dominate the news and affect everything from the stock market to attendance at art openings. Opportunities that come your way one day may not be there next month or even next week.

HINT: Analyze your environment, where you would like to live, how you would like to live, and how your life is now structured. Then analyze the timing.

For six years, I tried to get other artists to move here and obtain bulk space for very little money before it was too late. I generated interest, but I didn't have much success. Today, a significant number of artists are coming here and asking how they can get in on the action, only now they have missed the incredible bargains. It's still not too late to get deals, because five years from now I will say "You should have been here five years ago." Time's a-wasting.

At a panel where I was invited to participate in discussing the 'state of sculptors in the U.S.,' there were many questions from artists to panelists representing very established institutions, asking how the artists could show in their respective venues. They were knocking on the door when it really was too late. For example, after the director of Art Park gave a thorough history on the formation of that organization, I pointed out that there had been a window of opportunity when an artist could have possibly influenced who and how it would exhibit, but in each case, that window had been closed long before this symposium. Artists need to scout around for art projects in the formative stages. There may still be some room to come to North Adams, but each month the doors are closing on the most affordable and the most effective space available, as well as on new types of exhibition opportunities.

HINT: If you want to have a say on how, whom and what a museum, alternative space or other organization in the arts promote or show, you have to get in before they settle in their ways.

For six years I tried to get a few artists interested in obtaining the only other mill available between the Contemporary Artists Center and MASS MoCA. That mill, consisting of more than 110,000 square feet, could have been purchased for around $100,000 and needed about $150,000 for an adequate first-phase renovation. Divided by ten artists, that cost comes to $25,000 each, about the price of a nice car. If an artist divided his/her share with a partner, then the cost would have decreased to $12,500. A full share would have gotten, if no other development was planned, over 10,000 square feet of renovated space. Actually, I had designs to make the owners' units about 6,000 square feet, and develop the remaining space so that the building would also give income to the artist-owners.

HINT: There is power in a small group of artists.

Just think about it! My political idea was to give power to artists. In the beginning, the Guggenheim was going to establish, at 335,000 square feet, the world's largest contemporary art museum. Up the street, artists would control one mill of 130,000 square feet (the Beaver Mill with the CAC) and in another mill a group of artists could control 110,000 square feet. When the MoCA project changed because of politics into a new type of arts museum/facility with the first phase being 165,000 square feet, the balance would have tilted even more - with the artists controlling even more space than the museum. That's like giving artists a building right next door to the New York Guggenheim on Fifth Avenue and allowing them to do whatever alternative programming they desire.

For artists involved in alternative exhibition spaces, it does little good to do an innovative exhibition if no one will see it and if the art press won't write about it. To do it next door to a major museum is economically impossible in most places in the country. In North Adams it was possible. It was like two stars coming together once in a lifetime. You can guess how frustrated I was in not being able to get more artists interested. I couldn't tackle it myself; I had plenty to deal with. Now a lot of people are kicking themselves. The real frustration was that there was hardly any risk. On the downside, if MASS MoCA had not happened, artists would still have had great country/summer/weekend alternatives - or full-time studios near the Williams College Museum of Art and the Clark Art Institute, as well as the Contemporary Artists Center. Besides, if MASS MoCA didn't go ahead with what began as a $70 million project, I thought maybe a small group of artists could take over the buildings (the mill buildings were being donated by the successor to Sprague because, to them, the property was a liability) and only ask the state for a couple million dollars. I had faith in the reuse of abandoned mill space, given the strong surrounding art-based environment.

MORE ICING ON THE CAKE

Williams College, in the neighboring town five miles west of North Adams, has consistently been ranked number one or number two out of all the small liberal arts colleges in the country. It is also one of the best-endowed colleges in the country. Although it has only 2,000 students, it boasts a minority enrollment of over 25%, due to an ambitious program begun years ago. Williams has the expanded art museum now directed by Linda Shearer, who succeeded Tom Krens. (Linda came from being an associate curator at MOMA.) The museum has a rich collection ranging from early Asian and non-Western art to current art, and it holds many cutting-edge contemporary exhibitions each year. The college is also famous for its art history department. Its claim to fame has been what is referred to as the 'Williams Mafia.' Perhaps because of the quality of a few professors, especially S. Lane Faison, Jr., or just by coincidence or by connections - it's impossible to know - a group of Williams students graduating in the 60s happened to climb the art world ladder and ran or are now running several important institutions. There are Tom Krens, director of the Guggenheim; Glenn Lowry, the director, and Kirk Varnedoe, director of 20th Century Art at the Museum of Modern Art; Rusty Powell III, director of the National Gallery of Art; Robert Buck, director (retired) of the Brooklyn Museum; and David Turnick, an important collector and private dealer in New York. That's a lot of power from such a small school.

Several of those Williams alumni were supporting the MASS MoCA project, as were the college and the Clark Art Institute, also located in Williamstown. (The Clark has extensive collections in Impressionists, early American, Byzantine and other periods as well as a great research library and scholarly programs.) Most of the people mentioned visit here often, for college related or personal reasons. There are other international figures involved in, or on the board of, the MASS MoCA Foundation.

Together, they also have attracted and will attract the next generation of art leaders. For example, when Tom Krens left for the Guggenheim, he had two graduate students working under him. One, Michael Govan, went with him to New York and to my knowledge, became the youngest deputy director ever of a major museum and is now director of DIA Center for the Arts in New York. The other, Joe Thompson, stayed here to get MASS MoCA off and running - a ten-year ordeal. Now, with MASS MoCA a reality, he can finally curate and direct his own museum. Additionally, there are the people who come by invitation to the Clark, Williams College and the Contemporary Artists Center. So, if artists are active in the area, sooner or later some of these people will be dropping in.

Williams College Museum of Art and the Sterling and
Francine Clark Art Institute, Williamstown, MA

WHY HERE?

A little side discussion might be necessary about institutional developments and their effect on individual artists. Artists are usually kept out of the loop, anyway, as the art world just keeps trucking along. However, having lived in a large metropolitan center most of my life, I see a startling contrast to small-town living. This might be expected in everyday matters, but because of the events just described, you can see how this area can be an important art center, even though it is away from New York City. Over and over again, I will have to say that the artist needs to be doing good work, but if you are, there is an abundance of connections that can be made here (or in some other small but strategic place) just as well as in a big urban city.

The other thing worth mentioning is that active artists can have other input. MASS MoCA needed a lot of support to survive its many predicted deaths. Local artists have physically transformed the museum space for fundraisers and for important presentations. As an artist, I've been able to give critical support in several ways. I was able to do this just because I was willing to get involved and spend hundreds of hours of my time. But it was important. The CAC has been active in integrating art with the community and the downtown area. Various artists have given lectures, led tours, and taught. The CAC and the artists working in the mill jointly or privately have come together to host meetings, including the Artists Congress (500 artists came to North Adams, sponsored by the New England Foundation for the Arts), Volunteer Lawyers for the Arts, and various regional arts funding groups. Certainly, regional artists have been able to use the facilities of the Contemporary Artists Center to their benefit. Most of the artists I know go frequently to lectures, concerts, performances, and panel discussions sponsored by Williams College, CAC, the Clark, and Massachusetts College of Liberal Arts. Generally, the local

activity rivals that of any other active area, but the linkage to important contacts and institutions is even closer. As artists work together to form their own institutions, greater interaction will happen in the future.

STATE OF THE NATION

Through a lot of travel and research, I can report to you that all over the United States generally, and all over New England and the mid-Atlantic regions especially, there are vacant, decaying industrial buildings - yours for the asking. However, what is the point of being in a place that will not have a supportive art atmosphere, and where you may have to make an unreasonable commute to any meaningful museum or gallery? On the other hand, many communities may be close enough. Depending on circumstances, you might be able to put together a deal that a town would support, if you knew of a way to energize a depressed area. Some properties are owned by companies that would be glad to donate them to you. Be careful about accepting properties with hazardous waste problems, including asbestos, underground fuel tanks, oil spills, PCBs, and drums or spills of unknown materials - whether located in the interior or exterior of the building.

HOW TO BE A DETECTIVE

Go to different regions of the country and then different parts of a region. (Or, when you travel, always spend a little time thinking about whether you would want to live there as an artist, and investigate to see if there is a supportive environment for art making and art exhibiting.)

First feel what may be happening art-wise. Are there major museums and colleges in the area? Are there groups of artists and alternative spaces? Is there a significant affluent population (without which art simply will not thrive)? Is it urban enough to have supply stores nearby? Once you find an area you might like, sniff

around. This can be done simply by driving around and looking. Are the areas in decay, but if so, are they close to areas that seem more active? If you can't see a bright future in store for the area, forget about it and keep moving. Sometimes a lovely situation isn't so lovely if it isolates you.

While most artists need to be resourceful to keep their heads above water, for other artists the opposite is the case. There are artists all over the country who are affluent, not because of their art but because of their jobs or family wealth, who have what many people would love to have in terms of luxury residences and work areas, but so what? Will it help them promote their art or even create? Get out of your mind the idea that you someday ought have a mansion; it's not important. Take a drive up the coast from Miami Beach to Palm Beach or through Los Angeles' Bel-Air. Even with ten million dollars, you'd end up with just another house. You may never be able to compete, but you can be much more imaginative. A big warehouse has more to offer an artist than a big suburban house.

Sometimes, even if it's just an exercise, try to go after even bigger fish. For example, when the Wang Company went out of business, a $60 million three-building office complex went for $500,000 at auction. That's still a lot of money, but play the developer and get some partners. The new owners rented out part of it to Wang (doesn't make sense but that's what happened), and began life with a positive cash flow. I keep thinking, if artists controlled a complex as large as Wang or GE or Sony, what kinds of incredible things could go on. I also think an office complex, including everything from conference rooms to reception rooms to bathrooms, is an ideal environment to create and show art. In Houston, during the 80s, there was an opportunity to bottom-fish office buildings from bankrupt developers. Be imaginative and think ahead five or ten years. Talk to collectors who are also developers and business entrepreneurs - they are

the ones who help establish alternative spaces, and they are the ones who might help bankroll a new kind of studio center.

HINT: I always recommend that an artist have a three to five-year action plan. Less than three years is too short a period to do complex or significant projects, and more than five years becomes too abstract - you could be dead by then. Three to five years allows you to have a goal, a firm plan, and to mark progress as you steadily head for it. While you can think longer-term for general goals (for example, you may realize that purchasing a building will help you decades from now),it is best to work on specific projects that can be realized within a five-year period.

SO MUCH SPACE, SO LITTLE MONEY

Once you start eycballing specific properties - and you will have to investigate lots of them, sometimes with people who will think you have some money; otherwise they won't waste their time in the beginning - the next thing to learn involves the details of a particular situation. Is the owner desperate? Is a bank involved? Is the owner savvy about the use of the property? Remember, artists can find uses for properties which no one else would want. Such properties are ripe for owner financing. In fact, you can say how much you will need to put into such a poor property, and in the end (even if you never do), the owner should feel lucky that he or she isn't stuck with it any longer. Don't lie (be optimistic), but emphasize what will help you.

I was involved in the purchase of one property that had a bad roof and some bricks that were starting to pop from water freezing. I told the owner, who had naturally downplayed this during our meetings, that the building could not weather another winter and he would be faced with a major demolition expense. (This example is used not to brag, but to give you some realistic comparisons.)

That property was a unique and beautiful historic church, complete with a large sanctuary with thirty-foot ceilings and its own cupola. It belonged in a <u>Romeo and Juliet</u> performance.

The structure needed a lot, but it was still a bargain at $47,000 because it had almost 9,000 square feet of space just a few feet from Main Street and a few blocks from MASS MoCA. Remember, at loft building costs, 9,000 square feet times $60 per square foot would total $540,000 to build. Existing space is almost always a better deal. There are always modest economic uses for the short term to cover most expenses, but in the long term, with MoCA just blocks away, the potential for this property could only improve. It also came with owner financing. What a great potential studio combined with living combined with gallery it can make - and it's zoned right too. This property had been vacant for more than a decade. Obviously, I can steer you in and around the North Adams area, as well as other areas I've been to, and show you bargain properties that are good for art and also make good business sense. Plus, of course, I've outlined why I think North Adams is a prime location for a working artist. But you need to look for your own treasures.

If you spend time in any town, you will find your own possibilities. Hopefully, your target town or region will also have connections to the arts. If it does, I can guarantee you that, among the thousands of properties, there are some gold mines.

Get realistic about the fix-up, and be prepared for another career for half a year or so. But be forewarned: I have known artists who used to talk art, and after buying their first houses (already a mistake, they should have purchased gigantic industrial buildings), they sounded just like everybody else in an appreciating real-estate market - boring everyone to tears with renovation stories. *Don't let it sidetrack your career, and don't become a real-estate tycoon. Keep your focus on the reason you are getting into a large real-estate deal to begin with - to make art.*

Unitarian-Universalist Church, North Adams, Massachusetts; Built 1893

HARDHAT STUFF

This is to go through just a few areas of concern and offer some tips. Your first move, after you have located an area and found a building - and it's best to have a signed contract which locks the owner in to sell but allows you to back out - is to do a complete rundown on its needs and your desires. Know about roof, electrical, plumbing, structural, elevator, asbestos and fire emergency systems and what the local inspectors will make you do. (Go talk to them and get friendly.) Also, know the shortcuts. I've renovated a few properties for a fraction of the first estimates. If you ask a plumber how much it will take to redo the heating and pipes and fix up a kitchen and bathroom, etc., and you're from out of town, he will protect himself and hope for some business and say $50,000. If you know that you need a new furnace - you can get a big commercial one from Grainger for less than $2,000 - and as you learn each detail, by the time you add up exactly what has to be done, you'll be surprised to know that your cost might be only a quarter of the original estimate. And much of the work can be done gradually.

You can get away with murder in big space. What

would look like poor workmanship in a little house isn't even noticeable in gigantic loft space. For our loft, we sandblasted the entire floor, added simple sheetrock partitions painted white, used the cheapest exposed electrical conduit and light holders for flood bulbs, installed ductwork and left it exposed and unpainted, used poured concrete for the kitchen counters and kitchen island, and covered a lot of big white wall space with (if I may say so) dramatic art. People walk in and say, "Wow!"

Upstairs, we saved some by spending some. We put in a platform for the new bathroom pipes, but within the design we integrated our bed and sitting area for free, which made the space come alive. In a large open space, for not much more than installing more carpet (at wholesale), we poured extra concrete and created an indoor patio. By adding five big trees purchased for $19 each at IKEA, and by drilling five holes into the thick floor and cutting holes in the carpet for golf putting (why not?), we have a very dramatic space. Again, cheap paint sprayed or rolled did wonders, along with some more art. Normally, good design decisions do not have to cost a penny more than bad ones. The resulting space will simply look as if you put a lot more into it. This was for our living space; for the studio areas my standards are much more functional.

No one, other than an artist, could renovate and decorate large loft spaces for a reasonable amount of money (especially if the value of the art is included!). That is at least one thing to be pleased about. (In galleries I'm very reasonable. But for my own amusement, since I stopped showing at most private galleries fifteen years ago, and since I hadn't sold more than one or two paintings for over $10,000 each in several years, I decided to raise my prices. Now I'm not selling $40,000 paintings - but I feel better.) Seriously, I point out our fun improvements because I want people to understand that you can play it loose, have fun living space, have serious work space, have the necessities- all for less than what a one-bedroom apartment costs in most urban areas.

Residential loft area; working studios are elsewhere in the Beaver Mill.

Read The Art Studio/Loft Manual to learn about new economic approaches which artists can use to take over gigantic properties with very tiny budgets. Not only how to get materials and use unusual approaches, but also ways to do partnerships with others so that you have control of the building while also having the funding to do what is necessary. Sometimes you can do it all by yourself. With owner financing, you can go to a bank and try to get a renovation loan. Many communities have not-for-profit community development corporations that can lend you money. For my first big building in Washington, I couldn't get a bank to understand that space could be rented to artists (seriously, they asked why artists, i.e., housewives and hobbyists, would want to rent space in a warehouse when they could paint at home), but on the basis of renting dead storage space, they gave me one loan so I could do the lower level and get it rented, then a larger

91

loan so I could do the rest of the building. For the ten years I was actively managing the studio building, I never had a vacancy.

I know that some of you reading this will think, "I don't have two cents to my name, so how can I be reading about $15,000 or $50,000?" Most struggling artists I know still pay studio rent, have a separate family residence, drive a car, and so on. What I am basically suggesting is the possibility of transfering your expenses into something that will give you more benefits as an artist. I, too, had very little money in the beginning. But if you are the one with the deal, then you can 'shop it around' and get someone else to come in with the financing. Remember, your personal growth and the development of your art and studio continues year after year. You don't need to jump off a cliff just to take your first steps.

Another cautionary note: I worry about encouraging artists to get into the real estate game. It would be nice to say that artists should just stay in studios and keep their non-art side of life as simple as possible. This might mean just renting studios and hoping that their art is recognized (and bought) so that they really never have to worry about this business. The reality check is that, even for great artists, star recognition probably won't come in a timely fashion, and the ability to create great art will be impaired if great space is not available. If I am correct that space is the backbone of a studio operation, then there really isn't any other way than to learn the ropes.

MAKING ART
MATERIALS & PROCESSES

Once ample studio space is achieved, artists still need to produce their art by liberally using materials and processes. Retail art stores sell enormous amounts of materials to artists. Would General Motors go to a retail automobile parts store to purchase parts? Artists are small businesses, and the last place to purchase materials is a retail store. Of course it is even better to get ample supplies without paying anything. An abundant supply of art materials - without the worry about cost - allows experimentation and freedom in creating. Most artists struggle to buy good paper, paint, canvas, and sculpture materials. I have thousands of sheets of paper, hundreds of gallons of paint, tons of canvas, and more materials than I have time to use. I have industrial equipment in my studio, as well as access to a million-dollar machine using thousands of pounds of materials. I'm like a kid in a candy store - but hopefully with a better purpose and result. All artists need to set their sights on a more ambitious shopping list.

After getting materials, time becomes precious. Everyone has the same amount of time. Studio time translates into the best use of artists' time. Most artists waste much of their precious creative time by using outmoded techniques. If they had the financial resources, most artists would like the chores of their profession to be done for them - stretching canvas, priming work, or making armatures. With limited resources, how can artists have all the materials they need, all the help they need, and access to better processes?

FABRICATION FORESIGHT: ARE WE STILL USING TACKS?

Way back in a time I hesitate to mention since I was working then, artists would stretch canvas with a hammer,

tacks, and a professional canvas stretcher. It was always awkward, because you really needed a third hand. You had to pull the canvas with the stretcher tool using one hand, hold the tack with the other, and then figure out what to let go of so you could hold the hammer and pound in the tack. No artist used a staple gun then, even though staple guns had been in common use by businesses for years. It was late by industry standards when the use of staple guns by artists finally became commonplace.

When I was teaching at the Corcoran School of Art in Washington, I had to help students learn how to stretch canvas. When you help thirty people, some of them with weak arms and hands, stretch and staple canvas, you find out that your own hand soon has blisters - lots of them. It was at this point, frustrated, that I wrote a memo to the school administration asking for an electric staple gun. I had been using one for several years in my own studio, but few other artists used them.

At that time, you could purchase one through a wholesaler for around $110 (which 25 years ago was even more expensive, since you can pick one up at any Sears or local hardware store for less than $30 today). The answer to my request was, "no." (Organizations are rarely innovative.) The school's reasoning was that art students should be exposed (i.e., subjected) to the same environment that they will face in the real world; besides, an electric staple gun sounded dangerous. I tried to explain that the real art world consists of artists who are slow in business and who do not keep up with technology that could help them and even save them money in the long run. I hoped my students would fare a lot better when they got out into the real world. Additionally, I explained that an electric gun was actually safer than a hand-powered staple gun because, while it had power to go into a substance, if you shot it across the room there was little thrust. The staple would only go part way, compared to a hand staple gun that could put out an eye. Never mind logic; my reasoning fell on deaf ears. The point is

that there are professional and logical ways to organize, to manufacture, and to be productive. This information is rarely available in the art world (or in art schools), so artists should be in constant communication with businesses using similar tools and materials.

STRETCHER SYSTEMS

Many will argue that the future of art will include multi-media and that 'painting' is dead. There are many contemporary art authorities who will argue that painting will always be around, and certainly through our lifetime. So, for those who need to build and use stretchers, I have some pointers. This is also one example of how studio processes can be improved upon. Of course, if you have disposable money, hire a local cabinetmaker to make your stretchers. In the days of shaped canvases, there were always a few brilliant and eccentric woodworkers who liked to get involved with artists and would help build their 'crazy' designs at prices the artists could afford. For them, making rectangular stretchers was a snap.

When I lived in London in the late 60s, I discovered a woodshop that would build heavy stretchers, in large custom sizes, similar in design to the ready-made ones you can buy in smaller sizes. One week ahead, you would give the shop your orders - for example, a four- by- eight-foot stretcher with one crossbar support, and two stretchers six by twelve feet with two vertical supports. Every Tuesday they would cut and bundle up the various orders. You would pick up the bundle and assemble it in your studio just like a store-bought stretcher, except that these stretchers would be of much heavier lumber stock and could be in very large sizes with the appropriate number of crossbars. Over the years, I've often suggested to entrepreneurial woodworkers, in an urban area where many artists have studios, to work up a price sheet and try to get this system going. It could be very lucrative.

One woodworking genius, Louis Van Meers (Van),

who liked artists and liked the difficult problems that sculptors and painters often presented him, taught me the following system of stretcher building. The beauty of this system is that it is possible to build dozens of stretchers in one or two days. My advice is to do just that and stretch them and get them ready all at once. The idea is that, when your creative juices are flowing, you don't want to stop and get tangled into purchasing materials, building a stretcher, stretching canvas and priming several coats. By the time you've done this and you're finally ready to paint, your creativity has passed, and frankly, you're ready to go home and sleep.

Condensed, the system calls for 1"x4"s or 1"x3"s to be butt joined with plywood triangles or, if you can tolerate or desire, a 2 1/2"depth, to overlap the corners. Glue and nail the joints (or, preferably, screw with an electric drill or screw gun). Then take a 1"x3" and attach it with finish nails perpendicular (slide a spacer to maintain the same distance all the way around the edge) to the frame. What you are doing is making each side a 'T' shape (it's the same principle as an 'I' beam) so that each piece is held in place by another and they cannot warp. I built many stretchers about 8 by 18 feet this way, and they could be handled very easily.

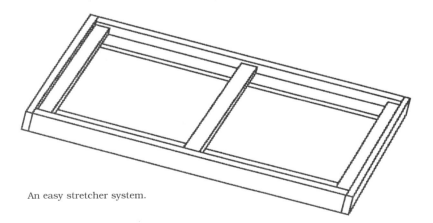

An easy stretcher system.

96

For example, if I wanted to build a stretcher that was 4 by 8 feet with one support, I would cut the following pieces: out of 1"x4" wood (clear white pine is best), three pieces 46 1/2" and two pieces 94 1/2"; out of 1"x3" wood, I would also need two pieces 94 1/2" and two pieces 48". As long as I stayed with even sizes (such as 4 by 8 feet, 6 by 10 feet, 3 by 6 feet, etc.), many of my stretcher parts would be the same.

Organizationally, I would write down all the stretchers I wanted to build - for example, four stretchers at 4 by 8 feet with one support, six stretchers at 4 by 6 feet with one support, four stretchers at 6 by 12 feet with two supports, and so forth. I would put down all the measurements and then assemble a list so that I might be cutting, for example, 22 pieces of 1"x4"s to a length of 96 1/2 inches. By doing bulk production work, once you get your saw set up, you can do all the cutting in a short time. Not to belabor the point, but this is the way you would do it if you were a business. Artists should take this approach to get the noncreative processes done.

Because many of my canvases had to be worked on horizontally, for instance on a tabletops, I added an extra procedure. I would slide the outside pieces (the top of the 'T') to one side so that there was only a quarter-inch gap. I then laid 1/4" plywood to cover the entire stretcher but fitting snugly within the perimeter 1"x3" pieces, then stretched canvas over the entire thing and put the stretched canvas on sawhorses. Although it weighed a lot, I had a hard surface under the canvas, which I needed because I was using special vinyl floor chips and resins that had to be cut with a razor blade. When the painting was finished, I pulled out the staples and undid the canvas on one side, took out the short wood end piece and slid out all the plywood; re-nailed the wood, re-stapled just that end, and I had a finished painting on a great stretcher.

A little side comment: I believe that artists need to be clever and businesslike in order to give themselves the luxury of later being able to walk into their studios and 'crack up' creatively. Some artists create very methodically, others very emotionally; but in both cases, artists should have methodical building practices. Artists should work so they don't lose fingers in table saws, so they don't waste valuable creative time, so they don't spend more money than necessary, and so they can actually create more opportunities to produce. If you want to splash paint on a canvas while nude, that's fine. Only have a different attitude when you are fabricating and using power tools. I've met too many artists walking around with fewer than ten fingers.

PAPER, PAPER AND MORE PAPER

Just as being a corporation can be helpful (as is discussed elsewhere), forming a not-for-profit, while a bit more complex, is also very useful. *Sometimes you can affiliate with existing not-for-profits.* With a not-for-profit behind them, artists can ask for materials - for free. In the meantime, artists need to avoid paying retail. Even paying wholesale is most often too much. First, try to get everything free, then offer a token amount if you have to. For example, good archival paper costs about one dollar a sheet, and can often be much more. A purchase of 25 sheets can cost you over $25. Think how careful an artist might then be when creating in the studio, in order not to waste this now precious material. On the other hand, I could go through 25 sheets in a few hours. Some of them might be successful, but many will not be. That's a lot of money to waste, if I were paying a dollar a sheet. But remember, that's retail. It doesn't bother me to waste paper artistically, since the paper costs me less than a penny. In any case, I have no choice because my art demands a lot of risk taking. (I can assure environmentalists that I recycle my paper.)

I happen to be located in New England where there are several paper mills operating. Some of these mills make artists' paper, and most make acid-free paper. *Every artist working with paper, as most do, should have at least one tour of a paper mill - it's an eye-opener. We offer tours to most artists who come to work at the Contemporary Artists Center in North Adams, because this can change their lives.* I found out that when a paper mill manufactures paper in a run of 10,000 sheets, for example, something might go wrong. It could be that there is a minute, barely noticeable color variation after 5,000 sheets are made. When this happens, the entire run is set aside and is then considered 'broke' paper, which basically means 'seconds.' If it is white paper, it can often be thrown back in the mixer for some future run. In many cases, however, it cannot be reused, since paper runs have to be exactly measured according to a recipe to fulfill a customer's order, and recycled paper confuses that recipe. Paper that can't be reused is then sold as broke paper. It is bought by a variety of commercial concerns - and is sold by the ton. The price varies, but we've purchased paper for as little as $100 per 1,000 pounds. A thousand pounds can mean several thousand sheets, depending on paper's weight and size!

Hundreds and thousands of sheets of archival paper, stored on studio shelves.

Imagine having a stack of 6,000 sheets in your studio - a supply of paper to last through many years of work! Instead of a dollar a sheet, you are now paying

about a penny a sheet. There is a catch - you need to be able to receive pallets of paper from a truck, but the paper can easily be unloaded and carried in smaller stacks. Now if you had 6,000 sheets stacked up in your studio, would it affect your work? Would it allow you to experiment in ways that perhaps you were hesitant to do when you only had 25 sheets? The point is that, not only are you saving a lot of money, you are also freeing up your work structure to allow for more possibilities. More freedom to the artist can mean more creative output.

Artists can get together and purchase paper in bulk. Just do it quietly, perhaps through a nondescript company name. You don't want the paper mills' retail and wholesale dealers stopping mill sales of broke paper. At the CAC, we've purchased and we've also received through donations over 20,000 pounds of paper, either in sheets or rolls. One large roll, needed for making large prints on our "Monster Press," came in weighing over 3,000 pounds. In order not to rock the boat, we do not allow this paper to be purchased or be taken out of the CAC unused. Much of it was donated for the benefit of artists who come to the CAC to do experimental work. It is given away to the artists working here, but there is still plenty left.

DRIPPING WITH PAINT

Paint is another expensive item. Artists have special preferences for the look of the paint on the canvas. However, let's consider the paint that goes on as prime coats on canvas or over sculptural parts. Two or three decades ago, cheap house paint, like the kind Pollock used, would fade, crack, and otherwise not hold up. Nowadays, the differences in paint quality are not as great, and even cheap paint is fine to use. Cheap latex paint usually has more water in it, so the coverage might not be as good, but the decision of what quality paint to use is often based on price. The more you spend the more coverage you have, because more solids are in the paint.

Free paint doesn't need to be selected on the basis of coverage; if it's free, use it.

For artists' paint, although I do not want to recommend specific brands, I've found Golden Artists Paints (Berlin, New York) unusually helpful by phone, letter or visit, for artists who have specific questions or needs. They will even custom-make paint for you. Utrecht has an economic line of paints sold in pints and gallons. It's worth checking www.urtechtart.com.

When I used to spray car lacquers on my sculptures (a practice I eventually stopped, since it is quite dangerous without extremely expensive wet exhaust systems, although the quality of paint, especially the new iridescent pearl paint, is exquisite), I looked around and discovered that when car refinishers (body shops mostly) painted cars, they always had paint left over after each job. These partial cans would be stored, in case the job needed touching up or just in case another job came in needing the same paint. Most often, after a few months, so much paint would pile up that the shop would finally just decide to throw it all away. One time, at my request, my intern spent a couple of hours telephoning all the paint shops in the city, and we found several who said we could have all their leftover paint if we would pick it up. We brought back to the studio hundreds of cans. Even though much of the paint came in ugly car bronzes and greens, these could be used for bottom coats, and I still had a lot of rich colors.

Hardware and paint stores often have returned paint. Along with their mismatched cans, they try to sell it all at a discount. One hardware store had about 200 cans out for sale, ranging from $2 to $10 per gallon. I offered $1 each and offered to take them all at one time. I think we settled for $1.50 per can and I loaded up the wagon.

In our area, there is an organization that tries to find users for excess industrial materials and leftovers. It's a great thing to set up if your area doesn't have one, but in

the meantime, make your own calls. You can even run a classified ad for the materials you need. There are lots of people who want to get rid of their old paint and other materials. I once needed twelve television sets for an exhibition project. Since only the screens would be visible and I was using VCRs, other than to fulfill my purpose, I didn't care what the TVs looked like or how they operated. After I put one classified ad in the local paper, I received several free TVs from people who didn't want them because one function or another was not working properly. Keep in mind that we live in a disposable era, and often it doesn't pay to repair things or to keep small quantities of materials. Artists can cash in.

Paint by the gallon and bucket, and lots of it.

Paint is very easy to get. Almost all discarded paint can be used for prime coats at the very least. One retail deal that is an exception to the rule and one you should know about is at Wal-Mart. A lot of paint sold at Wal-Mart is manufactured by United Coatings, now a part of Sherwin Williams. Most of their interior and exterior paint sells for over $12 per gallon. When customers return cans of paint for whatever reason, the stores send the paint back to the factory. The manufacturer has sold over $180 million in paint annually to the thousands of Wal-Marts all over the country. They throw all the returned paint into a tank, make a gray out of it, pour it into two-gallon pails

and send it back to Wal-Mart, which then retails the paint pails for $6 each. That's only $3 per gallon for paint of the same quality as the $12 per gallon paint. Wal-Mart also sells white flat latex in five-gallon pails for less than $20. If you can't get paint free, this may be the next best thing.

Artists doing very large works can go through a lot of paint very quickly. When I used to paint large (elephant-sized) organic sculptures, I needed a lot of paint just to cover all the cracks and bumps on the skin. I purchased, secondhand, an airless spray gun rated 1.4 g.p.m. That stands for gallons per minute; in other words, I could spray almost one and a half gallons every minute; that's about a five-gallon bucket in less than four minutes. Now you have a sense of why some artists need a lot of paint.

Along the way, my airless spray equipment has come in handy and saved me many times what I paid for it in the renovation of several studios and houses. If you don't need to worry about a lot of masking, you can paint an average house in one or two hours.

NEW PROCESSES AND TECHNIQUES

I don't want this book to be only about new materials and techniques. I have mentioned a couple to illustrate how even traditional processes can be upgraded and how all regions of the country have something to offer artists for free. Artists need to think more smartly. I've spent my life exploring better ways, not just to make my art have a different look, but also because the things I wanted to create were not possible to do with traditional materials.

In 1970, I wanted to add more weight and texture to my huge canvases consisting of layers of painted three-dimensional grids in perspective. I found and used for many years a vinyl chip floor material. The process I perfected using the vinyl chips can be compared to taking dry, peeling colored paint off the wall and sprinkling it on the canvas - like doing pointillism the easy way. If I

wanted a green, I could use green chips, or I could take a handful of yellow and toss in some blue, sprinkle it on and it would appear to be green from a few feet away. I've used industrial clear polycarbonate (Lexan), Plexiglas, silicone, Masonite, lacquers, resins, photo-litho, and many other new (at least to the art field) materials.

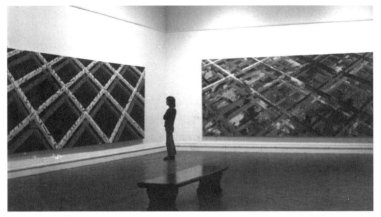

Eric Rudd, (left) Kosmos, 1971, vinyl chip, acrylic on canvas, 7'h x 22'w; (right) Topogo Wall, 1971, vinyl chip, acrylic on canvas, 8'h x 18'w; installation view of solo exhibition at the Corcoran Gallery of Art, Washington D.C., 1973.

Sculptors have spent centuries making armatures and using clay or plaster to make organically formed sculptures. Now there are fiberglass, spray metal, composites, and foam stock as well. There's also foam made with spray equipment. To my family and friends, it seemed like a big risk to spend a lot of money I didn't have on hand for industrial polyurethane foam equipment. When I purchased it in 1973, I didn't know if I would be using it for six months or six years. So far, I've used it for more than twenty-five years. It has proven to be one of the best purchase investments of my career.

A painter can paint a life-sized human figure on canvas in five minutes (obviously, with basic modeling but not too much detail). To do this in sculpture requires having a sturdy armature, building up clay or plaster and slowly molding the shape - a tedious process that,

including labor and drying time, can take several days. With polyurethane spray-in-place foam, on the other hand, I can actually make a sculpture of a life-sized human figure in five minutes. I can make an elephant in an hour. Not that I make elephants, and not that I crank out sculptures every hour, but the idea is to tell you how exciting it is not to be bogged down with a labor-intensive prep period; instead, I can get 'with it' and spend most of my time creating. Although relatively lightweight (volume can still add up - I tell people that one hundred pounds of feathers is still one hundred pounds), the foam has structural strength and allows all kinds of new forms and compositions to be created.

Spray-in-place polyurethane foam sculptures in progress, 1977.

A process like spray foaming is not for everyone and wasn't even for me during some periods of my work. I spent years doing very disciplined paintings and reliefs based on mathematical and geometric principles. During those years, I calculated that the creative time in my artwork represented only 5% of the process, with 95% of my time spent on the manual process of crafting the work, once the creative decisions had been decided upon. Even with this kind of style, I still found new materials and

techniques to help me produce a strong body of work. But when I started using foam, this percentage reversed, and I spent 95% of my time working creatively.

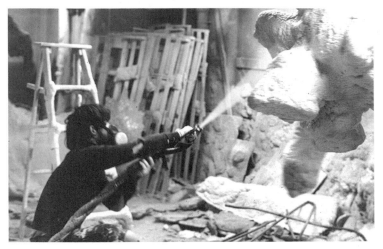

Spray-in-place polyurethane foam sculptures in progress, 1975.

Hint: The real art catalogs are the yellow pages (and now the Internet); the 'art stores' are all the wholesalers and manufacturers of building and industrial products.

I've only mentioned a few materials, but these concepts can be applied to any medium that interests you. I used to call Rohm & Haas to get information on plastics. I once made a deal with Owens-Corning (before I purchased the spray equipment) and got my dense, polyurethane foam stock for half price in exchange for a painting that they would donate (this saved me hundreds of dollars over several years). I once got a thousand pounds of liquid foam from Upjohn, when someone from the International Sculpture Conference called around lunchtime and by accident the CEO picked up the phone. I once got hundreds of pounds of vinyl chips, which I was using extensively in my work, from a company that had to get rid of some partial drums. I once got on loan 30,000 pounds of crushed metal for a temporary sculpture

installation; another artist got a car and then proceeded to drill pipes throughout the surface. I once got piles of scrap pieces of Plexiglas; another time hundreds of dollars in laminating sign material. We can get all the silver Mylar we want, as well as thousands of sheets of clear tracing Mylar, not to mention the polycarbonate, an industrial blow-molder, paint, and other materials already mentioned, including the tons of free canvas that came with my mill.

Check out the manufacturers near you. I used to complain that I didn't have the time to go around and get all the free stuff I could have had for artists to use, but if I really need it for my work I will make the effort. It helps if you have a project when you ask for materials. People like to think that they are helping you to accomplish a goal. And it is critically important to write thank-you notes and to keep people at the companies from which you are getting materials, abreast of your progress. This is not only civil, but I often have to go back to my sources and ask for second helpings.

Other artists have also been innovative in using new materials. Frank Stella used everything from honeycomb composite to felt to fluorescent and metallic paints; Jules Olitski used spray paint equipment; Jenny Holzer uses LED; and if you scan what a hundred artists are using, you will find that more than half are using new materials, many in combination with traditional materials.

ARTIST-ENGINEER?

In the late 60s, I was somewhat disheartened because my artistic ideas required so many new types of materials and processes. I am not mechanically minded at all. I can't do much more than check the oil in an engine, I hate putting two electrical wires together, and my use of a welder has been limited to working only with someone standing beside me. Over the years, I have come into contact with professionals in these fields and I have a good

idea of what should be done, just not how to do it myself. I was traditionally trained as a painter, so when my work turned more and more to sculpture, I thought I would be left behind. I felt this even early on as a painter by struggling with stretchers and frames. It got a lot worse when I began getting into sculptural pieces using wood construction and plastics. Slowly, once you have an idea of what you need in order to accomplish your art, you can force yourself to learn enough to do whatever process is necessary. *This might sound like an old idea, but if I can do it so can you.* And now I'm doing things way beyond using wood and plastic sheet.

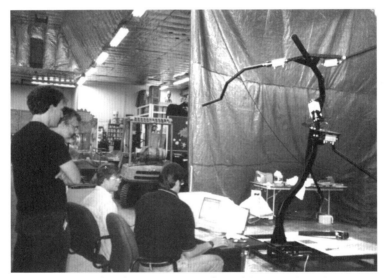

Testing the robotic movements of a sculpture armature at
Advanced Animations, Inc., August, 2000.

I couldn't put two pieces of wood together when I first started painting professionally, but by the time I finished building my first wooden sculpture so large that it touched three of my four studio walls, I had learned a lot - much of it the hard way - but I had learned. Each year, I've gained more knowledge. Sadly, when I get really good at something, instead of staying and enjoying the perfection of a technique, I get a new idea and I have to

move on to another challenge and new fabrication headaches.

There are times when going to a professional shop or fabricator is the most efficient way of creating. A recent sculpture using a robotic structure was fabricated at a facility specializing in animatronics. By scheduling the fabrication work during their slower work periods, I achieved tremendous cost savings.

FIND DEEP POCKETS AND CORPORATE FRIENDS

You need to get to the point quickly. If you meet a curator on the street, say what you do in a sentence or two. There won't be time for many more sentences. And be sincere. This holds true when you talk to companies to ask for process help or materials. If you heard me, you would instantly know by my accent and slurred speech that I am not a natural or slick salesperson. Yet I've been able to verbally transmit my enthusiasm for something just by being honest about my excitement and by coming to the point. People lead busy lives, and they may not have the patience, depending on when you hit them, to listen to your life story.

Hint: Never call someone Monday morning or Friday afternoon. Mondays are when people in business have to get the week organized, and they are not ready for the extra work your call might necessitate. Fridays are the time when they are thinking of the weekend; plus, if they can help you by requesting something from someone else, it will be too late. If they have to wait till the next week, your request may get buried under other paper work. The best times, I have found, are late morning or early afternoon.

During the late 1970s and early 1980s, I was putting polyurethane foam shapes into architectural-type structures to serve as armatures or frames for my work. This was in contrast to my larger pieces that were stand-

alone or hanging works. Anyway, the interaction between the organic foam shapes and the planes of my wood and glass rectangular columns intrigued me more and more, and I completed a whole series of them. Soon I wanted to expand upon the feeling of using glass and having the forms imbedded, visible and at times not visible. This work developed until I determined that I wanted to make monumental, abstract 'iceberg' forms with my painted foam shapes emerging as fossils, imbedded within or at times sticking out near the surface. Great notion, but how do you build an iceberg?

I started experimenting. Glass proved too difficult in the scale I wanted to undertake. Besides, it would be more about the outside planes, and I wanted depth. I would have loved to go to my neighborhood art supply store and order tons of clear clay, but of course it didn't exist. I thought that clear Styrofoam would be great, but after many phone calls I learned that chemically it cannot be made clear. I keep almost everything in my studio, so I went to my vast array of shelves and looked at things I had accumulated. I played around with the stuff we blew up as kids with a straw to make balloons, and thought about that. My polyurethane foam is a cellular material, and I thought about whether I could make my own clear cellular materials. At one point I was ready to order from Taiwan 50,000 clear plastic Christmas ornaments which I could throw into a cement mixer with a resin and pour into forms. (I still like that idea.)

I was constantly on the lookout for products that used clear materials. I explored products I found in grocery stores, and thought about bubble wrap and plastic soft drink bottles. I make great use of the yellow pages, and because I was then living in Washington I often called the Smithsonian and corporate and governmental liaison offices and every government agency I could find. In previous years, for example, I learned a lot about Mylar and helium from NASA, and about making forms out of Plexiglas from the exhibitions department of the Smithsonian.

Hint: Government agencies have to talk to taxpayers, and if you are nice they are extra helpful.

In this case, my research took me all around the country by phone. This got me into the packaging industry, and before long I had a telephone relationship with an engineer in GE Plastics' packaging division in Atlanta, Georgia. He sent me a box of odd-shaped, bubbly but strong plastic 'scrap,' and I knew I was getting close. I was also learning about the various forming processes for plastic. He suggested, finally, that I contact the main headquarters of GE Plastics to see if they could be of further help. I asked if there was anyone in particular, and he suggested the number two person in the plastics division - in reality the hands-on boss.

Artists need to be able to condense their entire lives into sixty-second sound bites. I say this now because the GE Plastics executive, Uwe Wascher, was like a god to the division and awfully difficult to gain access to for even a short conversation. Somehow I managed to get through his secretary and get him on the telephone. In one minute - the same length as a commercial - I identified myself as an artist, gave him an indication that I was somewhat reputable, said what I wanted to do, acknowledged that GE had its own agenda, and asked if he could help. Sixty seconds; that was about it, but it was enough.

GE Plastics' R & D center's mission is to develop new products or use plastics in existing products with various companies from around the world, to encourage the companies to buy the raw materials from GE. That's all GE Plastics sells - pellets of plastics to companies that manufacture, or have someone manufacture for them, products made out of plastic. Their attitude is to invite representatives from companies to their R & D center, not always knowing if a relationship will lead to a big sale down the road or not. The potential, however, is huge. For example, I learned that the tiny protective covers over Bic shavers amount to millions of dollars' worth of raw plastic

material. Even though I made it clear that I was an individual artist, this executive nevertheless treated me on the telephone as he would a sizable company, being extra helpful once he realized that this was for art.

It is interesting to note that the executive at G. E. Plastics who invited me to work there, Uwe Wascher, was European. (General Electric is a worldwide company.) While most of the executives I met through working there were cordial to me, I found a remarkable difference between the European executives, who understood the importance of art and had more sympathy for my efforts, and the American executives, who thought it was a bit of a joke and couldn't quite understand the difference between my sculptures and what ended up in their trash barrels. It's just another indication that there is a void in the cultural education of children in the United States.

When I finally drove to Pittsfield to meet with a GE engineer, I had with me a manual on blow-molding so advanced that the engineer asked where he could get a copy. In other words, I did my homework and came prepared. Because the trip had been initiated by a top executive, doors opened for me and GE agreed to try to help me. I had to wait several months for a window of time when the big blow-molder would be inactive, then drove up with full anticipation, only to find that the schedule had changed too late for them to warn me. They regretted that it had to be re-scheduled a month or two later. Finally, I was able to go back and they let me use, with an engineer and an operator assisting, a million-dollar blow-molder. They also gave me three to four thousand pounds of plastic pellets of Lexan, their premier product, to use. Not only that, but because they felt badly about the first trip, they offered to truck my sculptures to Washington - perhaps also to get them quickly out of their facilities?

For a week, I was able to make clear sculptures, with one as big as eighteen feet high, and many not much

112

smaller. It was quite an experience. When I got back to Washington, I wrote thank-yous to everyone involved. An article was written about the experience in <u>Sculpture</u> magazine, which was picked up by the Business Committee for the Arts, an organization that supports and publicizes the arts activities of most of the Fortune 500 companies in the country. So that was a nice pat on the back for General Electric. I was appreciative because, while you can sometimes get corporate support for an exhibition catalog, for example, it is almost impossible to get support from normally conservative companies for such a risky undertaking, where the result is really unknown. I am sure that doing my homework on the process, and being extra aware of GE's needs and concerns, including possible physical risk, made the invitation possible.

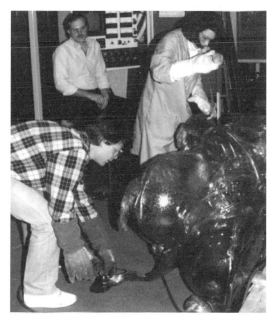

Blow molding Lexan (polycarbonate) at G. E. Plastics; 1988

It is interesting to note that if I had to pay 'retail' to do this work, occupying the equipment and personnel for a week, it probably would have cost me over $20,000. But by waiting until a window of downtime arose, it cost GE Plastics far less. That's why getting a $20,000 grant, for example, may not be as effective as looking for process and material opportunities.

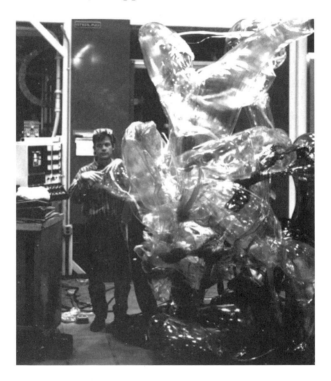

Uwe's Quark, 1988, Lexan, Noryl, pigments, 108"h x 70"w x 80"d; photo taken at G.E. Plastics' Polymer Processing Development Center, Pittsfield, MA.

A year and a half later I was able to return, again for a scheduled week, but it turned to two weeks because of equipment delays. It was during this trip, with extra time on my hands, that I started to look at the surrounding area and learned about a vacant mill. Since moving up to the area, I've been able to go back to GE Plastics several

times, and they even donated to me a small, outdated blow-molder so that I can carry on some work in my studio.

Hint: Make your contacts short but sweet; remember that big corporations are just run by people - be thoughtful; and follow up with thank-yous. Give them public support and credit for their help. The nice part is that what would cost you thousands of dollars may not be a big deal to them.

The person sitting next to you on the plane, the person who is spray-painting your car fender, the lawyer who likes to come into the gallery, the manufacturer you meet at a party, almost anyone can become a valuable resource - for materials, for ideas, for technical information, for new creative ventures - and it would enhance your position to broaden your views about the surrounding community.

THE GALLERY SCENE

Although I've made a great distinction regarding actions taken just to gain recognition versus actions taken to increase your chances to make better art, the art scene - including the activities of galleries, museums, critics, and collectors - remains a vital and healthy area of participation for artists. While I've suggested strategies to gain better space and materials, I've also suggested that new locations are chosen or established to enhance art activity. I do not suggest that it is usually healthy to work in a total vacuum.

To participate in the art commerce scene, one should be aware of the pitfalls as well as the stimulation. That way, it becomes a two-way street and not one where the artist is treated as a subordinate. Even though the artist's work is the reason that the action happens to begin with, artists nevertheless seem to be treated like pawns. At the same time, try to put yourself in the seat of the museum director, art critic, or gallery owner. There are many considerations which artists seem unable to recognize.

BEING THE STAR

One year, under very odd circumstances, I was asked to be an extra for a day in a major Hollywood movie. I soon observed the contrast between being the star and being one of a dozen extras. The center of attraction is the movie star, followed by her/his one or two supporting actors. Then there is the director, followed by the assistant directors. (Since the producer is not on scene, we will omit that whole contingency from discussion.) After these folks come the main technical team, the actors with smaller roles, more technical people, followed lastly by the extras.

When you have a one-person exhibition, you are the star. Putting all formality aside, it really is a neat feeling. Your art is on show. Supporting your show is a

considerable cast or team. You have the main gallery dealer, then her/his assistant and staff; then you have your own studio assistant and whomever else you bring in to help for this occasion. There are also the printer doing the invitations, the people who prepare or transport the art, the people whom the dealer gets in to help install, and the extra staff for the opening. You have the collectors, curators, friends and family coming to the opening, as well as the viewers who will come sometime while the show is up, and most importantly, you have the reporters who hopefully will spend time to look at and to write about the show in their reviews. All of this happens and all of these people are involved because your art is in the gallery. After endless days and nights working alone or with minimal contacts, no wonder this attention is so desired by artists.

WHY A GALLERY IS YOUR FRIEND

It's good to appreciate the struggles that gallery owners go through. First of all, most don't succeed, most don't make real profits, and most don't start because they think it's a short cut to financial security. Like any small business, galleries entail a lot of paper work, a lot of risk, and the necessity of dealing with a broad spectrum of issues. Most gallery owners get into the business because they love art.

For the individual artist, there are two main things to keep in mind. First, if a dealer decides to show a new artist, it is a huge financial commitment. After paying rent and utilities for the month, staffing for the entire time the gallery is open, paying for invitations, mailing, reception expenses, incidental office expenses such as copying, preparing transparencies and resumes, installation costs, advertising and pre-exhibition time with the artist - it will take a lot of sales to reimburse the dealer. Obviously, the dealer is also using the office and storage space to sell other works, but the upfront expenses for each exhibition are considerable.

Second, selling new contemporary art is not easy. For big names, there is a real market value and a liquidation value. For new artists, the minute the artwork goes out the door, it almost always has no value. Compare it to high-pressure salespeople selling timeshares or property lots in a so-called 'resort.' Through an abundance of slick literature, model home visits and personal contacts, naive people do buy into these 'investments.' If they knew the actual worth of their purchases, they would run in the opposite direction. Is art any different?

"People buy art because they like the art and want to hang it in their homes or offices for their pleasure. If it should go up in value, this is a bonus." That is the line that every dealer uses. Art is functionally useless, and original art can only be considered pure luxury. If decoration is considered a necessity, then it is easily satisfied by hanging good quality posters or decorative objects. I once read an insurance company's appraisal of a stolen painting, sold for $3,000 to a developer for an apartment building, for $325 as a minimum replacement value for a "decoration," assuming the artwork had no additional value based on 'reputation' or market value. In truth, people buy art for amounts way above pure decorative value, because the art business can be glamorous. They can read the gossip in the society section of the newspaper, attend openings and post-show parties, see artists' lofts, and brag to their friends. They can get 'invited' to the private back room of a gallery and see the 'real' goods, or they can be among the exclusive few invited before the exhibition opens to have an advance look and hopefully to make their selection before the 'masses' buy up the rest. The dealer will offer drinks, of course. If you've ever shopped for a fancy car, you get the idea. Try it – window-shopping is free. In fact, dress up and pretend you have $25,000 to spend on the purchase of an artwork, and see what kind of reception you get at the galleries.

When the art purchase has been completed - with

a 100% markup - and the art is taken home, the dealer prays that it will not come back (unless the purchaser wants to trade up). If the purchaser wants to sell the work privately in a few years, he or she is in store for a shock. If one tenth of the cost can be found on a resale, that would be a lot. (The collector hopes that he or she has purchased the one work of art that will be worth a fortune some day, but that's the collector's fantasy.) All the trappings of the gallery scene are what support sales by new artists. Without these efforts, your art is worth very, very little.

WHO DO YOU KNOW? WHO DO YOU TRUST?

Ivan Karp, founding director of the O. K. Harris Gallery is probably the only dealer in New York who will look personally at the slides of anyone who walks through the door, although it is rare that much becomes of it except your first rejection. As one of the early pioneers in establishing SoHo as a gallery destination, Ivan likes to say that only 10% of people, across the board, have visual perception. This means that even counting all the people in the business who need visual perception, only 10% have, as have 10% of people not in the art business. Therefore, only 10% of gallery directors, 10% of museum directors and curators, 10% of collectors, even 10% of artists have visual perception. The other 90% are, unfortunately, in the wrong field. Well, you can listen to this with a smile, but you can also get the impression, whether the exact percentage is correct or not, that there are a lot of critics, curators, dealers and friends without visual perception who tell artists what they should or shouldn't be doing. If you think you are one of the 10%, then at least don't listen to artistic advice; it's bound to send you on the wrong track.

There is a story about the late Howard Mehring, one of the color school painters who used to paint absolutely beautiful paintings with small stained dots, who

got some advice from art critic/dictator Clement Greenberg. Greenberg told him to stop doing the soft stains and to go hardedge as Noland, Davis and others were doing. Well, Howard chose using repeated upside-down 'T' shapes and did a lot of paintings which never really took him any further recognition-wise and probably not artistically either. Eventually, Howard stopped painting. It was strange to occasionally bump into Howard years later and to know that, even with his reputation, he just quit making art. When either Howard or someone confronted Greenberg many years later and made some reference to this advice, Greenberg said, "Well, I may have been wrong." It was too late for Howard, though.

Howard Mehring, Banner, 1980.6.13; photo: Smithsonian American Art Museum, Museum purchase through the Luisita L. and Franz H. Denghausen Endowment

Hint: Never, never listen to advice. Or, at least, don't take it if it doesn't feel right.

WALTER HOPPS

Timing can be everything and is not usually within your control. If you are working in one style and the trend is in another, you are left out. If the trend moves a little in your direction, then you can look like an enlightened leader. Your track record in the market is not always a true measure. Historical facts also do not always tell the whole story. Walter Hopps gives a different angle to the famous fact that Vincent van Gogh did not sell a painting within his lifetime. According to Walter, the art market was just beginning to discover struggling Vincent; had he lived just a little longer, he would have been selling a lot.

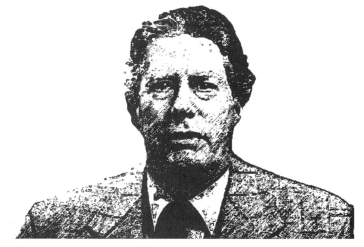

Walter Hopps

Although Greenberg was bad for Mehring, especially because Greenberg was the type of person to tell you how to paint, it can make a real difference to have a respected scholar, curator, or critic in your corner. I have Walter Hopps in my corner. Walter Hopps is one of the world's foremost museum directors and authorities on contemporary art, and is one of the few people in the contemporary art world I can personally say is a genius. His reputation among artists is legendary.

Walter Hopps made history in the mid-1950s by showing important California and New York artists at the Ferus Gallery in Los Angeles, which he started with artist Ed Kienholz. Later, as curator and then director of the Pasadena Museum, Walter showed such giants as Marcel Duchamp, Andy Warhol and Joseph Cornell. Walter went to Washington in 1965 to study future museum concepts at the Institute for Policy Studies. Because of his intensity, knowledge and passion, artists were drawn to him, and he soon became involved with and then was director of a small museum called the Washington Gallery of Modern Art, which later was absorbed by the Corcoran Gallery of Art, of which Walter soon became director.

After leaving the Corcoran, Hopps was curator of 20th Century Art at the National Museum of American Art, where he curated shows of Rauschenberg, Cornell and many others, before becoming associated full-time with the Menil Collection. As founding director of the highly regarded Menil Collection in Houston, Texas, Walter supervised the planning and operation of one of the most beautiful museums in the world. Past shows have included major retrospectives for Robert Rauschenberg, Ed Kienholz and Max Ernst. More recently, he was named senior curator of 20th century art at the Guggenheim and is organizing a Jim Rosenquist retrospective for the museum.

My analogy about Walter goes like this. Many curators will recognize and agree to accept into their museums an important artwork that is being offered by an important private collector. They can then focus on the art and talk about its relevance. Walter, who actively kept in touch with more living artists than anyone else I've ever known (if the phones rings after midnight, it's probably Walter), will walk into your studio and instantly size up the range of your work. He will invariably point to something that was not first on your list. Two months later, you are hard-pressed to know why you didn't recognize that work

as your finest. By staying in touch, however, Walter's involvement as a curator continues in his own way. If the artist (and all artists have financial problems) has a flat tire and has problems getting it repaired, Walter will get concerned and help get the flat tire fixed, so that the artist can load up his/her pickup with the artwork to take to the gallery, so that a particular work will get sold to a collector, who in a few years can be talked into donating the work to the museum. You see, in both cases the art gets into the museum. One curator is there to receive it, but Walter is there from the beginning, in the studio, encouraging the sequence of events to take place.

Walter and I met in the 1960s, and over the years he has built up the most extensive knowledge any museum director or curator has of my work. Walter has also curated most of my gallery shows. Through Walter, I also got an early knowledge of the inner dealings of the art world.

NO TIME TO LOSE - LOOK FAST

To me, making the scene is not about making connections to get ahead. If the work is there, and the timing is right, you will see progress. The real reason to make the scene is to see what your contemporaries are doing. It is also fun and stimulating. It's best to see the most in the least time and with the most ease; hence, a trip to New York City galleries is convenient. Although several hundred galleries are listed, about a hundred are important, either by showing important art or by showing potentially important art (which could include yours). In my younger days, I would take the bus or train to New York, begin uptown around Madison Avenue and 70th Street, and take in about 30 galleries by the time I got to 57th St. After finishing 57th (and I might do a quick Whitney or MOMA if staying just the day), I would head to SoHo and take in another 30 galleries. Obviously, most of

the time I would just walk in, take a two-minute look and walk right out. It doesn't take long to absorb what is happening, and in most cases the shows weren't worth staying for. On the average, though, five to ten shows would be worthwhile, and that was what the trip was all about. Today, upper Madison Avenue has fewer galleries. Important galleries are still located around 57th Street, and SoHo still has some of them. The new area of galleries is Chelsea around 22nd Street, anchored by the DIA Center for the Arts. This section has become in just a few short years more important than any other area in New York. (Many galleries distribute free gallery guides that are invaluable for quick reference.)

When I used to teach at the Corcoran School of Art in Washington and talk to my students about various artists, I felt how distant they seemed from it all. I pointed out that many of the artists they admired were just a few years older than they were (some younger!) and they could see their actual works and their latest works just a few hours north in New York. They did not have to get their inspiration from art magazines secondhand or from their teachers (since I was teaching then, I can say that most teachers are third-rate artists; remember, 90% have no visual perception). The students would discuss masterpieces without having seen them, although they were hanging at the Museum of Modern Art. My encouraging them to go see art in person was constant. In one class, the students took action. There's always one organizer in a group, and before I knew it I was escorting thirty young adults from one class for two days in New York. It was a blast.

HINT: Go to the shows often, see as many as you can; quantity will help you feel what not to do, and you will get stimulated by the few good shows. When you do see a good show, study it - the concept, the fabrication, the installation; and try to figure out why this artist is getting your attention. Use this for stimulation; don't copy.

You would be surprised to know how many artists write to the director of a major museum and expect him or her to put the artist into a show. Life is not like that. The head of a major museum may talk to Rauschenberg about doing a big show; that's like a big-time producer talking to a major star about a movie. Their partnership can mean a commitment of millions of dollars to generate revenues of millions of dollars. For major museums doing major shows, it involves less than making a movie, but still costs hundreds of thousands of dollars. You and I are not part of this scene. However, there are lots of associate, assistant, junior curators (or whatever title they may go by) just as there are lots of up-and-coming critics, writers, and dealers. Try to connect with people on your level. If your work has merit, a relationship will result. Many curators have launched their own careers because of their specialization in a trend, movement or group of artists. One helps the other, if all goes well. That doesn't mean that you can't deal with the big museums. For example, curators at the Guggenheim will assemble slides from artists who sent them in and view them every two weeks or so. They want to stay connected with what might be happening. This is a good way to get started.

SAYING NO FIRST

Having said all this, I want to make a few basic pointers regarding gallery relationships. I have found that politeness counts in business. Having a nice relationship with a dealer does not mean that the dealer represents a gallery which will benefit you. Walter used to tell me not to worry about showing at this place or that; he would advise me to turn them down, even though I didn't have the offer. I would reply, "But, Walter, no one is knocking down my door asking me to show." His point was, it simply was not going to help my career to waste time showing at a gallery that might even hurt my image. So learn to be patient.

126

In Washington D.C., with the loan of a large old building and a few local grants, some people organized their second annual show called "Art-O-Matic." The first show was held in an abandoned building that once was an industrial laundry, hence the name. The more recent show was held in a building that was first a Sears store, and then a building supply store that closed. Hundreds of artists displayed their 'wares' on hastily built plywood panels - four standing vertically and attached together at the inside edges. Needless to say, the whole exhibition took the appearance of a cross between a flea market and a homeless shelter.

Within the maze of clutter were some acceptable pieces, but you needed to imagine how they would look in a proper exhibition setting. Yet over 600 artists in this one city felt compelled to exhibit. Of course it was hoped that the quantity of the artwork would draw so many people that everyone would benefit. I'm not sure if the organizers were happy with the attendance numbers, nor do I know how many artists might have benefited through sales (many left business cards next to their work), but from a professional, curatorial point of view, if I had my work on exhibition there, I would have prayed that no serious museum curator or art critic walked through the doors.

If you don't give yourself self-worth, then others will not. But if you think that your work is of the 'craft fair' level and what you are interested in is a quick sale, then I don't want to discourage you from participating. I just can't imagine any artist whose work is collected in museums, and whom you might admire, ever participating in this kind of show. It's just a waste of time.

THERE ARE BETTER SALESPEOPLE THAN YOU

The other great way to get a gallery connection or an opportunity to install or show your art is to get someone else to do the negotiating and recommending on your behalf. A curator is best, followed closely by a collector

who champions your art, especially to a gallery the collector patronizes. You can meet these people during openings, through friends, through your family, and by simply asking to meet them. Do it. But do it only after you begin to get comfortable with your art. Recognize that, if you are just out of art school, your art may not have reached an original, mature level yet. As I've mentioned, if you try to force it prematurely, it will be seen as weak. Once your art is strong, you know it and everyone else knows it. Be wise as to gallery and curator connections, but keep them in perspective; 95% of your effort must be to produce.

THICK SKIN, EARLY START

What is mature can start very early. I had my first show at a very prestigious gallery when I was eighteen years old; my first one-person museum show when I was twenty-four, showing paintings that I had completed two years earlier. This is more common than you think. But I also have a thick skin, and it's needed. Very early in my career, I had mature work that was getting the interest of some powerful people in New York. Instead of showing this work for a group show I was invited to be in, I really wanted to exhibit my most recent work. (When you are so young, anything completed more than three months ago becomes old work.) Unfortunately, I had not had more than a week or two to think about the new work, and it really was not ready to be shown. Consequently, I got the most severe, put-down review in a major newspaper of anyone in memory. Let me tell you, if you have faith in yourself, you can live through anything, including a public dismissal.

A funny follow-up was that the next year, when I had a one-person show at my gallery, I received an incredibly good review; but for the first four, long paragraphs of the review, all the critic could talk about was how bad I had been and how he had said so and how I was

so promising now. How do you get a thick skin? The hard way, by disregarding the insults and keeping the focus on your work. Some advice I got early on was, if you get a very good art review and you happen to bump into the reporter, it's fine to say thank-you. You might add that it was nice of the reporter to take the time to look at the work. But if you get a bad or indifferent review, even if you bump into the reporter, never allude to the fact that you ever saw or read it.

IN THE NUDE

You might have noticed that people like to gossip. I'll bet even you like to know the juicy details about some personality in the art world. Actually, if people are talking about you, that's good. People usually don't waste time talking about unimportant folks. As much stupidity as there is in the popular People magazine, the personalities in it are actually quite clever. They are in the limelight enough to have others be curious about them and write about them.

I once told an artist friend, after we were talking about this tendency, that she should tell two people a secret: that she can only paint in her studio when she takes off all her clothes and paints in the nude. That's the kind of gem that will very quickly spread all over town. And believe it or not, it will only enhance her standing as an artist, plus possibly make her a few more sales. Collectors like to pass on the gossip to friends whom they invite to admire their new art acquisitions. In fact, the less of the truth they actually know about you, the better. Living in a normal neighborhood not only makes you sound too normal, but it makes the work you do seem boring too. Think about all the romantic novels and stories about famous artists in the past, and consider what might be said about you someday. Most of the stories are such exaggerations that you might as well start a few now. You never think about a movie star having to go to an

optometrist and wasting an hour in the waiting room for her appointment; you don't like to think of superstars having to do the same mundane things you and I do, and their press agents obviously only emphasize the glamorous activities. It's just the same in the art world; let your private life be private.

If you really want to be smart about the commercial end of art, then play being an artist. Not phony, mind you, but a distinctive haircut, dress, jacket, hat, or bald head can set you apart from the rest of the crowd. When you are out on the scene, then make the scene. Movie actors don't dress up for fun; it's business, and hopefully it will land them in the magazine that will promote their movies, or give them invitations to their next projects. But, again, this is such a small part of your real concerns. Do this for fun, and for business; just don't take it seriously.

HOW TO BE HONEST/CRUEL

Another piece of advice that goes against the grain has to do with those with whom you associate. Everyone will tell you that you should keep in touch with other artists. Indeed, they are often your entree to galleries. If you are in New York, these connections will depend on where and how you hang out. But if you are in a secondary market or an even smaller one, you have to remember, as cold as it might sound, that almost all of your artist colleagues will remain where they are. You want to set your sights on the bigger names. That doesn't mean that a few of the artists you know can't make it. They might be just as ambitious as you are. If you like their work, then build a relationship. In most cases, however, artists in your circle will be competent, but not having hope of doing important great art. The best way is to see how professional relationships go naturally. If you keep your sights high and your ideas are constantly pushing the envelope, you will rapidly find out which of your artist friends also have your degree of ambition.

Hint: Friendships are fine, but separate your friendships from your professional relationships.

Even as a student, I didn't look up to my teacher for inspiration. I compared my work at my age to what Picasso was making at the same age, for example. My other mentors were all in the history books - or are now.

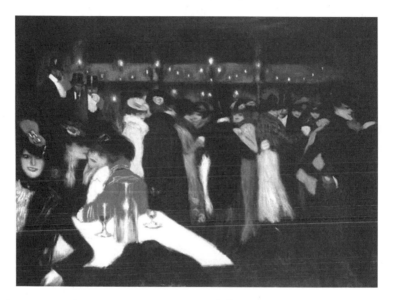

Picasso was only nineteen years old when he did this painting. His great paintings were done in his early 20s.

Pablo Picasso, Le Moulin de la Galette, Autumn 1900, Oil on Canvas, 88.2 x 115.5 cm (34 3/4 x 45 1/2 inches), Solomon R. Guggenheim Museum, New York, Thannhauser Collection; Gift, Justin K. Thannhauser, 1978; 78.2514 T34

If you're younger, you will have more contemporary mentors, like Rauschenberg or Holzer or someone younger. Most of the famous artists in history (whose works hang in museums) did great art starting when they were in their twenties. Go look in museums and look at the dates of the paintings on the wall and figure out how old the artists were when they did them. There is no time to waste on mundane or mediocre goals. Shoot for the stars while you're young.

131

Hint: Remember, if art were politics, you would not be running for town council, you would be preparing a run for the senate. Who else will support this ambition?

WHAT ARE YOUR ROOTS?

Your mentors, the dealers, and your inspiration may be elsewhere. For this reason, many artists leave their roots and go to the city to get in on the action. There are many factors discussed in this book regarding this decision. One of the negative consequences of leaving could be that your work might suffer.

Walter Hopps has strong views about regionalism. He believes that your ties, your roots, are important. In his opinion, not going to New York, but staying where you grew up or where you were most influenced, might be the right thing to do. If your art is tied to your region, then think twice about chasing the rainbow when the rainbow just might come to you.

If you decide to stay, however, don't let the daily association with artists, galleries, museums and scholars who do not have the standards you would find in New York City, for example, hamper your own goals. Regional artists get too involved with small-town politics - trying to get a show in such and such a local gallery, and trying to get a regional curator to see their work for some group show. When you put it all in perspective, you might realize that most of it is unimportant. Set your sights high.

To sort out the numerous ideas offered in art, there is a trend by younger artists to have a strong association with a political view or a cultural base. There is a new appreciation for and a new emphasis by museums on art which represent views and cultures that have been suppressed by a mostly white, mostly male groups of gallery and museum directors and collectors. Currently, everywhere art is shown, there are themes of African-American art, feminist art, Hispanic art, Asian art, ghetto

art, rural and folk art, religious art, totalitarian government art, gay art, freedom art, and so forth. Then there are all the combinations. Sometimes it is difficult to look at the art without reading the pages of manifestos describing the ideas being expressed in the art. By establishing these links, many artists in recent years have been able to create far more opportunities for showing and exposing their art than before. However, no art will hold up in the long run if it has no substance.

Naim June Paik, Technology, 1994.29; photo: Smithsonian American Art Museum, Gift from the Vincent Melzac Collection

It is also very difficult for some artists, for example, who have cultural backgrounds other than white, Christian American. Do young artists representing minority groups create art that reflects their cultural heritage or, since they have access to the international art styles (including current art magazines), do they join the international art world for universal ideas and concepts? This is a very real dilemma that is felt by more and more artists, including artists from cultures who, until the advent of modern communication, would not have known current 'western' trends.

This is also very true for many American artists with strong family and cultural backgrounds. As a first-generation American, I didn't experience firsthand my father's and my mother's cultures, yet obviously they could have had some influence on me. Museum director Walter Hopps used to talk continuously about my Russian family background and my connection to the Russian constructionists. Could this be true, I kept asking myself? In reality, I knew no more about that movement than I did about any other that I had studied. Besides, all the artists in the family were on my mother's Danish side.

When you come across an artwork in a museum, should you be able to recognize that a work of art was made by a female? An African-American? A Hispanic? A white male? An American-born? A recent immigrant? A homosexual? A heterosexual? We are coming close to the point where someone will do a software program that will allow us to identify, by scanning the art, who did it and what association that artist has - something like identifying someone from a fingerprint. Does it matter even if the subject matter or concept has nothing to do with a distinct political view? This also comes up when you look at a work of art and then read the title and find more than one distinct view. For example, if an artist were to take a glass of water and enlarge it, you might think it has Pop Art connections. If the title indicates that it symbolizes all the tears for all the Jews killed during the

Holocaust, then you would probably feel something entirely different. If the title instead indicated it was to celebrate "racial purity and racial cleansing," you would have a different read on it. And then if the artist was lucky enough for a Senator to object to it and for it to be a media story - well, you'll see another artist who just won the lottery. Does the title change the substance of the work? Do we need to appreciate the artist's title in order to appreciate the work? Finally, is the manipulation of the title an essential ingredient at all? There are times when artists drift more into literary issues than is needed. This is not a total objection, however, since all the traditionally sectionalized departments in the arts can merge together. Nevertheless, the tendency to rely on text does indicate loose ends and areas where turbulence easily occurs, as Andres Serrano's "Piss Christ" easily demonstrates. If he had said that Christ was portrayed in "Holy Water," then there would not have been a national and political uproar (fueled, of course, by its being exhibited with the help of a National Endowment for the Arts grant).

Knowing your roots, staying true to your upbringing can be very important in art; at the same time, we live in an age, especially with frequent moves, where it's likely that one individual has multiple strong influences. I've always felt this when traveling, especially when boarding planes in a foreign airport. I've observed so many people whose nationality is easy to identify but who speak different languages and have passports from still other regions. This is becoming more and more common; this is our world in the future (subject to current attempts at purifying populations for religious and political motives).

There has been a soul-searching re-examination of art history to uncover all the art that was passed over because of a narrow, Anglo-Saxon westernized view of what was great versus what was just of archaeological and anthropological interest. While French Impressionists were inspired by African masks and Japanese compositions, African and Japanese art were never really

considered on a par with Western cultural products. The art history in the textbooks was derived from a limited number of jurors. Today, the view is much wider; the possible candidates are more numerous.

What can I say about all this? Only that you should stay true to yourself. If you really, really believe in an issue strongly, then pursue it. If, on the other hand, you are joining a movement, a cause, or even associating with a sex, culture or group because you think that this is your way to get recognized, then I can tell you that, in all probability, it won't be enough to hold up in the long run. I've seen so much art with a 'message' that has bored me to tears. This is similar to artists looking for a 'unique' style for the sake of claiming a territory, no matter whether the style is really a sincere evolution for the artist (a la Gene Davis' advice). Your passion and honesty is transferred to your art. If it's phony, that will be evident and noticed.

THE OLDER YOU GET

Almost all the artists I know love to add something to their resumes. The truth is, unless you are applying for a teaching position or a grant aimed at older artists, the opposite should be happening. Dealers and curators want to have new talent, the ones who will make their names - not the has-beens. Let's face it: "If you've been making art for ten years and you were that good, you would be known. If you're not known, it must only be because everyone has passed you up." And there is some truth to this, except that, as everyone knows, since only a few can be selected for stardom, many equally good artists are left behind. Then what happens to the very good artists left behind because they were not given the opportunities of important museum shows, were not invited by the big print houses to do important editions, or did not have the money from sales to finance the assistants and materials and space needed to produce ambitious work?

The equally good artists who have been passed over don't get equal opportunities and don't do the work that the artists achieving stardom do - and within a few years, a difference in quality begins to show.

Just as the gap between the rich and poor people in this country is widening, the same tendency occurs in the art world. The art stars will have more art produced, more major projects, more exhibitions, and a better overall quality to their art than the artists left behind.

That is what normally happens, but if you are the one left behind because you didn't win the lottery, you can and must intervene and change this fate. This pattern is probably the biggest reason that really good artists don't cross the line to become great artists.

As far as recognition goes, by middle age it really is too late to get that 'young new talent' tag. Access to galleries gets tougher, not easier, as your resumes slowly get longer, filled with unimportant group shows or one-person shows in secondary markets. I've often said that an older artist (and as in the days of the hippies when over 30 was old, certainly by the late 30s you're old) should hire a young actor to impersonate the artist, and the resume should be stripped down to shows of the past five years only. By the way, leave out the birth date. I'm really serious, if you want to concentrate on making it by way of the existing 'New York system.'

If anyone tries this, let me know how you do. By the way, it's a fun mental exercise to think about the type of person you would hire to be 'you.' Would it be someone of the opposite sex? A different cultural orientation? A better sales personality? Or someone with a better business tone?

A side note, if you are the type who likes those long resumes: don't lie. I once was active in doing a fundraiser for a small contemporary art museum, and I invited a lot

of local artists to do performances, sell small works in an auction, and to participate in other lively things during a one-day Saturday event. For years afterwards, I observed in various local artists' resumes, under group shows, the name of this museum. Wait a minute - they were not in a group show underwritten by the museum and its curatorial department; I simply was asking artist friends to get involved to support this struggling museum. I've been around long enough to observe this kind of thing in many resumes, some with downright lies. It's a small world; artificial inflation will come back to hurt you, plus, what does it really say about you as an artist? It's sad, and not the kind of attitude that will lead to great art, that's for sure.

GIVE A LITTLE, TOO

It's amazing, but rarely does an artist give a gallery dealer or museum curator a compliment. It seems that it's always give me, give me, show me. How about making a point, when you see a show you like or an installation you like, to verbally say so, or even to drop a note? You can say you are an artist and might have interest in talking to the dealer someday in the future, but right now you wanted to take the time to say that you appreciate the work, installation, and success of the show you just saw. Dealers are human too. They want to be successful, but they also appreciate compliments. In fact, when you consider the drudgery of running a gallery - from producing and sending out a thousand announcements each month, to dealing with the personalities and demands of the exhibiting artists, to dealing with collectors who think they are doing the dealer a favor buying a work of art, so the dealer should kiss their feet (they know they are half right, because almost all galleries are marginally staying alive and paying rent, utilities, labor, and insurance each month) just to keep the bathroom stocked with toilet paper. You can see that their lives may also be tough.

HOW MANY CAN SEE YOUR ART?

Another aspect of showing art is the human factor. You want your artist colleagues, your friends, your family, and anyone you look up to, to be able to see your artwork in the gallery. It's a time to show off and get your ego stroked a little. But for your career, in most cases, it really doesn't matter if a hundred or a thousand people see the show; it's who sees the show. If one curator walks in and sees it and likes it, then you may be offered something. If one critic walks in and writes a favorable review, it might help with sales and future shows.

I once needed a home for a wall relief I had completed on the floor which was 12 feet high by 35 feet wide. Since I didn't have a wall that wide, I had never seen it except from the top of a ladder looking at it from an angle. A theme show invitation came up at the National Air and Space Museum and I accepted, since they had a great 50-foot wall. The gallery is on the second floor toward one end of the museum. This is the most popular museum in the country, I believe, with more than seven million visitors each year. The painting was up for a year and a half. If just 10% of the visitors went into the gallery, then more than one million people saw my work. This is four times the annual number of visitors to the Corcoran Gallery, which is a nearby art museum (and a show at the Corcoran would only last about six weeks, so you would really have to count only people who view it during a show), and three times the annual visitors to the Hirshhorn Art Museum across the street. The problem was that the visitors to the Air and Space Museum were there to see airplanes and rockets, not art. I would have much preferred my art to have ben across the street, even if 1/100th the number of people would have seen it.

Eric Rudd, Terrestrian Scan, 1981-82, Acrylic enamel on polyurethane foam over wood, 11.5'h x 34.5'w x 5"d; installation view at the National Air and Space Museum, Smithsonian, Washington D.C.

Thinking about the small number of people who see your work can also depress you. If you are lucky and get a show at a good gallery, except for an opening party when one to three hundred people may cram in, you might only have a couple of dozen people per day, although more on Saturdays. If the show is up for three weeks, the total number of viewers might not be more than one or two thousand. Then the show is down. Compare this to having something in a magazine that has a circulation of millions, or in a movie. Artists feel this discrepancy and are heading to the Internet and other media to see if there are more effective ways to let the public see their work.

FLOATING FRIED EGGS

Artists need at least one person whom they respect to give them feedback. It doesn't help if it's a mother or a best friend. It means a lot if the person is a curator, for example, who will be honest. Walter Hopps was my

person. It didn't matter if I worked away in obscurity; if Walter thought my work was important, and I believed in what I did, then I didn't need to satisfy my ego further. It was a nice state to be in, although perhaps not commercially smart.

I remember being with Walter, who, you have to remember, had a reputation of being the most knowledgeable art person in the country; certainly, in Washington, D.C., he was the art guru. We were doing something together one evening in his office and Walter started looking at his watch. He had tentatively planned to try to get to the Potomac River and watch some artist who was going to launch giant fried eggs into the water around midnight. Finally, Walter said that he just couldn't go, he had too many others things to do. I don't remember why I was with him; it could have been a bit in regard to my art, but I am sure it was mostly just because of the stuff Walter was doing; we hung out together a little. I do remember thinking that Walter's work that evening was not as critical in schedule as it often was, and I think we even went for a bite together. I remember thinking that by Walter's not appearing, probably the entire event for that artist was less spectacular. Walter's appearance could have made that artist's day, if not year, and I remember thinking that we could have just picked up a carry-out sandwich and driven over there. But Walter was used to getting more invitations than he could possibly handle. He knew that every artist wanted his attendance, and that evening it was his call as to how he felt.

The point is, either you do what you believe in or not; if you are depending on a prominent curator to make it significant or relevant in art history, I think you are in trouble. Performance art does need an audience, but it also means more problems for you. The pressure on the performer depends not on the number of people in the audience, but on who they are. If the right person sees the performer, then he or she might be offered more roles. For a visual work of art that does not include performance,

there is always hope that it can be installed again someday in a place where the quality of audience will be better (as in MOMA versus your studio or a vacant garage where you invite your artist friends).

I remember that, when I first opened my Dark Ride Project, within the first six weeks I had (because I had invited them and they were going to be in Williamstown anyway) Tom Krens, director of the Guggenheim (he was blown away) and Glenn Lowry, director of MOMA (he was respectful; there's a reason why he spent five years at the Sackler Museum) among other prominent guests, riding on my Sensory Integrator and touring the entire exhibition. It was a pleasing situation, but realistically, I knew that these two individuals were not all of a sudden going to put me in a major museum show. The point is, if important curators see your work, great, but it's not the end of the world if it doesn't happen, nor is it the solution to your problems and assurance of success if it does happen.

EXHIBITING: MAKE IT LOOK LIKE A MILLION DOLLARS

When you have an exhibition, and hopefully it is at a respected gallery, your work should be shown to its best advantage.

HINT: Don't ever get so desperate that you show at a place with which you really don't want to be associated. There are a few exceptions: notably, showing at a gallery and then leaving the gallery; this way you are not locked into the idea that you are part of the stable; it's like making a special guest appearance. Otherwise, wait, wait, wait for the right opportunity. You can ruin your future chances if you are linked, for example, with a co-op type of gallery.

But when you do have a show, make sure you are smart about the installation. Who is going to do it - you, the gallery dealer, or an invited curator? This is a rare chance to show off your art. The opportunity should *never*

be used to show off quantity; rather, if you show only three works, you want them to look like priceless jewels or museum pieces.

I've been lucky; I've had one of the greatest museum curator/directors in the country curate most of my solo shows. It has been a real pleasure and honor to have Walter Hopps' help. In one case, Walter was in Houston when I was installing a show in Washington. While we talked on the phone, he suggested I get a blank piece of paper and pencil, and for the next half hour or so, he outlined where each work should be placed and how. When he arrived at the gallery the day of the opening, only a few minor (as in one or two inches) changes were made. I remember during the opening overhearing a museum curator raving about the installation.

There is a trend to leave a lot of blank wall space; generally, that's good. In one early show which I was installing (until Walter happened to walk by and stopped to give some advice), I had about a dozen works, and we had spent hours moving them around and seeing which ones to include and which ones not. Finally, the entire show came together; the decision was made to hang just one work on the largest wall in the gallery. It was dramatic and daring, especially because this was 1974, before the trend was common, but it made each artwork seem much more impressive and alive. The tendency to hang too much, to crowd, and generally not take the same time and care in hanging as in creating can be unfortunate.

There are new ways to hang. I was chastised by Walter once when I was having a small show of paper/foam small works (not rectangular at all) and I hung a few around the room. I thought the installation was okay. Walter came in and really laid into me because I didn't hang the works the way they had been hung in my studio - all over the wall in groups - like clouds. Instead I had more or less lined them up as though they were framed drawings.

143

Eric Rudd, Glass Ontogen Series, Installation view at the Diane Brown Gallery, 1981; Acrylic Enamel on Polyurethane Foam, Glass (Curated by Walter Hopps)

Another time, I volunteered my time to help hang a Stella show (around 1967) and I remember Walter's pointing out that a weaker painting should be placed on the strongest wall. There are no rules to follow, but experience and visual perception and a good eye will tell you what guidelines to follow and how to be innovative. In a way, I interned under Walter. Not many artists are good at making curatorial decisions. If you can't install your own art, find someone good who can.

The installation of your art can be critical to its concept. For example, you may decide in the studio that your work can only be seen in a square white box. This would require building a room inside a gallery or museum space. Not very easy, and certainly not a popular idea for a commercial gallery, where works are hung so that collectors can envision how nice they would look in their homes. But if this an important part of your concept, don't compromise. You might even achieve better recognition with this special installation associated with your work.

MAKING IT POPULAR

What to show is another interesting decision. What you hang up will identify you to the public. The trouble with our busy society today is that we like everything in sound bites. The public likes to know what an artist does in one sentence - Pollock splashed paint, de Kooning did distorted nudes, Kline did large black and white brush strokes, Lichtenstein did comic cartoon blowups, etc. Or, conceptually, there are Peter Halley's echo of technology, Don Judd's minimalist shapes, Jenny Holzer's 'truisms,' etc. If you show different things, you will mix up your buying public and make it more difficult for your dealer to explain in one sentence what you do. Of course, you only think about it if you really care about recognition; you think about it a lot less if you concentrate on making good art instead. But everyone who shows art will somehow have to deal with this problem.

Even the studio process is tied to gallery sales. Artists generally work in series, because the first work resulting from an idea will probably not be as good as the 20th or the 100th. At the same time, the 200th would probably be just another variation that could be done in the artist's sleep, so before that happens, the artist moves on. It used to be that a theme or a series would last for a year or two, about the space between shows at the same gallery, so that each new show would introduce the latest work from the artist. The latest exhibition, like seeing a new car style, would be exciting because curious viewers would see the change. This might be a natural process and a good way to keep the artist's work progressing, or it could instead be a coincidence that it introduces a new fashion trend every year.

The selection process for an exhibition necessitates a lot of excluding; probably several directions an artist explores in the studio are gallery-worthy, but only one can really be chosen to put on public display. It might be the more popular, the more colorful, and so on. Eliminating

145

many of the commercial influences might purify the studio process, because these styles and trends might not be the way the artist wants to develop naturally. It's hard to tell until you try working outside of the gallery system, but the sacrifice could hurt your public success.

I want to interrupt briefly to emphasize that artists need to be smart about what happens out there in the commercial world. Certainly, many artists go through their lives without this insight. I don't want to mislead anyone into thinking that this is what I want you to primarily worry about. It is a small but real aspect of life. It can be compared to an astronaut knowing how to dispose of his body wastes during a scientific space flight - it is vital because not knowing could be disastrous, but otherwise it is of little consequence. By understanding the gallery scene, hopefully artists will put it in perspective and be able to concentrate their resources on one main goal - to make art that will deserve to be in the history books.

SIMPLE AGREEMENTS

A gallery relationship is business, but it is usually personal as well. There are dozens of advice books on the market telling artists about every detail of a contract. My advice is much simpler. Many galleries don't have written contracts, and if you are just getting off the ground, that's just fine. If you are offered a contract, read it carefully. The main thing you want to know is for how long it is valid? Is it for as long as you show with the gallery or is it for a time period of one year, two years or more? Maybe a gallery is taking financial advantage of you, or maybe you will have a difficult time collecting your percentage of sales, but as long as, first, you don't need to make any financial contributions for showing, and second, it is for a term no longer than one year, you're safe. Then, even if you have a bad experience, you can move on in life.

ANOTHER WAY - IN JAPAN

If you show at a gallery in the United States where you have to pay for all the expenses, including invitations, reception costs, and in many cases, part or all of the staffing and utilities, the gallery is not considered ranking high in the art world. Basically, if you have the money, you can purchase a temporary, commercial gallery show. You can even give yourself a show, but so what? Below that are the artists' cooperatives, where the same thing really happens. Membership dues from the artists pay for general overhead. Again, conflicts of quality often relegate these galleries to unimportant status - although they fulfill the cravings of thousands of show-needy artists.

In Japan, the opposite is true. Rental galleries are the norm for developing artists. Not only that, but these shows are also expensive for the exhibiting artists, and can easily run from $6,000 to $10,000 per show. To make matters worse, the galleries are tiny and the shows are short, usually one or two weeks at most and often only three days. Still, there's activity and artists do it. What do artists do about the steep fees? They go out and get support. They get beer companies, office supply companies, banks, and other businesses to sponsor their shows. Sponsorships are included in the announcements and catalogs. When you think about it, this could be a good thing to do in the U.S.

STUDIO OPERATIONS

The artist can have space in a rich environment with materials, processes, and access to an active art commerce scene. But to make it all work, the artist actually needs to produce. This process is similar to any business that manufactures a product. This is the business of making art. Of course, how well the factory is managed and operated and how well the art is crafted have an important impact on how the ideas are realized. Most artists I know can dream great masterpieces; few can actually execute them.

ROMANTIC STUDIO

Ah, the romantic artist's studio. Not so, today. Let's take a quick look at what is really involved in running even a modest artist's studio. First of all, you have the physical plant, and this must be arranged to your specifications. You might need to install a work sink, exhaust fan, or better lighting. You might need tables and workbenches, hanging devices, shelves and closed storage units, stacks, equipment closets, and desks.

The operation of this studio is extensive. Activities will include creating new work and preparing finished work to leave the studio; this might mean framing, wrapping, photographing and doing associated paper work for studio files. Then there is the conservation of existing artwork, which for most artists can be considerable. In fact, I used to say that my large studio, after two decades of working, had more items than most medium-sized museums - yet I work alone or with an intern, while museums have a substantial staff to deal with administration, conservation and installation.

Small items also are made in the studio; this will include drawing, printmaking, making models and other types of small works. Some of these works may need extra concentration because they involve experimenting with

149

new concepts and directions.

Within the various operations, the artist will need quiet time to work, and time to do active creative work, non-creative but essential fabrication work, and future planning. Then there are the tasks of maintaining the physical plant and equipment, including repair work or preventive work on power saws, paint sprayers and compressors. Even hand tools need attention. (Brushes always need to be cleaned.) The fun continues with general cleaning and trash removal.

The office work is considerable, with bills to pay, hopefully invoices or receipts to write, supply order forms to complete, trade publications to read, employee payroll forms to process, accounting to be current and then taxes to pay, and legal issues involving items such as contracts, leases and corporate filings, and art releases for shows, not to mention lots of general correspondence. These are the same concerns that all small businesses complain about, and they are real.

Outside work continues with 'field' visits to suppliers, fabricators and printers, going to gallery and museum exhibitions, openings and art parties, and getting together with colleagues.

Then there are the special events that take up a lot of additional time. Hopefully, this will include dealing with a show, where all aspects already mentioned are intensified enormously; doing commissions, traveling, giving lectures, teaching, giving tours and demonstrations, and inviting possible dealers, collectors, curators, and friends into the studio.

Most artists are so inadequately staffed, it seems as if they were one-person bands playing ten instruments at once. How can one person learn to do so much? It sort of sneaks up on you gradually, but if you are really active as an artist, it won't be too many years before all of the activities mentioned above really are part of your everyday routine. The list of worries is so long that there is constant danger of eating away the concentration needed for your art.

KEEPING ABREAST

It's a big world, and many things happen each day. You need to process all this information quickly enough so it won't interfere with your studio work. I can do a day trip to New York galleries and see more than 70 of them, as well as take in one or two museums. I can subscribe to - or to save money I can go to the library and read - <u>Artforum</u>, <u>ARTnews</u>, <u>Art in America</u>, <u>New Art Examiner</u>, <u>Sculpture</u>, as well as half a dozen European magazines. I also try to see the <u>New York Times</u> reviews, as well as local papers that will also include wire services. I read or skim other publications that might or might not include articles about art. In the supermarket while you wait in line, you can look at <u>Vogue</u> and other fashion magazines that usually have art-based articles. <u>Time</u>, <u>Newsweek</u> and other publications are available in most waiting rooms. I read, and recommend highly, the conservative <u>Wall Street Journal</u>. You don't need to have stocks to keep up with big businesses. They are your future buyers, your supporters of materials and shows, and how they do will affect your markets and opportunities. When I went to GE Plastics, I had to recognize their goals and reason for existence. They ended up spending probably $50,000 on me (if you add up all the time people who helped me had to spend, the materials they gave me and the value of the time on the expensive machines during the several weeks I spent there), but my trips were scheduled so that interruptions to their operations were minimal. If you aren't cognizant of other people's needs, you really can't expect much in return.

Where I am in art can be judged by what I'm reading. After the art magazines, my magazine of choice used to be <u>RSI</u>. This stands for roofing, siding and insulation; it was invaluable when I first started using spray polyurethane foam in 1973. By 1987, when I began doing the large industrial polycarbonate blow-molding, <u>Plastics Technology</u> became my magazine of choice. Since

the early 1990s, my favorite has been Funworld, the main magazine for the theme park industry. It is put out by IAAPA (International Association of Amusement Parks and Attractions), and once a year they have a gigantic trade show. Not only is the show fun because, once you pay your admission (discounted if you're a member), you can access unlimited rides, including virtual reality, interactive games, simulation movies, laser tag, and so on, but you can also see many of the companies that specialize in making illusions. For a sculptor, it's invaluable. There are companies making animatronics and other robotic creatures, silicone molds and skins, paint companies specializing in computer murals, foam companies, light companies, and so forth. Attractions use fine art techniques extensively, and they also use techniques that artists will be using someday. This is only one place where you can shop around and pick up ideas. Finally, I can't emphasize enough the importance of the Internet for studio operations - from getting material information, sources, and processes, or contacting anyone within the international business community. Get a good laptop and make it functional for your operations.

The special-effects companies and the computer-generated graphics companies are doing imaginative things - as interesting as most art I see in the galleries. This is both a blessing and a curse. It used to be that everything visual except art was dull. But every television commercial, print ad, architectural design, CD cover, and so forth, is done with creative pizazz. I look through professional design and special-effects trade publications, and I keep thinking that if any of the pages were enlarged onto canvas and hung on museum walls, they would get my attention in a positive way. That is why artists need to rethink how they are working and where art is going. A personal view, perhaps, but the amount of arty stuff out there cannot be disputed.

Displays and virtual reality rides at the International Association of
Amusement Parks and Attractions trade show.

Just stepping away and thinking about the impact of technology is mind-boggling. Art used to have a reason - to illustrate biblical stories, or to enhance the prestige of a ruler. Since photography, those reasons have lessened, and artists have sought other reasons and explored the abstract world. About the time Frank Stella first showed his minimalist paintings, artists seriously debated the need for traditional art school training and the need of being good at 'drawing,' for example, in order to create great art. Now, with the ease of scanning and manipulating images by anyone with basic computer skills, as well as with the ease of creating credible visual images even with no art training, it will be interesting to see if future art trends will recognize new art forms requiring the skill of the individual artists, or instead, if the trends will embrace the new technology and create opportunities for a multitude of people who could never have become artists in the past. It might be that artists with sufficient computer skills but limited 'talent' will create great art for the museum walls of the future.

In any case, new technical processes and materials, which are impossible to know about in art school, have to be discovered and learned. Every time I have to go to a warehouse, manufacturer or trade store to get something, I always sniff around ·and try to see what

they carry or what they make. The days when sculptors used only plaster, clay or metal are over; the days of using only oil or latex on linen are over. I remember that, when Stella did his first works with metallic paints and later used honeycomb sheets, artists were in awe of their construction. That's because so little innovation gets into the gallery for quite a while. (Remember my words on the staple gun?)

Obviously, some of the new stuff can be expensive, but not always. I wanted to find out about silicones and pigments in order to create some sculptures that would move with robotic skeletons inside. There's a million-dollar 'skin market' out there that Dow Corning and GE Plastics are trying to monopolize. They want to sell their materials to companies who do those robotic dinosaurs at theme parks. Specialized paint companies sell their pigments to work with these new silicones, as well as with scores of new plastics. I made a couple of calls, not hiding the fact that I was a small operation. I got enough free samples to keep me busy for a year. For companies used to doing a billion dollars in annual business, sending $200 in samples is just a small marketing expense. For someone who only wanted small quantities of various colors, the samples were perfect.

The more you act like a business to the outside world - and they don't have to know that you are doing artwork - the more samples will be made available to you. Add 'Studios' after your name, and you could be a large movie fabrication concern just as easily as a solo struggling artist.

BECOME A BOSS

If you are very active producing art, you will need help. Labor is expensive. My advice is to get an intern. Set up your studio so that the intern can do everything you do - from making the art, handling and storing it,

cataloging, selling, dealing with galleries, etc. This will allow the intern to have a broad variety of experiences. Working for an artist will be more attractive than opting to intern in a small office of a large organization. Contact nearby colleges and put up notices. Even area high schools could be a source. It might surprise you how many people will respond.

Sometimes it is a time commitment on your part. I used to end up teaching an intern in exchange for his or her help. If the internship lasted a short time, I didn't come out very far ahead. However, in many cases after an internship lasted several months, I would hire the intern on a part-time basis. Then very little additional training needed to be done, and I'd had time to assess the quality and personality of the intern. In most cases, my interns stayed with me for more than a year.

Being civil and helpful goes a long way. I've known interns who have worked for some superstar artists. After the novelty of working for such prominent people wore off and the arrogant personalities appeared, the interns soon became disillusioned and quit. The status of the artist is not as important as the way the artist treats the intern.

Having a studio operation with one or two assistants not only seems professional, it actually helps with your operations and allows you to get more accomplished. For me, it also helps me focus on many boring details such as cleaning and covering artwork with protective wrapping. One intern, who liked to do detailed deskwork, took the initiative to organize all my slides. Over the years, when slides were taken and a few used for whatever purpose, all the rest would just be thrown into some sort of box. This intern took all the slides, arranged them chronologically in metal slide boxes, and marked each one. It was a job I never would have bothered with, but which proved helpful down the road. Since then, I've often thought doing messy art in a studio that is as well organized as a law office, for example, would be a great environment, if one could just make it happen with the

snap of one's finger.

Nevertheless, starting with free interns and then paying minimum wage for twenty hours per week becomes cost-effective. Most artists can not avoid paying to have some studio tasks done by others; there simply isn't enough time in the day. By saving money normally used for outside work (framing, photography, finishing, etc.), interns can he hired to do those tasks effectively in-house as well as taking on other responsibilities. An assistant is always helpful when working on large projects, even if only for those moments when four hands are needed.

THE WORK IS IN THE DETAILS

A word about craftsmanship. Often it's not there. Get ideas out quickly, if you need to, but when you are working on major pieces take the time to do it right. I used to tell people about painting in very elementary terms. If a painting is done in stages, starting with one - 1,2,3,4,5,6,7,8,9 and 10, I have observed that many artists do 1,2,5,9 and 10. They are in a hurry to finish. So by the time they do the tenth layer/process/section, it is very noticeable that several steps have been left out. Maybe there is bare canvas between brush strokes when it is obvious that the painting was not meant to be that way; maybe one material is going into another material in a sculpture, and the way it's inserted just looks sloppy. It can be any number of details, but it says to most curators and collectors that this work is not worthy of either the museum or the high price. Of course, as I say this, I am more than aware that not all art is supposed to have a finished look and the artist exposes the process on purpose. Chamberlain's welds are not supposed to be filed and sanded, but left rough; Stella leaves his edges exposed; and so forth. There is art that is supposed to be tacked loose to the wall and there is art that is supposed to be stretched and framed. But there are sloppy ways to do both and professional ways to do both.

156

All over the world, there are untold numbers of people making crafts. Craftspeople are into textiles, glassblowing, woodworking, ceramics - just to name a few. When I travel to foreign lands, I often feel guilty at watching someone weaving, for example, an incredible rug, when I know that he or she is only making about ten cents an hour, while we artists can knock something off in a few minutes and then have the gall to ask hundreds of dollars. Often craftspeople are overlooked, as we instead elevate an artist's painting to be valued at hundreds of thousands of dollars, compared to the few dollars for the craft product which might have taken more time (and might even be better). On the other hand, we can also find thousands of craftspeople who think they can elevate their products to status of 'art' but are not successful. Many of these products fill the hundreds of art galleries found mostly in tourist destinations. Most regrettable, however, are the artists who definitely have the 'artist's mind,' but fail at the discipline needed to bring enough quality craft into the art for the work to be successful.

SLIDES

Paper work and slides are common items to deal with in any studio operation. I've known dozens upon dozens of artists who get cheap when it comes to getting good studio space, get cheap about doing ambitious work requiring a lot of materials, but somehow spend a fortune having slides taken of their work. Learn to photograph your work yourself. Anyone can learn to set up on the same wall or floor area, where you are sure of the lighting effects.

HINT: My advice is to learn how to photograph your work yourself - like a professional.

Never hang art outside on a garage door. (I saw one slide where the peeling paint on the fence was more

interesting than the artwork being shown on the slide.) Have a black background or solid white, absolutely square, no light spots, etc. If it is for reproduction purposes, hang a color strip next to the artwork, so that when you get the transparency, the printer will know if the colors are off in the painting. If you can't do it, find a photographer who can, but this doesn't mean you need to waste money on a professional. Get a good photography student, and let that person teach you.

There are two ideas from Walter Hopps that go against most of the advice you will hear. One is to carry around three photographs, not slides, even though everyone thinks you need a book full of slides. How often does someone ask about your work and when? Most likely this will happen at a party or opening or casual meeting. Then how do you try explaining a creative visual thing? People can't see slides unless they have a projector or viewer. If people are curious about your work, pull your three 3"x5" photographs out of your pocket and show them. You can tell them that you have slides, but at least they will be able to see your work immediately. You don't want fewer photos or more. Three indicates that there is a body of work; more photos are too many for a casual peek. Of course, you will mention that there is more work to look at if they are interested.

It is different if you have a formal appointment and you know that slide viewers will be available. But even in galleries, the first thing that a dealer will do is hold up the sheet and look at the slides, as they are. On that scale, you can see why a photograph eight times the size of a slide might be better.

Another rule that most advisors give is to have the slide of your artwork taken with the best quality, with nothing else in the slide. But Walter suggests otherwise. If you're showing off a painting that is sixteen feet wide and seven feet high, a person or chair in the corner might help convey the scale. I would do this only one photo or one slide. All dealers and curators know what 16 feet means, but it doesn't hurt to remind them.

RESUMES

All you need is a professionally typed resume, nothing creative. The better your art, the less you need all the rest. A dealer will do it for you, anyway. My point is that, if the work isn't there, all the fluffing of resume, slides and business card isn't going to make your art better. It would be better to get your mind off this aspect and get it back to what you need to do to make great art. You may be able to fool some people some of the time, but you can never fool yourself. Anyone can start a company and make himself or herself president; few can make art that will stop people in their tracks.

TIME TO PROTECT

I am as guilty of this as anyone else. I know that if every piece of my art were being shipped out of the studio and heading for a gallery for a certain sale of many thousands of dollars, then I would have a full-time employee make sure the backs, sides, shipping crates, documentation, installation, and even the artwork finish or glaze coats had all been completed professionally. When I am so busy with life, and it seems like I never have enough time to spend creating, I get sloppy about finishing these non-art details. Some things don't even get plastic protection the way they should; years later, I live to regret it. It's hard to preach about things that I am guilty of myself, but this is not to say that I don't make attempts to improve. This is a very important thing. Occassionally, time available to do new work has to be sacrificed in order to spend time handling old work. It's just as necessary to do this in normal times as it is when you have to do so because of an upcoming exhibition. Packing, storing, cataloging, and all the processes that take time away from the studio work still have to be done. What is the good of continuously producing a large quantity of art if the works are going to be short-lived as a result of poor maintenance procedures?

STORAGE

If you were lucky enough to have a show, most likely only a few works sold. After the gallery took its 50% share, you might have had enough to pay for the expenses associated with making the art; most likely you received a four-paragraph review, had a fun opening, and three weeks later the remaining works came back to your studio. You won't be able to show these works again at your gallery, and you might not have other dealers handling your work in other cities. Meanwhile, new work gets made and your storage problems increase.

Even big-name artists rarely have all their work sold. (If you are lucky and have lots of sales, make sure that you keep some prime examples for yourself; you will be glad you did twenty years from now.) Most artists dedicate a large proportion of studio space for storage of artwork. Paintings can be compressed together in stacks. However, sculptures taken back to the studio after an exhibition, most likely will need to be broken down into smaller parts. As the years go by, these parts have a tendency to become separated and less noticed. Perhaps as a natural way of editing art, the works of many good artists simply get lost in the shuffle, similar to what happens with 'valuables' put into the attic for storage.

It's a sad state, but an artwork which was so highly prized on a gallery wall or pedestal or by an excited artist when it was first considered finished in the studio a few years ago might now have been forgotten and left to waste. If the art is very good and simply has not been recognized due to inadequate exposure, how much effort should an artist put into safeguarding this work for posterity?

In 1977 I created what I regard as one of my most important sculptures. It was called "Arachnid I, Section A and B" and it was made out of painted polyurethane foam sprayed over a metal armature. The work was so large that I constructed it to come apart into five sections. I exhibited the sculpture in a commercial gallery that was

geared for sculpture, but even this gallery could only show one part. When the work came back to my studio, I determined that I would protect it and store it. I put the sculpture into a room with only a few other small works, since it took up the vast majority of the space.

Eric Rudd, Arachnoid I, Section A, 1977, Acrylic on polyurethane foam over steel, 80"h x 228"w x 147" d

Because I was renting out other space to artists, I knew that I could have easily rented this room out for $100 per month (and perhaps a bit more). I ended up storing this sculpture in Washington until I transferred it to my mill in North Adams in 1990. At $100 per month times twelve months times the thirteen years I stored it, the work prevented me from earning $15,600 in rental income. That's quite an investment I had to make in order to preserve one of my own works. Obviously, I didn't feel it as much as if I had to write a check eachmonth for $100. Nevertheless, the economics are real; either you make a commitment or you don't.

Storage is a difficult problem for most artists. I know an artist who goes to various art colonies to make large sculptures which are then briefly exhibited, only to then be disposed of in the dumpster before he leaves because no one can handle the storage of his work.

In Japan, I was able to make a series of large sculptures which were exhibited. Two of the works were probably among the best I've ever made. It was prohibitively expensive to have the works shipped to the United States. Despite efforts to "give them away" and/or store them, I had to leave the country thinking that, in a short time, the sculptures would be thrown away or left without proper protection to rot away.

COLD STORAGE

Here's an idea for someone. For many years, I've talked about - and joked about – a 'dead artists' museum.' Basically, if you have really good work and you die, your heirs couldn't sell the art on the open market if their lives depended on it. So what do you want to happen with your art? Not only might it not be of much value, but because there will be costs just to handle it, advertise it and sell it, if it doesn't sell or can't be donated (museums are very selective about taking donations; if you have enough of a reputation for the museum to want your art, you probably don't have this problem) then the storing, cataloging, handling, and insuring of the work can be a considerable negative drain.

I've always thought some entrepreneurial people should buy a very large and very cheap mill in North Adams (or similar place) and use it as a combination storage facility, where all artworks are photographed and digitized, and gallery, where selections could be exhibited over the years, with someone there to promote and handle works even after an artist's death.

How would they get money for this operation? From the artists, who would have insurance policies with the proceeds going to this facility to handle their work in perpetuity (an artist could have more than one insurance policy and have enough insurance to take care of family needs as well). I know several older artists who might have the assets, since their children are middle-aged

themselves, to finance this even without insurance.

The attraction, of course, is that the hope of recognition can continue after they're dead. They would know that their work would still be around and protected, and images and actual works could be distributed and promoted so that someday the artists might be recognized. In a spooky way, it's like spending the money to freeze your remains so that someday - you hope - you might be thawed out and medical science will cure you and you will have a second life. In this case, the issues are a bit more real; you will leave a lot of art, which someone will have to deal with.

If you are a superstar, there is no problem except dealing with assets, because your work will be in sufficient demand. There are plenty of books and professionals who can tell you the best ways to set up living trusts and foundations and give other estate-planning tips, if you think you have this level of recognition and estate value. I recommend seeking this advice even if your art doesn't have the demand; but you will also need a different strategy if you are realistic about the future demand for your work. The idea of a dead artists' museum/storage/archival facility is a possibility, but it also brings to the surface issues that all artists need to think about as they drift into their middle age.

FREE GRANT APPLICATIONS

The other idea for the dead artists' museum is for the living - and the young. While your life insurance will protect your work upon your death, a membership would allow this facility to start doing an inventory of your work, while freeing up studio space for new projects. If a savvy organization got this started (I propose outside New York City, because the existing storage facilities in the city are frightfully expensive), what could happen is that, for a reasonable cost, you would have access to use the place for some storage of works. They would be digitally photographed, a computer printer would spit out a

programmed catalog with your resume, and all grant applications that you would be eligible for would automatically be filled out. Imagine not worrying about which grants you should apply for, as well as not spending all that time filling in application blanks. The whole frustrating process could be done for you and all you would do is sign the bottom, just as with a tax return prepared by an accountant. A proper software program could probably allow you to apply for dozens of grants and opportunities which you presently overlook. This facility, in my mind, would be a cross between a business, a not-for-profit, and an alternative space museum.

HINT: Until this happens, apply for all the grants you possibly can, and get the data on a computer so it's easier and faster to do each time.

WHERE IGNORANCE IS BLISS

While the National Endowment for the Arts no longer gives grants to individual artists, there are still state, city, and regional grants available, and many channeled through foundations. I wanted to go to Asia and thought it would be a whole lot better if someone else paid my way. I really worked on an application to the Japan Foundation, got three fabulous references (and made one easy for a very busy museum director, at his request, by writing it myself so that his secretary, when he approved it, would just copy it onto their stationery and send it) and it worked. I got three whole months, with my wife, in Japan - all expenses paid. Obviously, the more you apply for, the more of a chance you will have. You will also get better and faster at applying for things.

Sometimes being naive is a blessing. If a foreign artist were coming to the U.S. for the first time, traveling around and spending a great deal of time in New York, and this artist decided that he or she would find a place to produce large sculptures and then show them in New York

City, we would all say that the artist was crazy, and we would be right. One doesn't just have a show in New York City, right?

Well, for some reason I thought it would be nice if I could somehow do a few blow-molded sculptures and show them while I was in Japan. Japanese galleries are at least twice as difficult to access as are those in New York. But, when you're on a roll, you keep on going. In a sentence I will summarize a lot by saying that my sponsor, without my prior knowledge, happened to be connected to a plastics factory that did blow-molding. Although he had not met me previously, he happened to like my ideas, and by midway through our stay he offered to sponsor (and get other sponsors) for a show, and arranged for the factory to underwrite my making several sculptures and to give a lecture. I was prepared to talk about the U.S. and what was happening in North Adams (MASS MoCA and CAC especially), but he asked me if I would give my impressions of the Japanese art scene. Quite a big subject for someone who had only been in Japan a short time! Nevertheless, I made the sculptures, had the exhibition, gave the lecture (I couldn't fake it, because each sentence had to be translated) and left Japan after three months, fulfilled but exhausted - having also traveled from the very north to the very south and to more than fifty cities.

Hint: If you push in a good direction, good things will happen.

EAT, SLEEP, BUT MAKE ART

We all have to make a living, eat and sleep, get a few pleasures, and sometimes have some necessities - a car, medical insurance, and so forth. My father joked that it was just as easy to marry a rich girl as a poor girl. But many affluent artists have had to deal with the 'where would she/he be without the money' attitude. In any case, I didn't listen to my father, but my wife and I both worked.

A steady income is better than no income. Many artists teach. It's a natural way to make money; the schedule is not quite 9 to 5, and you get some perks and benefits, as well as being able to keep your mind on your art. However, being a good teacher is also exhausting, and it can wipe out your creativity. Part-time is probably best, but then you don't get the full benefits and income. Many artists do anything for basic income, from being movers to driving cabs. Even artists who are relatively successful in selling their art pay their dues. Preparing artwork for gallery shows, getting involved with installations and with major commissions, and dealing with building contractors, architects, designers, and insurance representatives can account for as much time and trouble as doing a non-related job.

At one point, you need to examine your entire life style. You would like to believe that you live in a place because it has more opportunities to make and promote your art. But if you think that means you need to be in New York City, you might also find that you are sacrificing too much of your time and energy (probably living an hour away) without getting the art benefits. Sometimes artists need extra income to keep pace with more expensive living areas.

Some artists get jobs being assistants to famous artists or at respected galleries, in hopes that the connection will lead to something. Any of this can be fine, and all of it can be frustrating. There is no absolute solution except to organize all aspects of your life; you may find that moving to another location that is cheaper would free up your time in a better way, and that contact with New York can be maintained through frequent visits. You might discover that to keep New York contacts and to keep knocking on the doors will undermine your work too much. You might have to give up the time you spend trying to get recognition in order to give yourself enough time to make great art. On the other hand, you may find the stimulation of New York necessary and helpful, and

that, because of the type of work you do naturally, you can attain adequate space. It's an individual choice with no one answer suited for everyone. Almost all artists complain about their situations, no matter what decisions they make.

BAD TEETH?

Making a living means not only seeking income, but also decreasing what you spend. Frank Stella has bad teeth; his college roommate, who became a dentist, became quite a collector, acquiring some Stellas in trade for his dental work. Ed Kienholz was a king at bartering, acquiring many props for his work. I once had thousands of dollars in credit at an upscale hair salon, because the owners happened to be collectors. We would send our children for $30 haircuts in credit, rather than spend $10 in cash at another barber shop.

Barter, all the time, for anything. You are not really cheapening your art; few will know the details, but it will save you hard cash that you need. After all, artists don't sell more than five percent of what they produce, so if you use one or two percent for bartering, it won't really make a dent in your stock, it won't affect your dealer (unless you use it to get around giving your dealer a cut) and it could make life a lot easier. Taxes are still owed based on the value of goods and services received through barter, but that's a small price to pay; besides, if you are really ambitious, you should not have to pay any taxes; you will have more write-offs than you can deal with.

THE BUSINESS OF PASSION

No matter the style, whether you're expressionistic, hardedge or conceptual, if you do not feel passion about your art, either you are in the wrong business or you are not doing what you really should be doing. If you feel passion for your work, it will show; it will be noticed by

167

others. Most importantly, it serves as your foundation for good artwork.

Your passion for your art should always come across, no matter what you are doing. I knew a passionate art dealer who would talk about her gallery and her mission in life at every chance meeting, even to the person next to her on a plane or train. You never know whom you are sitting next to. She made lots of new clients that way, and it wasn't artificial. People walking into her gallery got just as enthusiastic about the art as she was; an attitude like hers is very contagious.

If, as an artist, you have this passion, it will be picked up by people you meet. Maybe the person you're sitting next to is a vice president of a paint company who can send to you, on an 'experimental' basis, a couple of pallets (about 300 gallons) of paint.

The only word of caution is to display your passion, but don't be pushy. If the quality is not there, no amount of pushing your work on a collector, dealer, or curator will make any of them accept your art.

NEW ECONOMICS - IRRITABLE **R**EGULATORY **S**TUFF

I've spent considerable time trying to think whether new economic concepts could help me as an artist. For example, artists are not really thinking about making profits; they think about getting enough income from sales, work, family or luck, in order to finance more work. If an artist were to win the lottery, he or she wouldn't retire from work, as is the case of winners who have typical jobs; the artist would just have more resources to do more ambitious work. This is not to say that some material pleasures are not welcomed, but they are a very small part of your life.

Often do-good art groups ask tax lawyers to give talks to artists, but talks I've attended have been basic 'how to file your taxes and make your art expenses deductible' lectures. In no case did a speaker analyze the

life of being an artist and try to search for a different system. The tax structure is set up for people to make a profit, or to claim a loss. Idealistically, artists want income to carry out work, but not necessarily to make profits. The IRS used to make it even more difficult for artists by having a guideline that businesses should make a profit during two out of five years. Setting aside the 1% (and probably 0.1%) consisting of the big-name artists, what artist do you know who makes a profit? I haven't made a profit in thirty-five years of work, because the more income I get, the more I spend. One day, if I strike it rich, which is the equivalent of winning the lottery, the IRS will get its due. A parallel example would be a writer who spends years writing novels, and one day, finally, a book hits the bestseller list and Hollywood calls. That's when he/she ponies up. I've known many art stars, even some you'd think must be in artist heaven money-wise, who are actually struggling. After galleries take their 50% share, and after pretty hefty studio expenses (if you show steadily, you need plenty of assistants), there are a lot of artists out there who still don't do as well as one might expect.

JUNKETS

Obviously, artists should deduct all their expenses, including a lot of travel expenses. There are plenty of books to tell you how to do it. My advice is to be aggressive, but don't cheat. Business people who work for large companies fly first class, stay at first-class hotels, and generally don't scrimp when they are doing business. Artists will take the bus, stay in a Motel 6, and then feel guilty about deducting these expenses. I've known good female artists, renting studios with commercial leases, whose husbands don't use those expenses as deductions because their male tax accountants can't accept the idea that this isn't just a hobby for the spouse. All artists, whether filing as a single person or filing jointly, need at

least to fill out a Schedule C tax form, or better yet, form a separate corporate entity - regardless of art income. If you travel somewhere, then you should go to an art museum, talk to a gallery dealer, and bring along your sketchbook. It is now a business trip. Think about your art as if it is a business, and don't worry about the lack of sales. If you make the covers of the art magazines, Uncle Sam will be knocking on your door for his fair share.

AGGRESSIVELY LEGAL

In trying to be creative in this area, I started thinking about different systems. The artist is really like a not-for-profit organization whose purpose is to do creative things. All economically viable organizations have a paid staff. If a not-for-profit entity with your name on it raised funds to support all your studio projects and gave you a $100,000 salary in addition, I think you might be satisfied, especially if you had a long-term contract. Obviously, the same could be true if the entity were a corporation, which would allow you, tax-wise, more latitude for deductions (for example, medical insurance could be deducted). The problem, of course, is lack of income. If you had adequate sales, you could be lazy and just declare them on a Schedule C tax form. I wanted to think of alternatives.

My inquiries centered on whether another structure could aid an artist in getting that income. A not-for-profit would allow an artist to more readily call up companies and ask for donations. A corporate structure would allow deductions more easily and would, in some cases, make it easier to purchase broke paper, as an example. In either case, artists should always secure resale numbers so they don't have to pay taxes on their art supplies. In theory, tax is paid only once, usually when someone purchases your artwork.

Securing a commercial lease makes it clear that your studio is a business expense. A home studio presents difficulties and invites scrutiny if you declare it on your

taxes. These are just a few tips, which are pretty standard. But I thought of a variation that may help the artist who is fairly well connected, beginning to sell, and wants to break out of the pack. Just as entertainers are sometimes backed by investor groups, I proposed that a group of investors pre-purchase some of my work.

For the moment, change your mindset and make art into two things - either a commodity that may appreciate in the future, or a decoration for offices and homes. It is difficult enough to sell art, even with the excitement of an opening for an exhibition, the promotion by the dealer, good reviews by critics, and positive word of mouth from friends. The dealer is selling something absolutely useless. In the real world, forget about how art can be meaningful to your life; art is a luxury. In most cases, friends of the collector won't even recognize the value or status of the purchased artwork. Forget that the art is your creation for a while, and think about it as you might think about something as mundane as magazine subscriptions.

BUYING FUTURES

Taking all this into account, I proposed selling over $30,000 worth of my future work for less than $7,500, and this was without considering possible appreciation, in which case the purchase could be worth a lot more than $30,000. Thus I offered my art at a very steep discount. I spread the payments out over five years, and rather than organize this as an investor group, which would make it complex under SEC regulations, I organized it as a pre-sale. My purpose was to insure my income for the next ten years. I knew that I would produce far in excess of what I was selling, so giving up a portion of my artwork was of little consequence to me. I also knew that, if I could persuade 25 collectors to buy in, I would not only be able to fulfill my dreams, maintain my studio and get the annual economic pressure off my back, but I would also

achieve a better studio operation (slides and record-keeping would also help market my art to better galleries and museums) as well as have 25 cheerleaders (presumably all affluent business people who would have considerable influence) to push my career along. In preparation for this deal, I produced the following promotional letter and question/answer document to give to prospective collectors. This has been abbreviated, but it will give you an idea of how you can use it and customize it for your purposes.

(sample)

Dear Art Friend:

Being an artist is exciting, but it has demanded long hours and resourceful action. My past work is an indication of the many great works to be created in the years to come. I believe that my work will be in the forefront of modern art.

In the course of an art career, an artist must continue to pursue idealistic goals regardless of economic consequences. Nevertheless, up to the present, I have carved out a strong place in contemporary art. I am proud of what I have created and I know that this quality will continue.

I am now at the stage historically when my greatest work should be completed. I want to be certain that during the next ten years my work will continue to develop and be carried out without interruption. Rather than struggle month to month and therefore take time away from doing studio work, I've decided to spend some time now to sell my future work. I want to sell shares in my future art output in order to insure that my ambitious work continues. At the same time, I want to guarantee a generous return to anyone who wishes to participate. And so I am writing to all my friends, collectors, patrons, and everyone who has shown an interest in the development of my art in the past.

My idea is simple enough. I want to sell 100 units of my art for $1,500 per year, for five years. This will mean a total of $7,500 invested in my past, present and future work after five years. The funds from this sale will be used over ten years. Just think, for the next decade and my most productive period when I will be doing my most important work, I will have adequate funds to produce and to promote my art.

With these funds, my studio will also be more efficiently operated. Even the smaller chores of being an artist, such as framing drawings or building pedestals or photographing and cataloging the art, will be accomplished without interrupting the creative process, because they will no longer deprive me of the funds necessary to carry out creative work.

Now, the guarantee. With my track record of previous years, I can predict that my artwork will continue as abundantly in the future. Your investment in the purchase of this work will give you ownership in work that will be worth more than $30,000 today, and possibly a lot more with appreciation.

Although you may choose from my past works, after the first five years approximately 50% of my work will be distributed. The person who owns one investment unit will receive, for example, five framed drawings or paper works, one large sculpture or relief, two medium-sized sculptures or wall works, and a one-half interest in a major, even monumental-sized work. Your ownership rights will allow you the options to trade for only smaller works, to trade for only larger works, or to trade for any combination of works.

After the second five-year period (ten years from now), approximately 25% of my work will be distributed and you will receive additional works. Who knows, if I become better known, your investment may be worth $90,000 in ten years.

How will this be monitored? I intend to write an annual report with photographs of work created each year; what was

produced, what was exhibited, and other opportunities I've had. I will also share with you what I am trying to do and where I am heading. Part of the funds raised from this sale will be used to better catalog my work, and this result I can share with you.

Writers, golfers and musicians have all bankrolled themselves in various ways. Now I am trying to do it as a fine artist. The security you will have if you decide to participate - which others cannot offer in other fields or in other 'investment opportunities' - is that, no matter what happens, you end up with the art to enjoy. My art will continue to be promoted and my success will become your success, because the art which you have pre-purchased will be more valuable. It is impossible to list every detail, but I've enclosed some common questions and answers. Please send back the enclosed reply card. I hope you will join me in this artistic adventure.

Very truly yours,

Here is the other part of my package for potential investors:

Questions and Answers:

Q. I only like certain styles of art. I don't want to get stuck with art I don't like. How will you control this?

A. My art continues to change and evolve. Some artists, like Albers, developed artistically very slowly. Others, like Picasso, did many styles as well as a variety of sculptures, paintings, prints, drawings, ceramics and reliefs. I am closer to Picasso's way of working. You will be able to choose whatever type of art you wish.

Q. What happens if certain works are more valuable than others? I will want to choose what I like for my home or office, but I also want the best value.

174

A. All my work will be valued, as it always is before gallery shows, and the total value will be divided for distribution to each investor. So one investor might choose three framed paper works that will equal another investor's choice of one relief. Based on today's values and my present rate of production, I can guarantee that each investor will receive $20,000 worth of art after five years, and an additional $10,000 worth of art after the tenth year. Of course, the art could be worth a lot more by then.

Q. How will you determine how to use the money?

A. If all the units are sold, there will be a maximum of $75,000 to use during any one year. Approximately $50,000 will be used for studio expenses to make the artwork, and only $25,000 will be used for my salary. Present income from teaching and art sales will make up the difference. It is important that, although I might continue to teach part-time, I will not need to use additional time to earn income. If less money is used one year for art materials, then more money could be available the next year for more expensive works.

Q. Do you intend to sell any other work?

A. Yes! Sales will add value to our 'company' as well as to further my reputation, which in turn will add value to your art.

Q. Are you going to advertise this sale?

A. While there is nothing to hide, it will not be advertised. I will continue to sell art through galleries.

Q. So what happens if you sell all your art?

A. For artists, that does not happen. It would lovely if it did, and it would mean that my work had become very

valuable. If it did, then you would be asked if you would like less art for a cash profit return. My minimum guarantee of the work you would receive would not change.

Q. What do I do with the work if I don't have room for it in my home?

A. You don't have to take actual receipt of it after the fifth year. I will continue to be able to store it in my large studio (I presently have 14,000 square feet), or you can donate the art at present values and take a tax deduction. Additionally, think about all the places where you could use art - in your corporate offices, for gifts, and for your family.

Q. In the past, when I have purchased art, I have always had help. I don't know if I can handle this much art or be able to choose.

A. Remember, the funding I propose from this sale will enable me to have an extremely well run studio facility. I will also have assistants working part-time who can help with selection and installation. You will also have constant reports to keep you informed. You will not have to walk into the studio one day and make an instant decision.

Q. If I become an investor by buying your future work, should I help in other ways?

A. Yes, please! Remember, my success is also yours. I hope that many investor-collectors will take an interest in my career in many ways. I want to benefit from the many years of experience of everyone involved.

Q. If I need a yellow painting, will you make me one?

A. No. The unusual thing about this offering is that you will be funding someone to continue to work in art where the commercial pressures will be absent. But that is the only way great art is created!

Q. Can I pick out some work before the fifth year?

A. Yes. Not only that, but you can borrow work and live with it. This not only allows you to enjoy the art sooner, it saves studio space for me. It will also help you decide which works to choose.

Q. Can I visit your studio?

A. By all means! Being an artist can be a lonely experience. I like having visitors to the studio. Just don't expect me to dress up. And you can come now, if you wish, if you are not familiar with my work or if you need help with this decision. The studio is located -----.

Q. I am interested. What is the next step?

A. Return the reply card. If you are interested, please say so. If you are more than interested, mail your first year's check of $1,500 as a deposit. This money will be put into an escrow account and not be touched until all purchase documents have been signed and at least 50% of the art units have been sold. The check should be made out to Eric Rudd/ XXX Esq. The law firm will handle the escrow account.

Q. Who are the business professionals you will use? What if something happens to you during the ten years?

A. XXX law firm will do the legal work. XXX will do the

accounting. XXX insurance firm will handle the insurance on the art as well as on me. If anything should happen, all remaining money will be returned and the art will be distributed. As other people are added, including assistants, you will get to know everyone.

Q. Can I buy more than one art unit?

A. Of course. Actually, I would like people to purchase several units. This might work out especially well for companies that can use a lot of art for their offices.

Q. Why should I do this when there are so many other investment opportunities?

A. That is a good question. This is not strictly an investment. It is also not just buying some art. It is an unusual offering. Do it if you are curious as to whether this will help me create great art.

Q. I have other questions.

A. Call me. Tel. -----.

I was about to push this idea seriously after some initial interest - it only takes a few investors to get it going - when my entire life began to change drastically. With an upcoming major move resulting in less pressure, I no longer needed to do it, nor could I, since I would be moving away from Washington, D.C. Although I cannot, therefore, tell you if it would have worked, I think the concept is of value to think about and offers a new way to market your art. Perhaps you will be inspired and come up with a better variation of this plan.

MEANINGFUL PROJECTS POLITICAL WARFARE

There are times when an artist has to take a stand - to defend his or her art, to promote the art in a meaningful way, or to help the plight of fellow artists collectively. More interesting than actions taken as a defensive response are actions establishing new and alternative opportunities, which are in contrast to the existing art system.

One overriding concern that I have had is that, putting aside the success of a very few artists and putting aside the bad work of a lot of artists, many very good artists are locked out of the system, even though they contribute the most important ingredient - the art. They are locked out because the art establishment - society's answer to dealing with and preserving art - has established institutions which are often too strong for individual artists to influence. Art museums, both the physical plant and the operation, involve millions of dollars; art magazines are dependent on the advertising of the bigger galleries who can afford ten-thousand-dollar ads; museums get support as well as art donations from collectors who are willing to shell out big bucks for speculative art, and so forth. Working artists do not have any economic or political power, and because artists are so numerous, the system can handpick, as well as reject, anyone it wants. This system has historically trampled on various sects of artists - minorities, females, artists who work outside the norm, and so forth.

My message is simple - it doesn't have to be that way. There are better alternatives. Artists individually can lead different lives. Artists collectively can compete with these institutions, and artists can have more influence than you might first think.

179

BETTER THAN A GALLERY SHOW

I often ask artists about this hypothetical example. You have two offers. One is from a respectable gallery for an exhibition in two years. Think about the kind of artwork you would try to complete for inclusion in that show. The other offer comes from an alternative museum allowing you to do a complete project that will fill up a gigantic gallery space of several thousand square feet (or better yet, for the Projects Room at MOMA). Here is a sizable space suitable to carry out a special type of installation. The question is, which offer would you take if you could only select one? Which offer would give you a better opportunity to create 'great' art?

Most art pieces sold in the United States by art galleries can fit in the trunk of a car. Big-name galleries can carry large items by big-name artists, but that's not the case with the vast majority of dealers. Clients need practical sizes to go over couches in normal-sized homes and apartments. The work that you would do for a future show would tend to be more practical than the show you would do for a large installation where selling was completely eliminated from consideration. I venture to guess that most artists would accept the museum-type space for a special installation rather than the gallery show. If this is the case, and if this is an honest answer, why not do this kind of work now? Most artists today, almost without thinking, get on the track of doing work that is acceptable to their dealers. Just as there are no signs on the streets telling us not to walk outside in the nude, gallery directors don't have to tell artists what to paint or sculpt. The art market's practical needs, like the knowledge of society's rules, are still known and felt in the studio.

Great art need not be only the large works, of course, but it is easy to point out how some very great art might not have been created under commercial pressures. Picasso might have gone broke had he only painted

masterpieces the size of "Guernica," as too would Monet had he only painted the monumental "Water Lilies" series. On the other hand, these works were the pinnacles of their careers; and practical matters, such as only doing monumental work if there is a commission, should not determine whether a masterpiece gets realized or not.

Throughout this book, I have tried to point out two ways which you can choice. You can decide not to worry about the intricacies of life and business, work in your studio, and hope you get famous. You will have your share of business experiences, good and bad, but they will be insignificant compared to the great art you are creating. Or you can decide to work on your 'career' and do everything you can to improve your chances. There are lots and lots of books to give you specific advice on contracts with dealers, contracts for commissions, preparing for a show, invoices, tax tips, etc. Of course, even if you opt for making great art, there is still some thinking about becoming recognized.

I prefer to think about making the art. In all honesty, if you go this route, then you should just say the hell with all this advice about galleries and selling. You'll learn by the seat of your pants. Even if you know it all, you'll still run into new problems. (Top business executives spend considerable time with lawyers, not because they are bad at business, but because disagreements and lawsuits are the norm.) So who really cares about all the tips offered by art 'experts'? If you are good at making the scene, you might help yourself a little bit; if you're not using the tips and you are awkward in dealing with the business of art, then you might be in one less article or one less show, but that's all. *It really won't matter as long as people believe your art will make history.*

The better way to go is to decide ahead of time (and this is the tough part) that you might not be recognized as great, nor get famous, but that you believe that you are capable of making great art and you don't want anyone or anything to stop you from doing that. In which case,

giving you dozens of gallery tips is still a waste of time because it really won't make a difference.

Instead, what can make a difference is to absorb the ideas on setting up your life and studio to allow the process of creation and concentration to occur. This is the goal. Getting famous would be incredible, and as I've mentioned, so would winning the lottery. Attempt to become an honest and great artist. If I had a choice of being a famous artist but with second-rate art, or staying unknown with art that was first-rate, you know by this point what my philosophy would call for. (History, by the way, has forgotten about many second-rate artists who were famous in their day.)

Rather than wait for an invitation from the Museum of Modern Art, or an acceptable alternative, to go ahead with ambitious projects, artists can take the bull by the horns and make the situations happen. Sponsorship is great, but lacking it should not be a reason to delay carrying out projects of importance.

DON'T PUT OFF UNTIL TOMORROW

The other important statement I can make is that, after working professionally for thirty-five years, my only regret is that I did not complete artwork I ought to have done. Sometimes I convinced myself that I just didn't have the $300 for the extra materials, but in hindsight I could kick myself.

A few years ago, I completed my Dark Ride Project, a prototype of a new kind of exhibition space merging my art with new ways to view and access it. The project was originally intended to be a museum show, but even with Walter Hopps' support, no museum would take it sight unseen, and the budget to do it right was in the hundreds of thousands of dollars.

When first-floor space became vacant in my mill, I decided to go ahead and build the Dark Ride Project with

what resources I had. In this case, living in a small town had its advantages. I got cooperation from many sources, and one year later, the 15,000-square-foot exhibition/artwork opened to the public. However, my idea for the exhibition really was clear by 1977. I made a half-hearted effort to purchase the car and track system for a funhouse ride from a couple of bankrupt small theme parks, but nothing materialized and the project was not built.

The Dark Ride Project was somewhat more sophisticated when it opened nineteen years later. The ride on the computer-controlled, robotic Sensory Integrator is more of an artistic achievement than riding on an existing funhouse type of car, but the project would have been a whole lot more importantly historically, I believe, had I completed it in 1977 rather than 1996. Who knows what recognition I might have achieved back then? There were periods when I had other important works (and these were not vague ideas, but the next logical works to complete in a series) that were never completed, mostly because each time the work would have stretched my budget too much. It is impossible to explain, but there is no doubt in my mind that several 'great' works were never given the chance to be realized for very stupid reasons. Don't let that happen to you.

When I scan artwork being made today, those that impress me most have included large installation works that seem to have been created and exhibited outside the normal types of museum and gallery spaces. Why should artists undertake such large projects for a temporary existence? Why do it in a place where the usual art viewers would not see it? Whatever the reason, the results are ambitious, wild, and intriguing. Even though in almost every case they are sponsored by an institution, they have a hint in them of 'challenging the norm.' The irony is that this is the way art will develop more and more in the future, until it becomes the norm.

Did you ever have a desire to make outrageous artwork only to abandon the
project because it was not economically feasible?

These are not projects constructed in the
boondocks. In most cases they have been reviewed in
magazines, or I would never have known about them. In
fact, the artists were well connected in order for the
installations to have been photographed for the art
magazines. Nevertheless, large artworks installed in new
types of facilities encourage other artists to seek
alternative sponsors and places. There are a few artists
who come to mind, even though I don't know all their
works. I was impressed by David Mach, who piled
thousands upon thousands of magazines into
monumental sculptures. I've been impressed with Ann
Hamilton, who has done a number of installations
combined with performance, requiring extensive
assembling of materials. I've been impressed with Charles
Simonds, who builds dwellings and cities with miniature
bricks and installs them in quirky places, in the manner
wasps or hornets would attach their nests to the sides of
buildings or trees. I've been impressed with Tadashi
Kawamata, the Japanese sculptor who piles thousands of

sticks and beams to form beautiful but fragile structures, even though one of them was large enough to cover an entire skeleton building. I've admired these works and others not because they are anything like the work I do, but because they have been ambitious projects requiring a lot of time in unusual settings. While I will not judge them publicly, I can say that at the very least, they were ambitious attempts. Most of them were museum sponsored. Some projects have required months and years of private fundraising. If more artists want to do these kinds of major installations, it is obvious that the short exhibition slots in a limited number of galleries and museums cannot be adequate to fulfill their needs; more and newer types of alternative spaces need to be initiated by artists.

Hint: Don't be conservative, ever. In fact, your wildest and most complex ideas are probably your best ones. And thinking about them is not the same as creating them. An idea is rarely carried out to completion in its original form. Go after your ideas, even if they don't seem like real 'art,' and work seriously on them. You will be glad you did, although it might be years before you appreciate that fact.

A LIGHT PUZZLE

One day in 1978, Walter Hopps walked into my studio and asked if I wanted to be in a show in Paris. I didn't say no! I was working on tile relief paintings, somewhat similar to rough ceiling tiles that I painted with sprays from different directions. When you looked at the tile from one direction, you would see a color on one side of the bumps, but from the other direction, the bumps would change colors - something like viewing mountains from the air, where one side will be light and the other side will have shadow. I would assemble these tiles (the surface varied from my sprayed polyurethane foam) so

185

that, together, they reminded you of satellite photos of the earth, assembled from rectangular sheets of photographic data, only my terrains were more 'out of this world.' There was never just one view, because as you moved sideways, various tiles would begin to change as you changed your viewing angle. It was a very soft, organic and kinetic experience. I always thought of them as a high-tech, digitized version of Monet's "Water Lilies.

In addition to large and small works on a flat wall, I was working with tiles surrounding the viewer; the idea was to have a type of meditation room where you would walk in and be surrounded by my tile surface. This would include the floor, ceiling and the four walls. This is the work in which Walter became interested.

I had two problems: one was shipping it to Pairs and being able to assemble it at a practical cost. The other problem was the fact that if you walked inside this art cube and closed the door, it was pitch-black. My idea was that just a few people at a time should walk in (preferably donning special slippers so that I could keep the floor as part of the surface work), but how could I illuminate the room so they could view the subtle colors?

Hanging a light in the room blinded the viewer from seeing the surfaces. I tried separating the walls to let in light from the corners, but the light source created dark and light shadows that overcame the subtle colors sprayed onto the surface. I thought about a skylight, and about having the floor translucent to allow light coming from there. Each possible solution wouldn't quite work. If there was enough light to light up the room, it was too powerful to see the surface.

Puzzle: How can you have light in a room yet not see the light? (Think about it before reading more.)

One day, my wife and I were shopping with our young children when we happened to walk by the toy section of a department store. All of a sudden, I saw my

186

answer. I had observed a child's firefighter's hat with a blinking red light on top. If I could put a diffused light on the viewer's head, and he or she walked into the room, there would be light all around and the viewer wouldn't be able to see it because it would be on top of his or her head. Even the shadows wouldn't be there, because shadows would be straight down. Having the light on the head was the only place where I could have unlimited light and not see the source at all! It was brilliant, if I may say so myself. I practiced by buying lights that were used by miners and construction workers, and began a whole investigation on exploring art as though it were in a cave. This became the opening for a whole new concept.

Meanwhile, for the Paris show, I had it all figured out. One or two people at a time (they should be close together) would walk in and see the surfaces. I solved the transportation problem because, just as there are mechanical systems for suspended ceilings, I could use those same systems and simply have my foamed tiles attached. This would mean that an entire room could be put into boxes, sent to Paris, and in a matter of hours be assembled. It would all work out masterfully, except for one detail: the show got cancelled and never happened.

The most important point I can convey to you from this experience, unfortunately, is that while I know the work would have been a very important piece, perhaps even a masterpiece, I never finished it. I guess, since the show was off, I didn't have enough incentive to complete such a complicated work. This was a mistake that I can still kick myself for making. To repeat, I have very few regrets in my life as an artist except for the works I know I could have done but, for some stupid reason, didn't do. Although I completed several major works in the tile series, the 'room' would have been a milestone.

Hint: Never allow outside conditions to stop you from making your masterpieces.

MAKE THE MUSEUM CRY 'UNCLE'

Politics. It's all around us. It used to be with whom you slept to get a show. Connections, gossip, how it will 'play' to the masses, who will support it - this is very similar to a political campaign. If you think of it in that light, don't waste your time running for a local committee or a local council; run for mayor, senator or governor. Think about what it takes to do that, then compare it with the art world.

Of course there are those artists who are too idealistic to be part of the system. However, they can also be effective in changing the status quo. Let's say that you live near a major art museum and you don't feel it has been supportive of contemporary art, of regional artists and of your work. This is a very common situation. Now, think about who runs the museum, why they run it and with whose financial support they depend. You have the paid director, the curator, and the administrative staff. You have an affluent board of directors who volunteer and contribute heavily (board members are often told to 'give, get, or get out'), their time and money, because they are genuinely interested in the arts and because this activity is a good social status symbol. However, they do not want aggravation.

What can you do if friendly talks have not changed the attitudes of the people who run a museum? Protest. But protest visibly. Protest signs in front of a museum are not for good public-relations, but they make excellent materials for newspapers. Everyone likes a good spat, and it doesn't take much to start one. You can write to the board of directors directly, and you can make reasonable but strong demands. In short, you can quite easily bring an entire museum to its knees in little time, with support from local artists and with a reasonable complaint and effective media handling. I'm not suggesting you do this for fun; I'm suggesting that you don't always have to be locked out just because one director decides that a jewelry show will bring in more money and admissions than

supporting the local art scene. Major museums have a responsibility to support regional art, and they should be an integral part of the local scene. Most museums do care about the art activities in the area, but it is up to artists to keep the museums actively involved.

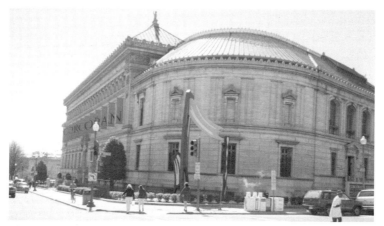

The Corcoran Gallery of Art, Washington D.C. has been subjected to many artists' protests over the years, in part due to its location and due to an active local art scene. On the other side, the museum's administrations have been pressured by politicians. The cancellation of the Robert Mapplethorpe exhibition, for example, brought the museum negative press from around the world.

Artists have been doing this effectively in other areas. Sexism has been brought to the surface, thanks to groups like the Guerrilla Girls and individual artists such as Judy Chicago, Sue Williams and others. Conditions inside the museums of this country are not dissimilar to those in corporations, and salary and benefit issues have also plagued museum management. Artists should take an active role in overseeing these institutions. Even alternative museums, which are traditionally associated with artists' causes, can be as abusive to artists and staff as the established museums. Whenever one director or small group has an agenda, it can cause the organization to disregard other people who have good intentions but whose ideas are not part of the program. Although I learned this the hard way, suffice it to say that every institution has its dark side.

189

POLITICS 101, OR WHY NOT HAVE AN ARTIST RUNNING THE SHOW?

I really believe that almost anything you do is art, so let me tell you about a 'failed' performance piece that I'm pretty proud of. Keep in mind that this took place about two years before MASS MoCA opened.

"The Best Mayor North Adams NEVER had," proclaimed a friend of mine as he was introducing me during a party. It was still more than a week before the election, and it was pretty obvious from the very beginning that I had no real chance of winning in the primary. So why would an intelligent and busy artist take time away from other affairs and spend his own capital in an admittedly fruitless endeavor to run for political office? In the name of ART!

The fall season brings a change of color on trees and cooler temperatures, while questions about 'responsibility' and 'direction' infiltrate barbershop conversations and newspaper editorials. Every two years in North Adams, there is a question of who, if anyone, will challenge Mayor John Barrett III's (now 14-year) hold on city power.

Absent a challenger, my name had been thrown out as a possibility two years earlier. Had I run that year, I would have been the only challenger and would have collected at least 40% or more of the vote; that is the number of people who always vote against the mayor. In any case, although I was appreciated as a volunteer for organizations, it was made pretty clear to me that, since I was not born in North Adams, I shouldn't upset the status quo. Besides, I was an artist.

But this time in 1997, with a strong organization, young Paul Babeu announced that he was running. I was annoyed about the fact that several potential candidates who could win more easily had once again thrown in their towels. So much talk at the lunch table about change, and so little action to back it up.

It's fair to state that, for the previous ten years, despite the promise of MASS MoCA, the downtown area continued to be more vacant then filled; school scores had declined; and jobs, population, and property values had fallen sharply. As a result, social problems - especially among the youth - had increased. Conditions called for dramatic goals and bold actions.

As an idealist, I've always been optimistic about what a small community could accomplish with 'creative' leadership. Nevertheless, I went to bed the night before the last day a candidate could turn in the necessary fifty signatures to run for office, assured that I would not dabble in politics. I woke up the next morning and said to myself, "Why not?"

I'm an artist. For decades, I'd spent the majority of my time creating art only because I believed in it. So why wouldn't running for office be just like performance art? (Certainly a tie and jacket, compared to my usual painting clothes, felt like a costume.) Plus, the thought of an artist being mayor, and automatically the head of the MASS MoCA commission, which then was totally a Guggenheim project, was intriguing. It is not often that an artist can be in such a position.

I arrived at the city clerk's office around 8:30 in the morning, and standing right there was a reporter. I wasn't even going to get my necessary signatures before giving the news media a new headline, "Artist Eric Rudd to Run for Mayor."

The gods were with me. I decided to go to the K-Mart parking lot to get signatures supporting my right to run. Unbeknownst to me, a truck driver had backed into an electrical box at the Wal-Mart and the store had closed for the day. (This later became a campaign issue, because the manager told the press that the store had lost $50,000 in sales in six hours; I don't think all the independent downtown stores can do that in one week, let alone six hours!) All the Wal-Mart shoppers were coming to K-Mart, so I had struck gold as far as finding people to ask. That

afternoon, I returned to the city clerk's office with 137 signatures. It was official!

How to begin? I had no organization, no group urging me as there had been two years earlier, no war chest of funds, no planned strategy, and no practical hopes of winning. What a nutty thing to do - but I was stuck!

In rapid succession, I decided upon and implemented my major campaign strategies. I got special rates for radio and print ads and I secured a vacant downtown window to decorate for free. I was not willing to spend a fortune. Economically, I considered this like making a large sculpture piece - so I needed to get the most mileage out of my spending.

Just one artifact from the artistically successful,
but politically failed mayoral campaign.

My modest-sized newspaper ads needed to get attention - and they did! One ad showed me standing outside Paul Babeu's headquarters and read, "Political Headquarters are One Use - But Not the Best Use- for

Downtown Store Fronts." An even more eye-catching ad, according to political pundits, was conceived when Paul happened to be standing inside his headquarters while I was being photographed outside. I waved him out and asked him to "take a chance" while promising not to embarrass him. He agreed, so we had our photo taken together - smiling. It later became a popular ad that declared, "I will work with everyone, even my opponents!" It was geared to contrast my style with the incumbent's. Other ads promised park benches, stores, jobs, and people on Main Street again.

Creating radio ads was another new experience. Three straightforward radio ads emphasized my business experience, because I wanted to contrast with Paul's youth and I wanted to make sure that 'artist' wasn't translated by the mayor as 'kook.' I wrote copy for three other ads mostly to get attention. One consisted of a dialog between a husband about to go shopping and his wife asking him to pick up a few things like stores on Main Street and higher SAT scores for the kids. He asks how he will know what to choose, and she replies, "Read the label! If it says Eric Rudd you know you're choosing the best!" Another ad got listeners' attention by announcing a special weather report for North Adams about a "positive front coming from the Beaver Mill" resulting in "a better crop of students and a growth of stores on Main Street." The third ad was a special sports report about a new winning team. It continued with "Enjoy shuttle service to the gate, better parking, park benches, and a more friendly attitude from the new coach in the corner office." To add realism, the last ad was read by the popular local sports announcer.

With help from a graphic designer friend, we quickly made up a cheap handout flyer and decorated my Main Street window with "Eric Rudd for Mayor" and a six-foot computer-enlarged photo of me.

The mayor then did me a favor. He had scheduled the second downtown sidewalk celebration to coincide with the campaign. A few thousand people came out - I could

never have hit so many people personally in such a short time. I wanted to have something eye-catching, such as an airplane skywriting, but unfortunately the plane with the smoke tanks was under repair. After brainstorming with friends, I decided to give away boxes of crayons with a label that stated, "Coloring a Brighter Future in North Adams - Eric Rudd, Mayor." Standing outside my political window, Barbara and I gave out almost 500 boxes to children, while parents received the flyer. I thought that was a positive way to do politics.

The best way to get the message out, on a very limited budget, was to try to use the 'free' press. John Barrett had basically used his kickoff speech to give his platform, and Paul Babeu came out with a 21-point booklet of issues. I wanted to get more substance out, so, over the course of five weeks, I faxed to the media a series of detailed proposals. Being realistic about my chances, I wasn't afraid to introduce daring - but not impossible - ideas. The ideas were creative, and all I had to do was give them out to a handful of news sources.

My series of press releases also covered youth issues, social problems, and ways I would restore a sense of civility and community. At the same time, The Advocate did a weekly series of candidate interviews, and a few letters to the editors spiced things up nicely. The strategy worked - I was constantly in the news.

I found out that public TV is watched! Early in the campaign, each candidate was asked to appear on a half-hour show called "Bone Soup." I always thought that if people could hear my ideas in full, instead of getting the condensed summaries in the news, they would like them. So we put a TV set in the Main Street window with a looped videotape of the show, and it played 24 hours a day. At the very least, the television entertained passengers standing at the bus stop located in front of the window.

Two debates were scheduled, after a media battle between Babeu and Barrett regarding dates - which I thought was a bit childish. Even though this was only for

the office of mayor in a small city in western Massachusetts, the first debate had all the trappings of a full-fledged presidential campaign. Standing in front of a room full of people (heavily stacked with Babeu supporters), the invited press questioners and moderator, lots of cameras, since it was being carried live on public-access television and covered by stations from Albany, and reporters and photographers from all local newspapers, I joked publicly that the last time I had debated was 35 years ago.

In sports I may not be great, but I have a lot more fun playing than watching. The debate was an intensely watched event, but participating in it was really fun!

How did I do? Friends said that I did the best; most said that I did fine and that I added a sense of humor, while at the same time pointing out serious issues and offering solutions. Certainly, it's difficult to summarize all that one wants to talk about in one- and two-minute responses. Of course I went away thinking "I should have mentioned...." Nevertheless, what an experience!

The radio debate was equally charged, with all candidates together in a tiny room. Personal affairs kept me busy as the primary election neared. I had to squeeze out last-minute ad copy, do more press releases, and give last-minute interviews.

Why did I start so many last-minute efforts - and incur last-minute expenses - when I knew I had no chance? Like the final seconds of a marathon, the excitement of a political finish encourages a burst of energy. Whether I would lose by thousands of votes or one vote, I wanted to end the campaign doing my best.

Finally, the morning of the election arrived. Barbara and I arrived a bit early, so we headed for the local cafe for a bite. The cafe was empty except for one person ordering a take-out coffee - Mayor John Barrett. I smiled and wished him the same luck he would wish upon me, and he mumbled brief pleasantries. Somehow I sensed that he wished he had never encouraged art and artists to

195

come to North Adams.

After filming Paul Babeu, Channel 13 did an on-camera sidewalk interview with me, then followed with camera running as Barbara and I walked across the street, went inside and then into the voting room, and kept filming as we voted. I felt like a 'star.' As it turned out, it was about 20 seconds of finished TV time.

Seeing all the campaign signs outside the voting places, I felt underpowered. I hadn't made signs, nor had I asked anyone to stand outside all day waving them. But, since I had braved other aspects of the campaign, I thought that I shouldn't now, near the very end, deprive myself of the full political experience. So we quickly went home and photocopied and put together three signs on poles.

During the day, Barbara, our son Nikolai and I took turns at various voting places, standing with our signs and making friends with others campaigners, no matter whose signs they were holding. I teased Paul because one of his supporters ended up holding both our signs. Another political first!

Rain held off for most of the day, the evening chill came, and the light faded as 7 p.m., poll closing time, finally arrived. We went home quickly, then we came back to the Ward One voting room to see the results in that ward. That's when reality returned! I had only garnered 30 votes, with the two others getting a few hundred. Not even 5%. My campaign had gone so well, I thought; how could so few votes have resulted?

The other wards repeated the first, and I ended up with only 117 votes. From a political point of view, a complete failure. Even an embarrassment, but I have a thick skin. It was a performance piece. I had not really expected to win, but, like believing you can win the lottery, I had dreamt upsets! I quickly reminded myself of my main purpose, which was to introduce a constructive, positive campaign about the issues and to offer creative, new solutions.

Paul Babeu won the primary. It was a narrow

margin, but a win nonetheless. John Barrett quickly said that he had never expected to come in first and so was pleased. (The two candidates with the most votes in the primary face each other in the election.) Well, that's politics. I went to Paul's celebration and made my concession speech.

Actually, I was very taken by the warm reception and spirited applause that Babeu supporters gave me. So many said they would gladly have voted for me if only Paul hadn't been running.

Alas, winning was not meant to be. Did I get my money's worth from a personal point of view? It was better than Disneyland, better than a eating at the best restaurant in the country, as good as finishing a good artwork, and an experience to smile about for years to come.

So why would an artist do something so crazy as run for Mayor of North Adams? As a professional politician, I'm a failure. You can't fudge the numbers. But as an artist, I think I did a credible, quality work of art; something I can be proud of. If the community gained because of the ideas discussed, then that was a bonus. The primary had the highest percentage of voters ever. Who knows, perhaps all the political artifacts from my campaign - the brochures, the original ads, the few quickly made signs to hold up outside of voting places - will be in a gallery someday. I can already visualize my political documentation exhibition.

Just a footnote: While the mayor narrowly lost the primary, he won the election by a swing of only 150 voters. Needless to say, challenging the mayor did not help our relationship, but we have since made up. Three years later, some artists came to the CAC on a grant to create art that would interact with the community. One artist, who coincidentally also had a major work on exhibit at MASS MoCA, wanted to run for mayor as his art piece. He was disappointed to discover it had already been done.

LOCAL ART

One conflict that museums have is, if they show local art, do they unintentionally make a distinction between important national art and local art? Ideally, you want a curator who will take up your cause and include you as part of the national art that the museum shows. In addition, if the show is generated by the museum, it should send your work out to other destinations. Another very important issue to think about if you do organize and try to influence museums, since in reality most art is not that good, is the fact that you can not expect a museum to accept local art if the quality is not there. You need to be objective when judging not only your own art, but also the art of your friends and colleagues, many whom you associate with because they have studios near you, have mutual friends or hang out with you. You need to pretend that you are the museum curator and your reputation as a curator is on the line. In that capacity, what would you want to show in your museum?

As for sleeping around to achieve fame, it won't really work. There will always be stories about people who made it and the affairs they had, but the stories are there because the art was good and the gallery was good, and human nature being what it is simply means that there will always be a proportion of people behaving in ways that will create gossip. However, first you have to be part of the scene; if you decide to concentrate only on your art, you won't be missing much.

Then there are pro-active individual projects undertaken without needing permission from the establishment. Artist Christopher Gillooly, for example, installed a large-scaled sculpture on a roof adjacent to an art museum, where viewers (with their paid tickets to the museum galleries) could gaze out a window and view his work.

Other strategies which are more complex but perhaps more beneficial include starting, with a group, a

new museum, an institute of contemporary art or an alternative space in your area. You will be surprised how money and support can come out of the woodwork if you put together a concrete proposal. Most deals work more easily when a property exists. People have little imagination, and it is easier if you can point to a building and say that this is the new museum of...(make up the name). Again, use of the media is vital to garner public support.

MUSEUM BABIES

Other tactics include establishing your own - individual - museum. Rather than making a work of art, which is sold and someday donated to a museum, all depending on the way the art gods shine on you, you can take the initiative yourself. In the past decade or so, many collectors have started their own museums. These have gotten the unfortunate name of 'vanity' museums, because often they are named after the collectors. This is a shame, because some collections should stay together. A collector with a good eye and feel might have a better sense of the relationship amongst the works than a curator who has to install randomly purchased selections. When a collection is sold off in parts, museums often pick up the one or two works which ought to be included. The result is a string of homogenized museums, each with one Stella, one Warhol, one Rauschenberg, one Nevelson, and so forth. They become rather boring. Private collections were actually the basis for most museums in this country. Some collections remained essentially intact as they became museums, including the Phillips Collection in Washington D.C., the Sterling and Francine Clark Art Institute in Williamstown, Massachuetts, the Barnes Collection in Philadelphia, and so forth.

The mission of this book is to give artists more control and freedom to make art as well as to have control over their art after it is made. If artists feel their art is

worthy, why allow it to be thrown away someday just because curators do not take steps to preserve it in the museums? Artists need to find ways to preserve their own work.

There are museums based on one individual collector's choices and there are museums showing the work of only one single artist, such as the museums for Warhol, Picasso, Rembrandt and Rodin. There ought to be more museums showing work by a single artist and they should be started by the artist himself or herself. Politically, artists can skip the middle people and go from the studio to semi-permanent display without playing the gallery and selling games. You would be surprised again at how the economics can work.

There are lots of free or next-to-free buildings around, in regions where the tourist market might be smallish, but at least it is a trapped market in the sense that there are fewer other attractions. You can look for all kinds of places. This endeavor encourages a new type of museum, not the stuffy traditional place you might be thinking about. I'm not suggesting that an artist start his or her own Metropolitan Museum or even one like the MOMA.

Artists make art today that go beyond the simple dimensions of a rectangular painting or a freestanding sculpture. The trend in contemporary art seems to be going in the direction of multi-media installations, where an entire room or outdoor area is included in the artwork. Even for artists accustomed to more traditional mediums, some combination of other materials and new exhibition approaches can be used to enhance the art shown. Assuming this trend continues, then a whole new breed of environments might have to be taken into consideration. As I stated elsewhere, it might begin with materials; the fine art store might be good for some drawing supplies and for hobbyists, but the wholesale supply stores for industry are really where the bulk of materials will be found. Exhibition-wise, it might not be as simple as transporting

a group of artworks and installing them inside a rigid space, as found in most museums. If complete transformation of the exhibition space is called for, then spaces that can accommodate this kind of restructuring need to be found.

If you are an artist with ambitious plans for large-scale artworks which you feel are important, what can you do if you need public space to show them? If you use your studio space to set up a work, what do you do with the work once it is completed? You can shop around for a university gallery or alternative museum space that will accept your work; most likely it will be a six-week-max opportunity a year or two hence. That might not suffice. You need to have your own space at your disposal when and how you want it. This, I predict, might be the alternative exhibition space trend of the next few decades.

Along with securing the space go the problems of security and staffing, overhead expenses including utilities, insurance and advertising (even if this means a sign over the door), as well as installation costs. But if your work is as ambitious and as personal and as urgent as I think it should be in order to justify vast resources, it is worth the extra energy it takes to make it happen. If enough artists do this and link up, now easily via the Internet, they can do joint media work and be a force to be reckoned with in the art world. Even if little more happens than completing a work of art which is more complex than traditional studio artwork, that is an accomplishment of which to be proud.

GUGGENHEIM ON THE MOVE

Tom Krens, director of the Guggenheim Museum, has spoken several times at the Contemporary Artists Center in North Adams, and has taken time to look carefully at the work of all the artists in residence at the time of his visits. He has talked a lot about his position and what he was trying to accomplish with MASS MoCA

and then with the Guggenheim Museum. One of his points was that, by having several museums around the world, he could not only make better use of the Guggenheim's collection and have it accessible to a greater audience, but also give curators choices in what type of museum space shows would be installed. Some shows might look better at the downtown Guggenheim SoHo rather than in the architecturally strong downward spiral of the uptown museum. Different envelopes for art could stimulate different curatorial decisions.

One of Thomas Krens' informal talks to artists at the
Contemporary Artists Center.

He also talked about the future of museums and the economic and social realities. The four main museums in New York bring in millions of dollars in revenues for the city from hundreds of thousands of tourists. Blockbuster shows and museum gift shops bring in museum income; outreach programs increase public appreciation. Most interesting, especially since he did not see my Dark Ride Project until after one of his talks, was his comparing museum operations to Disney theme parks.

Another interesting director, Dennis Barrie (who was arrested for having the Cincinnati Art Museum's show of Mapplethorpe's photographs) once said that after a first visit to Disney World with his family he almost got out of the museum business, because he thought Disney was

doing everything right in handling great numbers of visitors and help them understand their exhibits, and museums were doing everything to discourage the public from coming. (Eventually he did get out of the art museum business to direct the new Rock and Roll Museum in Cleveland.) This is not to say that art should come down to the levels of pop culture and Mickey Mouse, but that there are ways to educate, entertain, and enhance what is being shown.

In the theme park/destination industry, including new cityscape projects, it is understood that to attract visitors, there must be facilities in which to park, eat, and rest, and there must be a feeling that the environment is secure. Add ingredients such as shopping, activities for children, adequate restrooms, and easy navigational paths. Like large theme parks and 'mega' shopping centers, museums are applying similar methods to attract and entertain visitors while at the same time hopefully presenting worthwhile art.

I mention the efforts of museums because in artists' spaces, including new alternatives, these same concerns must be considered. In the museum world, some critics claim that museums have gone too far in their appeal to a wide audience at the sacrifice of artistic merit. Notwithstanding this argument, it is possible to make the educational components of exhibitions more interesting without lowering the standards of the art on display. Text on a wall may not be comprehended by an audience that has not had sufficient art history exposure.

A good segment of the population does not have the language, cultural or educational background, or even the physical stamina to take in a large Western art museum. If you are reading this, you are probably a product of Western art history training and young enough to walk through acres of gallery space. If you are comfortable in both the Metropolitan and the MOMA, then you are really the exception.

Of course, one school of thought believes that art is

only for educated people. There is another school comprised of artists who react to this by making art a populist endeavor. The truth probably is that both sides can be correct. If we become exclusive, we ignorantly exclude great art of Africa, China, and South America, for example, which has only recently begun to be appreciated. Art once exclusive to its immediate audience when created, with some effort can be enjoyed and appreciated by an expanded audience. At the same time, the idea that art is for the elite is really saying that the public needs some education about art in order to enjoy it and to appreciate it on a more advanced level.

In thinking about how the public enjoys art, I'm also nagged by the thought that if I've spent thirty years developing my art, why should anyone, even a museum curator, be able to look at one or two pieces and understand instantly what I'm doing. (Curators appear to understand, because they are instantly categorizing my art based on their store of information and therefore making assumptions that perhaps are not accurate.) For this reason, introducing a show to an audience can be crucial to its reception.

The more you think about these issues, which you will when you are exhibiting, the more you are entering the world of the curators. How much should the artist get involved with this, and how much should you just say, "Here is what I did; you deal with how it's presented in the museum/gallery"? The trouble with letting go of your art is that you need a curator whose standards equal yours, and that you have been offered such an ideal situation. I've been suggesting that the artist needs to be more pro-active not only in creating the art, but in showing it as well.

A WALK ON THE DARK SIDE

Back in 1977, after years of smaller experiments and plans, many of them not carried out (big mistake), I wanted to approach the exhibition of art through a totally

new concept - incorporating many of my ideas which closely paralleled the developments going on in the entertainment and amusement theme park industries. The leader of it all, of course, was Disney. So in 1977 I made a few attempts at purchasing the track and car system of a funhouse ride from some small amusement parks going out of business during a recession that year. My plan was to use the existing mechanical system, but instead of skeletons popping out at you the ride would go through my sculptural art environment. I also planned several walk-through exhibitions in the dark, with special slide-along rails to guide the viewer. The only problem was that I really didn't have - or so I thought at the time - the funds or the space to actually get the ride, transport it, set it up in a space, and complete the project.

Dark Ride Project's "Sensory Integrator" which carries viewers on a ten-minute ride through the art installation. Riders look through the viewing port while the robotic vehicle travels.

Thirteen years later when I came to North Adams, I was more determined than ever to build the ride and I started planning it in earnest. But to do it as an exhibition and to do it right, the budget grew and grew, and no museum, especially during a period of conservatism, would have been willing to sponsor it or to help raise necessary funds. I needed to find another way to complete the project. A large museum show, unless you are a superstar and the museum is assured of the public appeal, is practically impossible to pull off. So when ground-floor space became vacant in my mill, I decided to do the project myself, drastically reducing costs by being resourceful. Construction, with just a few interns, began for real in the summer of 1995. By the next summer, nineteen years after I first envisioned the project, my 15,000-square-foot futuristic exhibition called the Dark Ride Project was opened to the public.

The concept was to develop a work of art accessed by viewers only by taking an eleven-minute ride through 'creative space' in a robotic, computer-controlled vehicle called the Sensory Integrator. To complete the exhibition, I also became its curator. The exhibition was planned so that people walking in immediately find themselves in a dark cave-like environment, with monitors buried in the cave's wall. Exploring further, viewers come to a dark mini-theater to watch a graphically active introduction to the art concept, narrated by Walter Hopps.

Following the fifteen-minute introduction, which is signed for the hearing- impaired and translated in several languages, the viewers find themselves in the Gateway Station, a room where there are informational videos, a young people's introductory video with headphones (adults seem to love this segment as well), and the gateway station counter, where, since everything has been free up to this point, viewers buy a ticket to travel on the Sensory Integrator and/or to see the main environments/galleries. It's not cheap, but I priced it as I would price art; the idea is that I don't want to cheapen the experience, and I

needed to cover expenses. After purchasing a voyage pass for $10 to do everything, or $6 to do only the galleries (with discounts for children, seniors, and local residents), the next step is the walk alone, up a ramp, to board the menacing Sensory Integrator.

After the rider climbs aboard, the hood device automatically comes down over the rider's head, so that the only possible view is straight ahead through a rectangular viewing window. Then off he or she goes into the ride, and the fun part for other people watching is that the Sensory Integrator eventually comes back empty. The rider actually gets off in a different location to explore the galleries. Those afraid or claustrophobic can walk through other areas and join the riders, after their rides have ended, inside the galleries. The rider, in a sense, loses his or her perspective because of the forward and side turning of the Integrator, while at the same time some of the viewing area is also moving. The feeling, in an abstract way, is that of traveling into a creative space, then feeling as if you are landing somehow in another type of landscape. Near the end of the ride, the Integrator travels into a large, dark, cavernous chamber filled with sculptural forms, where one can barely make out the figures - some moving, some not.

During the ride, the viewer had no freedom over the viewing. At the end of the ride, after getting off and exiting down the ramp, the viewer becomes more aware then ever of the ability to control how to look, where to look and for how long. Independently walking around in the new space, the viewer sees that it somewhat resembles miniature airport landing strips. As viewers stroll along blue-lit pathways, lights come on and off, with sculptures instantly showing themselves, then disappearing. There are close views and there are areas where viewers can see sculptures in distant landscape-like scenes. One path takes the viewer into the Purity Vacuum, a white cave-like environment where humanoids float and blend into and out of the rough interior skin.

207

Continuing the walk finds the viewer exiting among exploratory sketches, then at an information station showing how sculptures were created, and finally going to the last gallery, a more traditional gallery in the sense that there are white walls - but still with a sense of a path, which continues the sense of a voyage. The viewer then discovers that he or she is back at the Gateway Station, where a video catalog can be purchased, the logbook can be signed, and the informational monitors as well as the Walter Hopps introduction video can be watched again.

As you can gather, it's quite a large project. Either it's a big ego project, or I've finally been able to control how I want my art to be shown and how I want the public to be introduced to the ideas that I've spent thirty years developing. As a work in progress, it has many possibilities for expansion. Now my studio work can be tested out, at my leisure, without being subject to the sometimes arbitrary and often demeaning whims of a curator. Of course, it would be nice if the show would be 'booked' or replicated elsewhere, but I'm pleased I was able to get it off the ground on my own.

As the Dark Ride Project presently exists, it makes a huge political statement. If I can attract sufficient numbers of viewers willing to pay the admission price, then I've essentially eliminated the need to sell my work, which I at times have found humiliating. Now, I'm really 'renting' the work, and by paying the admission the viewer is able to view it for that rental time period.

In the Dark Ride Project introduction, Walter Hopps talks about the first American museum, started by Charles Wilson Peale, who collected and showed not only his art, but also many types of curiosities. He opened the Charles Wilson Peale Cabinet of Curiosities, which became a full-fledged museum; today we know it as the Pennsylvania Academy of Fine Arts. In his day the major fine artists, such as Peale or Frederick Church, would paint their masterpieces and the work would go on a national tour. People would pay their admission and go behind the red velvet curtains to see the hyped-up

masterpiece, whether it showed Niagara Falls, the Grand Canyon, or the Amazon Jungle. In a sense, I am returning to this tradition but with a different twist.

Interns helping to construct the "Purity Vacuum" environment in the Dark Ride Project, 1995.

Economically, if I can attract twenty viewers a day, five days a week, at $10, that is $1,000 per week. If only ten people come per day, that's still $500 a week, $2,000 per month; an ample amount to cover labor and utilities. I predict that not only can and will more artists do this, but galleries will follow suit. Additional venues can be established by artists or galleries in partnerships with companies operating restaurants, concert halls, and tourist venues.

EATING WITH ART

One of the most satisfying 'installations' I've ever had took place in 1981 when I was having a show. Since my dealer had a secondary space in my studio building, we decided to have an after-opening party. The hors d'oeuvres were served in her SoHo-type gallery space upstairs, and then guests were invited downstairs into my studio for a sit-down buffet dinner. I had cleaned out the

main studio space, installed for the first time one of my largest sculptures (of which only one half had ever been exhibited, in 1977, since the gallery didn't have room for both parts) and hung two objects on the wall. Scattered around the thirty-foot work were eight or nine round tables, to accommodate about 90 people. It was smashing success. Ever since then, I've thought that a restaurant with large sculptures would be a perfect environment. Obviously, restaurants are known for showing art on walls, but usually as decoration; I would design the restaurant to fit into the gallery installation, not the other way around. My design would incorporate different levels, sculpted terrain and walls, and large sculptures on rotating bases. From the restaurant tables, diners would be able to view some works close up and others from a distance. (There could also be mini-stages/platforms where performance art and changing exhibitions would be accommodated.) Rather than people getting tired feet and backs when visiting art museums, they could sit and leisurely enjoy the art over a meal.

The point is, there will be other kinds of venues for artists. Art should not look like an afterthought. I can't stand it when retail operations 'allow' artists to hang their work 'for free.' There is no compensation for all the artists who seem too desperate to exhibit, and who accept any type of public wall space. I'm proposing a serious installation and a partnership between artist and sponsor. I also think that, if art were presented in a livelier manner, the public would begin to appreciate it more.

I'd rather throw a football than watch someone else do it on TV. However, when watching the TV news, I've viewed the sports portion with interest. The reason is that many sports anchors make the sports news fun to watch. It's lively, and they emphasize this. Art is rarely reviewed on television, with a few PBS/cable broadcast exceptions. I would love to go on TV weekly and do a group of reviews. Taking cues from sports stations and even the movie reviewers, I know it could be presented to a lay

audience so that they would enjoy it, and more importantly, they would feel like going to see the art for themselves. It really goes back to putting the passion into the art or perhaps even into the debate about the art.

A minority opinion: Although I have strong feelings that the National Endowment for the Arts should be much expanded, at the same time I'm not horrified by Senator Jesse Helms and his supporters. It is far better to have public debate than back-room decisions. The education of the public has been helped, not hurt, by these conservative politicians. As more art comes into the mainstream through new venues, a better educated public will overwhelm the minority of people who have strict, narrow ideas about what art encompasses and about the long-term benefits of free expression.

My dream for small North Adams is that it becomes one of the contemporary art capitals of the world. And it can happen quite easily. If a dozen or more artists, for example, would come to North Adams and have their own spaces, then this place - where the international art press comes because of MASS MoCA (partnered with the Guggenheim and affiliated with art museums close by) - would have not only a very lively art scene, but possibly an historically important one. Imagine one community with twenty-five art museums - all accessible. What Siena became in Italy, a small but important place not far from Florence, North Adams could be to New York City.

We were once the only Westerners in a faraway Japanese spa resort. For an extra fee, we got a wooden medallion to wear (with the traditional robes and wooden sandals) and went from one bath to another within the village, to as many as we wanted to try, all different but beautifully landscaped, in perhaps thirty inns. Since we don't have the natural hot springs in North Adams, I'm suggesting we make it art museums.

The Dark Ride Project is, I hope, breaking some

211

ground in terms of what is possible for other artists. It might be larger than many artists can deal with, but size is not the reason for its distinction. And if you think this was a big undertaking, an unexpected and unusual offshoot of the Dark Ride Project came about to give me the opportunity of a lifetime. I will describe this most unusual (don't peek) project in the last chapter, but I want to mention it because if you live right and push yourself beyond normal expectations, all kinds of good things, even without superstardom, will happen. I also want to mention this last, because it further documents the political and practical points I've made up to now - that there are new frontiers, and artists do not have to limit their goals, works, or dreams to anyone else's narrow expectations.

CORPORATE PARTNERS

Art has never been a pure process. Sponsorship - as well as a lot of artistic control - was given by the church, by royal families, by the rich, and by special collectors. Museums cannot make artistic decisions without fully realizing the economic and public relations impact a show will have. Everywhere we turn we see performers and athletes endorsing commercial products. On one hand, it contaminates the professions. On the other hand, advertising income allows a profession to thrive as well as to be appreciated by a large audience. To many minds, there is little difference between selling commercials on television and doing fundraisers to support programming. The difference is supposed to be that commercial television broadcasts the programs for general entertainment and without significant artistic value, while public television presents more artistic or educational programs. With cable access, the distinction has lessened, and specialized stations are programming history, music, food, travel, and other subjects, and finding plenty of sponsors. The debate about whether or how much impact sponsorship has is just

that, a debate. The question at hand for you, as a working artist who wants to get somewhere, is whether you can find the support to carry out the work you want to do - without compromising your art.

Now one quick word about compromising - all artists compromise. We compromise because we can't always economically carry out our dreams, so we settle for what we can create. We compromise when we know the dimensions of the gallery we are about to show in. Too often I've observed paintings that fit gallery walls so precisely that it is apparent the artist custom made the art for the wall. We might even compromise if we know that the dealer has a better time selling specific colors, styles or types of our art.

Is it compromsing our noble pursuits if we make a painting that precisely fits a large gallery or museum wall? It can be thought of as an opportunity to realize something big, or it can be thought of negatively as a slippery path to becoming a decorator or fabricator to fulfil assignments.

USE SOME PUBLIC TASTE

Rarely do we have easy fights about artisitc standards. During one of my early shows, I wanted a dark, almost black painting to be hung all by itself in the small room at the back of the gallery - like a somber meditation room a la the Rothko Chapel in Houston (except it had not been built yet). My dealer wanted two colorful paintings to be hung there. It was one of the few strained moments; I won, and the dark painting hung. She was right; it didn't sell (although it did find its way into a museum collection a few years later). But there was a difference between the dealer's needs and my feelings of wanting a 'pure' installation.

Few dealers will say, "I want five yellow paintings and two red ones and no blue ones." But in selecting the works to be hung and a dealer thinks color will sell, the dark ones may be relegated to the gallery storage room.

Public art is much the same. You might have models of twenty good, large-scale sculptures which you would like to get built. A commission comes along for a sculpture in front of a public library, and as you survey your twenty models, perhaps only two or three are appropriate. Is it censorship or compromise if you choose those three and leave out the seventeen that might be controversial in one way or another and therefore inappropriate for the type of audience which will be exposed to your work? Works inside an art museum, perhaps with a sign outside stating that the works might have mature content, are fine. But to put an erect penis on public display outside on Main Street, U.S.A., not only is not appropriate today, but the ensuing arguments have been played out before.

This brings me to make a point about the National Endowment for the Arts, which has come under a lot of criticism and has defensively reacted by eliminating grants to individual artists. Do artists really expect to do challenging art and simultaneously be sanctioned and funded by the United States government and taxpayers? Obviously, it has become a game trying to push the issue and achieve similar fame as came to Serrano and Mapplethorpe. It's too bad, though, because there are lots of ways that the NEA could help individual artists without getting into the battle lines.

We've had a long history of fighting the censors, but let's keep moving and not repeat the obvious. Art must never be censored while it is being made. Art should never be censored when shown in a museum. However, that doesn't mean that curators don't have their work cut out to educate viewers before they are confronted with the art. For example, the Hirshhorn Art Museum (part of the Smithsonian) exhibited an artist's work showing an African-American lynching of the early 1900s. Some viewers reacted because they thought the artist was celebrating lynching, so additional explanations had to be posted. Would we consider it important art if the artist had an immoral view of the subject matter? Should a museum show it?

214

Some restrictions might apply to art in public space. That's not to say that Serra's huge metal commission resembling a curved wall, pulled down because office workers and judges in the government building thought it was ugly, deserved to be removed. The only real issue has to do with children and whether it's appropriate to push mature ideas (sex, violence) onto minors. But people who commission art for private property have the right to choose art that they want.

It seems pretty obvious that if a sculptor has ten sculptural models in his studio, for example, each of the proposed sculptures might be appropriate for different sites, depending on content as well as cost, size, weather, color, maintenance and how well they fit aesthetically within the proposed setting.

Artists need to pick their battles. Exhibiting in a public library in a small town is not the same as putting a work in front of the Museum of Modern Art in New York City, or even on its gallery wall or in its sculpture garden. A sculpture appropriate for one place just might not be appropriate for another. If we can separate the real issues and the real fights needing to be fought, and then see if there is room for partnerships, many resources can suddenly become available to the artist. They can include not only monetary support, but also exhibition support and material or fabrication support. It is usually not a question of maintaining one's standards and not buckling under pressure; it most likely is about making logical choices about what art to present.

Too bad the NEA couldn't substitute for the terminated individual grant program an equivalent program geared toward purchasing existing works from individual artists for exhibition in government office buildings (as part of the GSA's Art in Architecture and Art in Public Places, or part of the Percent for Art Program where a percentage of the cost of all new federal buildings has to go for art and design related elements).

This does not end the morality and censorship

debate. It goes on and on. The truth behind the ethical issues that make the news is usually far away from the real debate. I, unfortunately, got too involved with the controversy that almost sank the Corcoran Gallery when it refused the Mapplethorpe exhibition that had, after a court fight and an arrest, actually gone smoothly enough in Cincinnati once it opened. The real truth was that the Corcoran's director, her husband and another associate were very conservative people with strong ties to the Jesse Helms' faction in congress. She decided, based on the recommendations from these politicians who really didn't know many details, to cancel the show. The uproar that followed was heard, in a negative way for the museum, around the world. Everything that happened after that was just spin control and media control. Knowing the details, I saw how the issues outlined in the news were never the whole story. It had more to do with the conservative right controlling art than with any of the explanations put out by the public relations department of the museum. There are fights worth fighting, and this was one of them.

Keep in mind that not all political art duels are based on principles. The Brooklyn Museum of Art's decision to exhibit the British "Sensation" show was a deliberate act designed to invite controversy and thus get free publicity as well as more visitors into the museum. The New York mayor's charge against the 'immoral' exhibition was an equally deliberate response staged to generate votes for his upcoming senatorial campaign. Both sides were using the media, and the real issues got buried in the frenzy.

History has recorded stories such as these for almost as long as art has been made. Every ten to twenty years, they seem to flare up more than usual. Some artists have really been at risk, havng endured police raids and jail time. Now, the threat is a lot less; the radical artists are not really risking all that much. In this country, being courageous as an artist can rarely be compared to risking

your life. There really is no censorship during the creation process, because the days of police breaking down your door are over. But when you are considering how your art will be seen by the public, the issue of censorship will work its way into the process.

The late Don Thalacker, who headed the first GSA program of art in public places and wrote a book about the program, used to tell me all kinds of frightening stories. I only had a few experiences with public art, but in each case I felt hatred and threat from some quarters.

I constructed one of my first large outdoor sculptures for a commercial gallery-sponsored group show, which happened to occupy space adjacent to the National Portrait Gallery. Unbeknownst to me, the director of that museum hated contemporary sculpture. While some of my large sculptures had been vandalized when I had them outdoors for a while in the suburbs, this piece was set outside in downtown Washington near lots of rough 'street people.' Despite this, it did not receive a single scratch. In fact, during the daytime, an enterprising photographer set up his camera and took people's pictures standing in front of this 'attraction.' When my piece couldn't be removed as early as we first thought, I learned that this director ordered the government to remove it from his sight and transport it to another plaza. It's interesting what can be done with taxpayers' money. Then a few weeks later it was suddenly moved again, back to my studio, with moving equipment I never could have afforded to use. It seemed that the director, fearing this would happen again, had assembled agency heads and made himself final arbiter of all public sculptures that could be placed within a ten-block radius of his museum. This happened to cover the most important downtown real estate in Washington D.C. Not a whole lot of tolerance was shown by some people.

Eric Rudd, Stanley, Rick, Harry & Tonto, 1979, Acrylic enamel on polyurethane foam over steel, painted steel, plexiglass, 12'h x 14'w x 10'h.

Another time, I was invited as one of four area artists to participate in an international exhibition in Washington during the International Sculpture Conference of 1980. We were escorted around town (even though I knew the city well) to select a site, and I chose a corner of the new, ugly, FBI building on Pennsylvania Avenue. California sculptor Guy Dill chose the other corner. The conference had to go through dozens of government agencies before it was decided that the location was out of the question. Again, contemporary art put fear into some. With an alternative site, I ended up inside the largest interior space in Washington, in the Pension Building. Sculptor Alice Aycock was opposite me. I built a twenty-foot cubed framework and hung a hundred giant flake shapes made out of foam. The piece was a pavilion and viewers could walk inside it. Now it seems to me that we have thousands of ugly things in this world that get no

Eric Rudd, Pavilion, 1980, Acrylic enamel on polyurethane foam over paper, painted steel, 20' x' 20' x 20,' Installation at the International Sculpture Conference, Washington D.C.

mention and stir up little feeling in people, but when it comes to public sculpture, well, that's fair game for unrelenting criticism. At the end of the exhibition, when I was taking it down, a woman - not knowing I was the artist, but thinking I was just a workman helping to disassemble the piece - came up to me and said how glad she was it was going because she couldn't stand looking at it any longer.

My favorite story - and education is the key - is about a serious, but at the same time a fun sculpture, done in North Adams for the sake of the community to introduce the idea of art in the cityscape. It consisted of thirty thousand pounds of crushed metal blocks, stacked up with a platform built around them, and an odd-shaped part of the last outdoor movie screen in North Adams (which had recently been demolished to make way for a Wal-Mart). The idea was to show how beautiful crushed

219

metal could be - just as nice as marble or fine hardwood in sculptures - and how it could be used in a beautiful way even though it was regarded as junk. The scrap metal also brought into the work some issues regarding the recycling of materials. At night, I projected slides from across the street onto the screens. The slide images had a lot to do with the materials and their life cycles. So there were a lot of things going on, but for the community, it really became an 'is it art or is it trash issue.

Eric Rudd, installing 30,000 lbs. of compressed metal for Old Sheet, 1993; Contemporary Artists Center, North Adams, MA

One day, a friend was getting his hair cut in a local barbershop, and the barber, not knowing that his customer knew me, mentioned the "pile of junk they call art" up on the parking lot across from the art center. My friend mentioned that it was a sculpture piece, and they started discussing it. My friend asked the barber if he ever had to deal with people's hair in a very strange way, and the man got carried away with describing all kinds of crazy hairdos. He then admitted that he could see some beauty in them, although to most people they were just strange. They talked more about the issues of aesthetics and what could be considered art, and finally my friend remarked, "Did you ever think I would be getting my hair cut in a local barber shop in North Adams and, instead of talking about sports or politics, we would be talking about the

aesthetics of art?" As you can see, it's a question of education and it comes slowly but steadily, if you take the time to present it and then be patient in withstanding the initial reactions.

EXCURSIONS

I don't want to harp on the virtue of living in a smaller community where errands take a few minutes rather than hours, but it is true. I wrote a play a few years ago. Even with this book, the time I spend writing is limited, but it had occurred to me years ago that seeing my fast processes in making art, especially spray polyurethane foam where figures can be made in minutes, can be as interesting as viewing the final product. To structure this as a performance piece, I ended up writing a play where the art is created on a traditional stage. In a big metropolitan city, I daresay that the competition is so great that my play would have remained in a desk drawer. But in North Adams, with a small theater on Main Street, I was able to get it performed. If you have ever been involved with theater, you know the energy level of working with cast, director, lighting, audio, and stage crew. The production may be small, with a smaller audience (we did it as a staged reading for just two nights, but sold out), but the experience is one to cherished. My play might not have been 'great theater,' but it has stimulated many new ideas for my sculptures.

A current project is also one that began years ago, but with little progress as it competed for my time. With a new sense of conviction, I completed an epic with more than one hundred and fifty life-sized - although quite abstract - figures. Where else but in a small community could one find the space to install it? The church that I talked about earlier has become the setting for this installation where I can develop it as I see fit.

There are opportunities for growth and for personal projects that might cause you to venture outside your normal routines and processes. Julian Schnabel is directing films and has written books. I know visual artists who play in bands, act, write poetry, and do collaborations with dance companies. These creative acts may not compete equally with their 'main' art, but it all

223

becomes part of their art experience. The busier one is, the fewer excursions into new areas will be taken. The more crowded the community, the more competition. But excursions into related areas just might become the experiences needed to stimulate the main art. The experience just might be the catalyst for making great art.

CONTEMPORARY ARTISTS CENTER

Places do exist where artists can go to recharge, to think, to meet a new circle of artists, to meet curators and gallery/museum directors, to make art, and even to do all this in pleasant surroundings. Some of these places are very difficult to get into and not worthwhile, and others are easy to get into but still simply not worthwhile. Artists sometimes feel that they are alone without support, even when doing important work. I wanted a place where serious, ambitious artists could meet, talk with and do things with other ambitious artists. If the New York scene was coming apart because of a distressed gallery market and because economics forced artists to find scattered lofts, I thought it possible to create a meaningful substitute. I have observed personally and it has been shown historically that when artists gravitate to each other, important art events transpire. That was the initial impulse around the formation of the Contemporary Artists Center. We also had the reality of having a lot of extra space that was perfect for making art. In one sense, we were right smack in the midst of a lot of important art institutions, but the other feeling, especially because I was moving here from Washington, D.C., was that we were moving to the boondocks. We thought it would be nice to have stimulating conversation - at least for a part of the year - and this could be accomplished by establishing an artists' facility.

While it would be great to have an endowment from a rich patron and invite all artists to come for free, in reality that seldom happens. If it did, we would have so

Activities at the Contemporary Artists Center. (top to bottom) Studio residencies (pictured: Spanish artist Rosa Vazquez talking to dealer Renato Danese), discussions with museum and gallery directors and curators (pictured: Jenny Holzer), exhibitions in five galleries, and 'Monster Press,' printmaking on a 5 x 10 foot bed using 800,000 lbs. of pressure. Photographs courtesy of the Contemporary Artists Center.

many applications that it would be necessary to judge (i.e. recognize) each applicant from slides and resumes, and the problems of the New York system would follow. Now, at least, it is relatively easy to be accepted, and we try to keep costs very low. There is, of course, a range in the artistic abilities of the artists as well as in their approaches and styles, but by and large all the artists who come for studio residencies are serious about their work.

We also seek grants so some artists can come for free. Often these artists work on special projects and their results are exhibited.

The CAC has five galleries that are visited by some very interesting curators and gallery and museum directors, many of whom we invite to talk and meet the artists one-on-one. The center also has artists' discussions, collaborates in more complex projects, and has developed some very interesting studio equipment. For example, unless you are a superstar, you are excluded from the few print houses in the country that have large-scale presses. We built in-house one of the largest art printing presses in the world. Printmakers are used to creating prints measured in inches, not feet. Our press allows artists to make prints on a bed measuring five by ten feet. To a printmaker accustomed to traditional equipment, that's like a painter painting a football field.

The center also is cognizant of its relationship to the town and region, and it offers some workshops, classes, and community art events. We especially encourage a dialog between the artists and area residents and businesses. One annual show we produce takes over the entire downtown area, and artists fill all the vacant store windows with installations. More than a thousand people come out for an evening sidewalk opening each summer to take advantage of the art installations as well as performances, music, and other kinds of interactive art,

Three years ago, I added my own "community sculpture" to this downtown exhibition and created a street beach party where 80,000 pounds of donated sand

is piled up, curb to curb, along the length of a downtown street. Hundreds of children and adults come to form their 'wild' sand creations, just two blocks away from MASS MoCA, a museum that many of these same beach participants avoid because they don't understand the art there. Ironic, isn't it? (By the way, the city picks up the sand and keeps it for winter street sanding.) My "Beach Party" sculpture is now considered an annual event of its own.

However, the emphasis for the Contemporary Artists Center is to be an R&D center, a la GE Plastics, but for artists. Individually, artists utilize space, processes, and materials for experimentation and creation of new work. We are generally very pro-active for artists. Collectively, we discuss and then try to act out ideas that will change the system and will result in artists being more in control of their future. The center has been flourishing since 1990, although always with a slim budget. Nevertheless, it is an example of a place where professional artists can come, produce, discuss, meet important people and get new contacts, without feeling that they are back at school or in a place for less serious artists. I wanted it to be an extension of their own studios; a place that they can contribute to as well as receive from. This kind of interaction can be a very positive experience.

I cannot overemphasize this point: the Contemporary Artists Center is a resource for artists, not an institution where artists either accept and abide by its rules or are excluded. Artists can come to the CAC and change its character, use it to support new projects, and generally mold it just as a lump of clay can become art. Although I've stepped aside as director, the CAC's programs continue. There may be other places like this; as you scout, just make sure that you, the artist, can make a difference.

AN OUT-OF-THE-WORLD EXPERIENCE

I want to finish by telling you of a new project that I am doing, and this follows a few of my other experiences that were briefly alluded to earlier. I think you will agree that it is a startling opportunity: in a sense, like winning one of the lotteries. If so, I also want you to understand that I sincerely know that this opportunity would not have been offered, had I not lived my life as an artist with the idealistic determination that I've tried to convey to you in this book.

Depending on when you are reading this, I've either succeeded, failed, or am still at work on it - but at the time I write this, whether it ever gets realized or not, I know that at least I came very close. I hope to be the first artist in the world to launch an artwork into outer space!

An out-of-the-world experience!

Imagine a rocket that launches into orbit a large artwork: a sculpture in space that has no military, no communication, no scientific purpose for being there, other than to allow humankind's emotional expressions to have a presence outside of the earth's gravitational pull, and at the same time be globally accessible to everyone.

Why put art into space?

Space is the ultimate art gallery, even the ultimate studio. For thirty years, I've actively dealt with the contrasting influences that architecture, weight and gravity have on artwork. Paintings hang on walls with a definite up and down; sculptures have bases, or they are composed to rest on the ground with some aesthetic dignity; sculptures made of metal and bronze have an authority just due to their materials, before even the form or meaning of the work is absorbed; large public art is spirited by its relationship to the size of a building, a

228

nearby wall or bench, and the viewer. How do we measure something in space? What do we measure it against? Do we see a viewer? Can we tell that a sculpture is ten feet or ten thousand feet wide? The closest reference would be the earth, and that could make the sculpture seem thousands of miles large, or as tiny as a grain of sand.

Who will see a work of art in space? Obviously, it is a select audience of astronauts who might venture close enough; yet, by photo documentation, the world can experience the work. In fact, depending on where it is, access by way of digital viewing is available to people all over the globe. A website would make the experience free for all.

For years, artists have admired the shapes and surfaces of space equipment. The lunar lander is a sculptural work that could be publicly displayed in its own right, without ever having needed to land on the moon. In this case, form does indeed follow function, and the function is so new that it creates new designs. Yet at what point do we add an aesthetic influence? I proposed a satellite that could maintain all its functions but be of an interesting design. I still like that idea. When the opportunity became available to launch my own satellite-artwork, not physically connected in any way to something else or someone else's project, then the idea of form took a role identical to my studio work, where I can decide on shape, color, material, and so forth, to compose and construct the sculpture based only on what I want to see.

All art has limitations, if we want to call them that. We can also call them opportunities. For example, plywood is readily available in four by eight-foot sheets. One could say that not having it in thirty-foot sheets is a limitation, or, on the contrary, just by having it in an affordable and manageable size, sculptors have more opportunities than their predecessors, who were more limited by the lumber available. Almost all of my artworks can either fit through a door, some only through very large doors, or they are fabricated in sections; they need to fit

229

onto moving trucks, they need to be structurally strong enough so that large sculptures do not fall down and hurt someone; if hung, they need places to attach to walls; outdoor pieces have to withstand the elements and people; and all of the works, even when I use very specialized or industrial materials such as rigid spray polyurethane foam or blow-molded polycarbonates, are composed of materials and are made with equipment developed in an industrialized world. This is the palette offered to me; even when I invent new applications, they are within practical, human limits. Space offers me a new frontier, and a new set of standards unlike those I face in the studio.

For this first work, there are limitations. As it is my 'Top Secret' project, I can't reveal the specs, but as you think about the complexities of transporting a large work of art into space, you will realize that a lot of technology comes into play. In that environment, I need to make sure that no pieces break loose (a paint chip or a bolt at 25,000 miles per hour can cause damage), and that it can withstand temperatures from 400 degrees above to 200 degrees below zero. But just think of all the limitations I don't face - such as placement to ground, perception of weight, perception of scale, etc.

Do I want to be the first in space? Who wouldn't? I always venture down my own path in art, and I want to face new challenges. Limitations to be overcome are not new to me.

In Jules Verne's <u>From the Earth to the Moon</u>, the spacecraft was comfortable inside, much like a formal room in a house of that day. It had molding, wooden rails, carpeting, furniture, and so forth. It may even have had a drawing or chart in a traditional frame on the wall. Since then, designs of space vehicles and space paraphernalia, have 'modernized' the look and emphasized the function - but have not been designed for aesthetic enjoyment. My work addresses very fundamental questions: the meaning of art removed from the topography of our normal life (which has led to some exploration already – for example,

art made for an urban placement compared to art made for a desert).

Do we need art in space? Up to now, space ventures have been temporary, with the voyager traveling back to earth and normal surroundings. With the planned space station, humans will be away from earth for extended periods. Projecting a hundred years from now, could we have some people who might spend the majority of their time away from earth? Do we leave behind not only some pleasures of earthly life, but also many of the aspects that make life more meaningful?

Another element to consider for my space sculpture is the political and social meaning of doing a public artwork outside of earth. It brings into focus a host of new ideas concerning specific influences - Western thought about art, compared to Asian thought, compared to African thought, etc. - about how all these cultures interreact with each other, and whether there are now universal considerations that go beyond any specific terrritorial culture. In other words, rather than having a Western influence, for example, can a universal influence someday become the dominent force? While I personally don't believe that alien space travelers will swoop down and view the art (although I do believe that life of some sort exists on other planets) it does point art in a new direction.

I've often admired the variety of shapes and colors of space. Especially with theories of the big bang, which now may be more complex than first envisioned, do we really know why there are so many varieties of planets, stars, and space rubble? Many of these ideas have inspired my forms hanging in black spaces in my studio. I've always thought of them as additional heavenly bodies- shapes that belong more in outer space than in the white rectangular space of an art museum. Now they may actually be in space!

The Dark Ride Project deals with the time and opportunity to view the art. In the Sensory Integrator, this view is controlled by the artist. A space sculpture becomes

a natural extension of these ideas - and the viewers on the earth will be able to see it only by a narrow - photographic-view. Yet it invites everyone to someday come out to space and participate. Someday, new generations of humans may go to space as readily as they now board an airplane, and the cultural world will have yet another face to it.

How does one artist get this opportunity, when so many want it and others have tried? I sincerely believe that if I constantly push in an interesting direction, good things will eventually happen. In some ways this is a continuation of the Dark Ride Project, but it also came about because I had the ability to have an open agenda when an opportunity arose.

There have been a couple of small artworks and plaques that have gone up and down with the space shuttle or on Apollo trips. But no one has launched an artwork into space. How could they? To do so would be a million-dollar venture; perhaps only the artist Christo could finance that kind of endeavor. There have been many artists working on sky art and space art projects - mostly through models and conceptual proposals. Unbeknownst to most, it turned out that there was a way to do it within a very reasonable budget - similar to the window of opportunity I was able to get at GE Plastics. I can't tell you the specifics until it happens, but so far it's been quite a ride. Just as I mentioned earlier that national and international events can affect one artist's exhibition chances, so, too, this project is subject to delays and cancellations due to outside forces. We'll see within the next few years.

I highly recommend that artists respectfully but continuously educate others and communicate with people who are employed by the industries of the world. Who knows the opportunities that only need you to make them happen?

CONCLUSION

My space project forces me to examine the big picture - about my art, about the purpose of art, and about what I really want to do with my talent, ambition, and curiosity. As one examines life on this scale, the detailed complexities of the existing art world system start to unravel and become less dominating.

What is this book for? We all know that, through luck and skill, a few artists will win the lottery and become famous in their lifetimes, and even in their prime. We also know that just about everyone else is relegated to struggle and be left just a few crumbs of success. I could have filled up these pages with more details - the ABCs of how to deal with a gallery, how to file your taxes, how to do various art techniques, how to frame, how to photograph and present your art, and so forth. Those ideas will only help you, generally, to pick up a few more crumbs.

I wanted this book to give talented and ambitious artists, who want to do great art and be great artists, some help to achieve that status without needing to win the lottery. I want these artists to be able to realize their dreams in their work. That is the real goal. To actually create. There are more good artists out there than there are winning slots. Even talented artists might not become recognized and might be disregarded along with the multitude of uninspiring, mediocre artists. I don't care what style - from an artist who wants to spend a career drawing insects to an artist who wants to make monumental installations - there are conditions that will help the artist to make good art. There are also conditions that will hamper good art from being made, and these, of course, should be avoided. I do make a distinction about great art because of my desire to see more quality, more thought, more craft, and more innovation when I look at art. I hope that some of the ideas and experiences I've shared in this book will be picked up and used as catalysts to make it happen.

Most of all, I want artists to know that they have more power to live like artists, more power to create the art, and more power to integrate their art with the world - than they ever realized.

There is power for the people; artists do not need to be wholly owned and controlled by the actions of a curator or dealer or critic or art system. Artists can use their own powers to overcome the many obstacles that society puts out. This book hopefully has given you, the artist, tools to build a more solid foundation in order to create great art for tomorrow.

I hope that, as a viewer, I will be as open to new ideas as the artists who present the new art would want me to be.

Index

The Art Studio/Loft Manual
For Ambitious Artists and Creators

Do You Need a Great Art
Studio-Loft for Little Money?

For painters, sculptors,
printmakers, photographers.
For dancers, performers,
musicians, filmmakers.
For arts and theater groups -
and anyone who needs
gigantic work – live – exhibition
- performance space.
-and for anyone who is on a
limited budget!

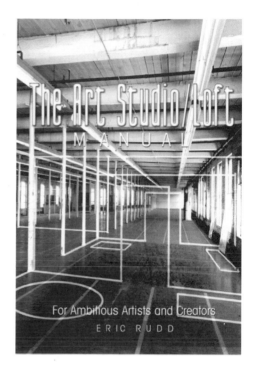

- How to find great studios;
 gold mines and pitfalls.
- How to turn them into
 living/work combos.
- Money matters: how to do
 it cheaply or let others pay.
- Real estate and legal
 issues; zoning, negotiation,
 purchase/lease.
- Construction: how to fix
 them up and save money.
- Design and modify large spaces and make them
 functional for your work and needs.
- Cost cutting measures, tricks, ideas, and hard
 practical advice.
- Think Big! 2,000 SF or 10,000 SF or more!
- How to make great studio space happen for you.

The first book to give practical solutions for thousands of artists and creators.
Stop renting. Get out of the spare bedroom or garage: if you need and dream
of large studio-lofts, you will need to read this book. Just one idea can save
you hundreds of dollars and hours of your time! Just one idea may find you
the studio of your dreams.

A Must Read For All Studio Users

Easy Order Form

Fax orders: (413) 663-6662 (Send this form)
Telephone orders: Call (888) 689-0978 toll free

(Have your credit card ready.)
Online orders available at www.cirecorp.com

Postal orders: Cire Corporaton - Publisher
Historic Beaver Mill, 189 Beaver Street, North Adams, MA 01247-2873. USA.

Please send the following books: I understand that I may return any of them for a full refund, for any reason, no questions asked.

THE ART WORLD DREAM
Alternative Strategies for Working Artists by Eric Rudd

THE STUDIO-LOFT MANUAL
For Ambitious Artists and Creators by Eric Rudd

Quantity _____ THE ART WORLD DREAM @ $19.95 Total: $_____
Quantity _____ THE ART STUDIO-LOFT MANUAL @ $19.95 Total: $_____
 TOTAL FOR BOOKS: $_____
 Massachusetts Residents Add 5% $_____
 Shipping $_____
 Total Enclosed or Charged: $_____

Shipping by air: US: $4 for the first book and $2 for each additional book.
International: $9 for the first book and $5 for each additional book.

Method of payment: ❑ Check ❑ Money Order ❑ Credit Card
Payment: Check or Money Order payable to Cire Corp in the amount of: $ _____
Credit Card: ❑ Visa ❑ Mastercard ❑ AmEx

Card number _____

Name on Card_____ Exp. Date: _____/_____

Signature _____ _____

Purchaser -ship to:

Name: _____

Address: _____

City _____State _____ Zip: _____

Telephone:_____

Email address:_____

The book is a gift, enclose a card that says a gift from: _____
and ship the book to the name and address below:
Ship to Gift Recipient: (if blank, we will ship to purchaser)

Name: _____

Address: _____

City _____State _____ Zip: _____

Telephone:_____

Email address:_____

❑ Please have someone contact me about speaking/seminars
Name and address of Institution or Organization: _____

Easy Order Form

Fax orders: (413) 663-6662 (Send this form)
Telephone orders: Call (888) 689-0978 toll free

(Have your credit card ready.)
Online orders available at www.cirecorp.com

Postal orders: Cire Corporaton - Publisher
Historic Beaver Mill, 189 Beaver Street, North Adams, MA 01247-2873. USA.

Please send the following books: I understand that I may return any of them for a full refund, for any reason, no questions asked.

THE ART WORLD DREAM
Alternative Strategies for Working Artists by Eric Rudd

THE STUDIO-LOFT MANUAL
For Ambitious Artists and Creators by Eric Rudd

Quantity _____ THE ART WORLD DREAM @ $19.95 Total: $_____
Quantity _____ THE ART STUDIO-LOFT MANUAL @ $19.95 Total: $_____
 TOTAL FOR BOOKS: $_____
 Massachusetts Residents Add 5% $_____
 Shipping $_____
 Total Enclosed or Charged: $_____

Shipping by air: US: $4 for the first book and $2 for each additional book. International: $9 for the first book and $5 for each additional book.

Method of payment: ❑ Check ❑ Money Order ❑ Credit Card
Payment: Check or Money Order payable to Cire Corp in the amount of: $ _____
Credit Card: ❑ Visa ❑ Mastercard ❑ AmEx
Card number _____
Name on Card_____ Exp. Date: _____/_____
Signature _____

Purchaser -ship to:
Name: _____
Address: _____
City _____State _____ Zip: _____
Telephone: _____
Email address:_____

The book is a gift, enclose a card that says a gift from: _____
and ship the book to the name and address below:
Ship to Gift Recipient: (if blank, we will ship to purchaser)
Name: _____
Address: _____
City _____State _____ Zip: _____
Telephone: _____
Email address:_____

❑ Please have someone contact me about speaking/seminars
Name and address of Institution or Organization: _____
